The

# EVERYTHING

## Photography Book

Dear Reader,

We are born with the urge to create and view images. Throug[h] ... images. Through photography, we can both capture the moments and events tha[t] ... world as well as communicate what we can't put into words. Ou[r] ...inds constantly replace old memories with new ones. Pictures, however, are unchanging—a growing visual catalog of our lives. We use photography to express who we are and what we feel.

Photography is a richly rewarding art. Regardless of your level of interest—beginner, serious amateur, professional—you'll learn something new every time you put your eye to the viewfinder. Through photography, you can achieve three goals: experiencing the joy of exploring your creative side, the thrill in successfully creating an image that speaks to you and others, and the pleasure of viewers appreciating your end result.

This book gives you the basics of photography and the visual arts so you can experience your environment with a photographic eye, express yourself, and create images that thrill you and your friends. Reading these pages will make picking up your camera both natural and novel, ordinary and exciting. Material that at first seems challenging or elementary will soon hang in your tool belt for use when you are making a portrait of your toddler, snapping a picture of your new car, or recording your mother on her eightieth birthday.

Sincerely,

The EVERYTHING® Series

## Editorial

| | |
|---|---|
| Publishing Director | Gary M. Krebs |
| Managing Editor | Kate McBride |
| Copy Chief | Laura MacLaughlin |
| Acquisitions Editor | Bethany Brown |
| Development Editor | Michael Paydos |
| Production Editor | Khrysti Nazzaro |

## Production

| | |
|---|---|
| Production Director | Susan Beale |
| Production Manager | Michelle Roy Kelly |
| Series Designers | Daria Perreault |
| | Colleen Cunningham |
| Cover Design | Paul Beatrice |
| | Frank Rivera |
| Layout and Graphics | Colleen Cunningham |
| | Rachael Eiben |
| | Michelle Roy Kelly |
| | Daria Perreault |
| | Erin Ring |
| Series Cover Artist | Barry Littmann |
| Interior Photographs | Eliot Khuner and Tom Minczeski |
| Color Insert Photographs | Eliot Khuner, 2000 EyeWire® by Getty Images™, ©1998 Corbis Corp. Digital Stock, ©1999 PhotoDisc, Inc. |

Page 1, 2, and 3 courtesy of Eliot Khuner; page 4 *top left photo*, courtesy of Eliot Khuner; page 4 *top right photo* and *bottom photo*, 2000 EyeWire® by Getty Images™; page 5 courtesy of Eliot Khuner; page 6 *top photo*, ©1998 Corbis Corp. Digital Stock; page 6 *bottom photo*, courtesy of Eliot Khuner; page 7 *top photo*, courtesy of Eliot Khuner; page 7 *bottom photo*, ©1998 Corbis Corp. Digital Stock; page 8 *top photo*, courtesy of Eliot Khuner; page 8 *bottom photo*, ©1999 PhotoDisc, Inc.

**Visit the entire Everything® Series at everything.com**

# THE
# EVERYTHING
# PHOTOGRAPHY
# BOOK

Foolproof techniques for taking
sensational pictures

Eliot Khuner with Sonia Weiss

Adams Media
Avon, Massachusetts

An Everything® Series Book.
Everything® and everything.com® are registered trademarks of F+W Publications, Inc.

Published by Adams Media, an F+W Publications Company
57 Littlefield Street, Avon, MA 02322 U.S.A.
*www.adamsmedia.com*

ISBN: 1-58062-878-8
Printed in the United States of America.

J I H G F E D C B

**Library of Congress Cataloging-in-Publication Data**
Khuner, Eliot.
The everything photography book / Eliot Khuner with Sonia Weiss.
p.    cm.
(An everything series book)
ISBN 1-58062-878-8
1. Photography–Handbooks, manuals, etc. I. Weiss, Sonia. II. Title.
III. Series: Everything series.
TR146.K49           2003
771–dc21      2003004473

*This book is available at quantity discounts for bulk purchases.*
*For information, call 1-800-872-5627.*

# Contents

# Acknowledgments

Special thanks to photographers Eliot Khuner and Tom Minczeski.

Special thanks to the following models for appearing in the book:

Debbie Beaukema
John Caybut
Rachel Mori Foster
Tony Gapastione
Eliot Khuner
Gertrude Khuner
Barbara Kragen

Julia Laurin
Mabel Lartigue
Tom Minczeski
Danielle Throckmorton
Jamie Throckmorton
Jonathon Woon

# Top Ten Things
## *You Need to Know about Photography*

1. What camera is right for you—something simple and easy, or do you want a camera that will give you full creative control to get that exact shot? You need to know so you don't spend too much money or end up with something that isn't enough for your needs.

2. You need to know what lens to use for what purpose, and you should know what lenses are essential versus those that may simply be extras.

3. Lighting, lighting, lighting—the word "photo" means "light," and having the correct light is the most important element in getting a good photograph.

4. Using a flash. When the light isn't quite perfect, this essential device makes up for it.

5. Composition—what the scene of your photograph will be. How can it be the most interesting?

6. Shutter speed and aperture settings. Photographers using manual shooting modes must understand these concepts inside and out.

7. You'll need to know what accessories are essential and which are merely decorative bells and whistles (usually pretty pricey, too).

8. You need to decide what you want to shoot and how you want to shoot it. Do you want to take a clear, factual shot, or are you interested in something a little more interpretive and creative? Minor changes can alter results significantly.

9. Sometimes, you need to direct the printing process to get the best results from your shot. You need to know what to say and to whom to say it.

10. Most important, you need to know what you want to get out of photography. Is this a hobby? Simply a way of recording events? Or is it possibly something that will become a major passion in your life?

# Introduction

▶ WHILE IT WOULD BE NICE TO BEGIN THIS BOOK without dragging out that hackneyed old saying—a picture is worth a thousand words—no one yet has come up with a better way of describing our passion for capturing memories and images on film—and, in this day and age, on memory chips as well.

You may not remember most of what you see today, but you will if you record it through the lens of a camera. Unlike memories, which can shift and fade over time, photographs are unchanging images. They are a visual catalog of our lives. Moments, people, objects, and places rise from the ordinary to the significant when you capture them in photographs. With a photograph, you are telling the viewer, "This is something or someone important to me."

Cameras help us fix forever in time the people and things most dear to us—our parents, our kids, our friends, our pets. Just as you reflect on your life when viewing old pictures of yourself, so will your children use the images you create to look back on their lives. Your unknown descendants are looking over your shoulder as you record your life on film.

Cameras are also handy tools for simply documenting how things look. We use them to take pictures of precious objects for insurance purposes, for selling items online, for documenting beginnings, middles, and ends of projects. These images are often purely factual, without emotional content, yet they too serve an important purpose.

With the advent of digital photography in the mid 1990s, many people predicted that film-based photography would become a thing of the past, much like earlier predictions that the rise of the computer would result in the demise of the printed word. But film-based

photography is very much alive (as is the printed word) and is, in fact, thriving. Not only that, the same technological advances that made digital photography possible have made film-based cameras more affordable, easier to use, and capable of doing more than they ever could before.

There is no denying digital photography's advantages over film-based shooting. At the same time, film-based photography continues to offer many advantages over digital imaging. Many photographers use both, choosing the platform that best suits their needs depending on what they're shooting. Regardless of equipment choice, knowing how to take good pictures—how to compose them, how to light them, how to capture action versus still images—is still important. No amount of technological advances will ever replace the photographer's place behind the viewfinder.

While this book is meant to provide a general overview of what photography is all about, its primary focus is on film-based 35mm photography. More specifically, we discuss using a 35mm single-lens reflex, or SLR, camera. The reason for this emphasis is simple. SLR cameras are the most versatile cameras made, and they offer the greatest range of features and capabilities. If you shoot with other kinds of cameras, you'll still find much of interest here as well. But keep in mind that some of the techniques and technical information presented might be beyond the capabilities of your equipment.

These are exciting times for anyone who enjoys taking pictures. Not only are there more equipment choices and options than ever before, there are also more opportunities for sharing your work with others. Regardless of what kind of photographer you are or aspire to be, the richness of photography is so great that it can't be exhausted in a lifetime. Even the most experienced professional photographers will tell you that there is always a new challenge, something else to be learned, a technique to be honed, a skill to be mastered.

The more you use your camera, the better your life will be. The more you take pictures, the more ways you will have to experience and savor life. Having a photographer's eye, mind, and heart will give your life deeper meaning. You will create memories and connections for years and years to come.

**Chapter 1**

# The Joy of Photography

Most of us take our ability to capture images on film for granted. But the technology that makes it possible to do so didn't exist even as recently as 175 years ago. While many concepts essential to photography have been known for thousands of years, new inventions happening as you read this book are still altering the world that is photography.

# Developments in a Dark Room

No one knows exactly when or how it happened, but at some time in ancient history, someone noticed that when light came into a darkened room through a small hole, it created an upside-down (and laterally reversed) image of what was outside on the wall opposite the hole. Centuries later, this optical principle was given the name *camera obscura,* which is Latin for "dark room."

The earliest mention of a *camera obscura* was by the Chinese philosopher Mo-Ti, from the fifth century B.C., who called the darkened room a "collecting place" or "locked treasure room." The Greek philosopher Aristotle also recorded the optical principle of the *camera obscura* after he viewed a solar eclipse through the holes of a sieve and through the tiny gaps between the leaves of a tree.

**QUESTION?**

**What causes the *camera obscura* image to appear upside down and reversed?**
Under normal conditions, light travels in a straight line. When we see an object, we're actually seeing light reflecting off the object's surface. When the light that is reflected off an object passes through a small hole in thin material, only the light heading in specific directions passes through the hole, converging at a point and then projecting on an opposite surface upside down and laterally reversed.

In the tenth century, Arabian scholar Ali Al-Hazen Ibn Al-Haitham, also known as Al-Hazen, used a portable *camera obscura* to observe solar eclipses. An expert in philosophy, physics, and mathematics, Al-Hazen was a serious researcher for his time. He was the first to explain how the eye can see. Among his many other observations was the fact that the image projected by the camera's pinhole became sharper as the hole became smaller.

# Bringing Things into Focus

The earliest *camera obscuras* were primarily used for observing solar eclipses and for other scientific applications. The images they projected remained primitive, as only the size of the pinhole could refine them. In the sixteenth century, a focusing lens was added to the pinhole opening, which sharpened the images that appeared on the viewing wall. The lens also made possible a bigger pinhole that would let in more light and create larger and better images. Another important advancement was a mirror that turned images right side up and reflected them onto a viewing surface.

The *camera obscura* now had practical applications, and painters and draftsmen used the table-top-sized devices to project images onto paper that they could then trace with pen, charcoal, or pencil. Over time, the *camera obscura* was refined and made even smaller so it could be used in the field. However, there was no way to permanently capture *camera obscura* images themselves for later use.

If you still don't quite understand the concept of *camera obscura*, don't worry. It isn't essential to know every technical aspect of photography. This information would be important if you were planning on *building* a camera, but let's figure out how to take good pictures first, okay?

# The Quest for Permanent Images

Hundreds of years before the photographic process was invented, people had already noticed that certain objects and elements changed color when left in the sun. What they didn't know was whether these changes were caused by light, heat, or air. In 1727, German professor Johann Heinrich Schulze determined that heat did not cause silver salts to darken when he baked some in an oven. He then decided to test light's effect on the chemical. He carved some letters out of a piece of paper, stuck the paper to a bottle filled with the salts, and placed it in the sun. The sun darkened only the exposed parts of the chemical. The parts underneath the paper remained lighter.

In the early 1800s, Frenchman Joseph Nicéphore Niépce (pronounced "neep-ce") captured the view outside his window by placing a sheet of paper coated with silver salts at the back of a *camera obscura* and exposing it through the lens. Since he didn't know how to protect the image from further exposure, however, it vanished when the paper was exposed to full daylight.

Several years later, Niépce devised a way to make a permanent image on a metal plate coated with bitumen, another photoreactive substance. It took about eight hours for the image of the view from his window to form on the light-sensitive material. Niépce called his process "heliography," meaning "writing of the sun."

## The Daguerreotype Develops

Louis Jacques Mandé Daguerre, another Frenchman, was experimenting with photoreactive chemicals at the same time as Niépce. A noted artist, Daguerre regularly used a *camera obscura* as a painting aid, and he wanted to find a way to make images last. He learned of Niépce's work in 1826 and formed a short partnership with him that ended when Niépce died in 1833. After his partner's death, Daguerre continued his quest for a permanent image. Instead of heliography, however, Daguerre worked on developing a new process that would yield faster exposure times.

The daguerreotype, as Daguerre called his process, was a significant advancement in the quest for a permanent photographic image, but it still had its flaws. Since it was a positive process, it only yielded one-of-a-kind images, and the plates they were made on were extremely delicate. Exposure times were still lengthy, about thirty minutes or so, which ruled out portraiture. Over time, however, the process was refined, and exposure times were reduced to seconds.

## The First Negative

In England, William Henry Fox Talbot, a researcher and chemist, was also experimenting with creating permanent images after trying—and failing—to draw some pictures while on vacation. Frustrated over his lack of artistic talent, he decided to find a way to capture permanent images with a *camera obscura*.

Instead of metal, Talbot—or Fox Talbot, as he's often called—used paper embedded with silver chloride, which he topped with various objects and exposed to the sun. This process created a negative image, rendering dark objects light and light objects dark. He then soaked the paper negative in oil, which made the light areas translucent, and made a positive print by shining light through it onto another piece of photosensitive paper.

Talbot's negative-to-positive process made it possible to create more than one copy of the same image. However, the images it produced were crude and fuzzy compared to Daguerre's crisply rendered plates. Most people preferred the latter, and Talbot's invention was never widely employed, although it did represent an important step in the development of modern photography.

William Talbot's negative-positive system most likely predates the daguerreotype. Although Daguerre's invention was announced earlier, Talbot's letters indicate that he had invented his system in 1835 and chose not to announce it until he perfected it. When Daguerre's invention was made public in 1839, Talbot then rushed to publicize his own work.

Talbot's inventions didn't end with the negative-positive process. In the next few years, he also came up with the following techniques and ideas:

- **The calotype** (from the Greek "kalos," meaning beautiful), or latent image. This was an accidental discovery, made after Talbot underexposed some photosensitive paper. Instead of tossing it, he applied more silver compound and the images miraculously appeared. This discovery significantly decreased exposure times—before it, photosensitive materials had to be exposed long enough for light alone to darken them.
- **Using a fine mesh screen** to create a halftone image for printing purposes.
- **Photoglyphy,** a photo-engraving process he patented in 1858.

- **Flash photography,** which he demonstrated in 1851 when he photographed a newspaper using the light from an electric spark. He did this to demonstrate how a moving subject (the newspaper was spinning) could be captured sharply by a very short duration flash, in this case less than 1/10,000 of a second.

Talbot displayed how well several of his inventions worked in 1844, when he published *The Pencil of Nature,* the first book to contain photographs. A true visionary, he also predicted such technologies as infrared photography, photo duplication (copy machines), and microfilm.

**FACT**

The earliest known surviving photographic negative on paper was taken by Fox Talbot in 1835. "Latticed Window," an image of a window in his home, Lacock Abbey, resides in the photographic collection of the Science Museum at the National Museum of Photography, Film & Television in Bradford, England.

Inspired by Daguerre and Talbot, English astronomer Sir John Herschel also began experimenting with the photographic process. He discovered that thiosulphate of soda, the chemical now referred to as "hypo," would fix images on photosensitive paper by stopping the chemical action of silver salts.

## The Advent of Wet and Dry Plates

In 1851, the new science of photography was further refined by Frederick Scott Archer's invention of wet-plate collodion photography. This process involved spreading a mixture of collodion, a wound-dressing material made of nitrated cotton dissolved in ether and alcohol, and other chemicals on sheets of glass. It delivered more highly refined images than either Talbot's or Daguerre's methods. In 1871, English physician Richard Leach Maddox took Archer's discovery a step further with his "dry plate" process, which used an emulsion of gelatin and silver bromide on a glass plate.

# The Camera Comes of Age

At the same time that Talbot and others were experimenting with the chemical side of photography, advances were being made in the machine itself. A shutter was added to control exposure times, which had grown significantly shorter due to the advances in imaging materials. With exposures now shortened to a little as 1/25th of a second, not only were action shots now possible, but people didn't have to freeze in place for minutes at a time to have their pictures taken. Although the cameras of the period were still bulky and large by modern standards, they had shrunk in size as much as possible to still be able to accommodate the large imaging plates of the time.

## Enter the Kodak Moment

In the late 1870s, American George Eastman, a junior bank clerk and avid amateur photographer, began experimenting with gelatin emulsions in his mother's kitchen at night. In 1880, in Rochester, New York, he established a manufacturing company to make dry plates based on his formula. Eastman continued to tinker with his emulsions, and in 1885, he patented a machine that coated a continuous roll of paper with emulsion.

Three years later, Eastman introduced the Kodak Camera. With the promotional slogan "You press the button, we do the rest," it sold for $25 and came already loaded with a 20-foot roll of paper film, enough for 100 exposures. (A year later, Eastman substituted the paper roll with one made of celluloid.) After all frames were exposed, the user sent the entire camera back to Eastman's company. There, the film was processed, printed, and the camera was loaded with a new roll, after which it was sent back to its owner with the negatives and a set of prints.

Eastman continued to refine his camera, making each new version a bit smaller and a little more technologically advanced than previous models. He was able to bring the cost of a camera down to $5—a good price for the time, but Eastman was determined to come up with an even cheaper product that anyone could afford to buy. In 1900, with the debut of the Brownie, he fulfilled his long-held dream of putting the magic of photography into the hands of anyone who wanted to snap a shutter.

The Brownie cost just $1, and it used film that sold for 15 cents a roll.

The first Kodak cameras used film that was physically much larger than what we're used to today as the chemicals used in film manufacturing and the lenses of the time were somewhat crude. As time went on, emulsions and lenses became more refined, and the need for large-format film to produce acceptable images diminished.

## Photography Made Small

By the early 1900s, advances in photographic film and lenses made possible the first truly miniature camera. Designed by Oskar Barnack for the Leitz optical company, and introduced to the public in 1925, the Leica 1 ("Lei" from Leitz and "ca" from camera) was small and light enough to be held in one hand. It used much smaller film than other cameras did, and it had high-quality lenses that produced superlative images with available light.

The Leica 1 was the first 35mm camera, so called as the film it took measured 35mm in width. It became particularly popular with newspaper photographers as its diminutive size and advanced lenses made it easy for them to take pictures without having to stop and set up bulky, obtrusive equipment.

In the 1930s and 1940s, photo imaging made a giant leap forward. Color transparency film was introduced in 1935, and in 1942 came color negative film. The debut of the Polaroid Land Camera in 1947 made it possible to take a picture and develop it on the spot in a minute or less.

# Modern-Day Cameras

Over the years, and even today, cameras continue to evolve. Simpler, cheaper, and more capable of producing higher-quality results, there is a camera available to fit any person's needs.

## The Single Lens Reflex Camera

The 35mm single lens reflex, or SLR, camera, which debuted in 1960, ushered in modern-day photography. It continues to be the technology and

format in widest use to this day. Unlike earlier 35mm cameras, SLR cameras featured special mechanisms that allowed photographers to see the same image in the viewfinder as what the lens captures on film. With their interchangeable lenses and complete control over shutter speed, lens opening, and focusing, SLR cameras also offered photographers the tools for expanding their creative abilities beyond what was previously possible.

For photographers wanting to take advantage of some of the versatility and creativity of the new cameras without having to learn the techniques necessary to master them, numerous manufacturers came out with easier-to-use (and cheaper) versions, including the point-and-shoot camera. In the 1980s, the introduction of capabilities like autofocus, autoexposure, and other automatic features allowed users to concentrate more on the images they wanted to capture and less on the mechanical processes necessary to create them.

**FACT**

George Eastman invented the name "Kodak" for his first camera and his fledgling company. When asked about the origins of the name, he said he liked the sound of the letter "K," and he experimented with a number of combinations using it until he came up with a name he liked.

## APS Cameras

In the mid 1990s, photography in the point-and-shoot world evolved further with the introduction of the Advanced Photo System (APS). Developed by an international consortium of camera and film manufacturers as a fully integrated photographic system for amateur photographers, APS features a special magnetic coding process that facilitates communications between the camera, film, and photofinishing equipment and makes for almost goof-proof picture taking. APS cameras are smaller than 35mm cameras. They have smaller lenses and use smaller film as well. They're fully automatic and self-loading, which virtually eliminates any user errors. They feature three different picture formats—C, or classic, similar to a standard 35mm print (3.5" x 5" or 4" x 6"); H, or high-vision (also called group or HDTV), measuring 3.5" x 6"

or 4" x 7"; and panoramic, measuring 3.5" x 8.5" or 4" x 11.5". APS cameras also allow users to switch between formats on the same roll of film. Magnetic strips on the film record the exposure and sizing parameters for each picture. During processing, the photofinishing equipment reads the information recorded for each negative and makes the necessary adjustments.

While the APS system makes panoramic pictures a breeze to create, it's possible to make pictures in this format with 35mm cameras as well. A lab can blow up the image and print it on 4" x 10" paper. You can also turn any print into a panorama shot by trimming off the top and bottom.

## Digital Enters the Picture

Digital imaging, which also debuted in the 1990s, is the latest step in the evolution of photography. Instead of recording images on film, digital cameras use tiny light sensors to convert images into electrical charges. A processor inside the camera then analyzes the information and translates it into a digital image comprised of pixels, or tiny dots. After the image is composed, it is stored either on a memory chip inside the camera or on a removable memory card or disk. Images can be transferred to a computer, where they can be viewed, edited, and printed out on a printer. Some cameras can even make short videos or have the capability to output images to televisions.

The technology behind digital cameras made them extremely expensive when they were first introduced, which put them beyond the reach of most photographers. Since then, they've come down substantially in price, with good-quality cameras widely available in the $200 to $300 range.

*Chapter 2*

# Getting to Know the SLR Camera

Capable of capturing the most minute details on the tiniest objects and then, with a quick change of lens, of bringing far-away images up close, the 35mm single-lens reflex camera, or SLR, gives photographers virtually complete creative control over how they create their images. Here's more about one of the most versatile and widely used camera today.

## All about the Body

The main part of the SLR camera, the body, packs a lot of punch in a small package.

Most SLR bodies are made of high-impact plastic or a lightweight metal, which makes them light and durable. Some manufacturers combine the two. They're designed to fit comfortably in your hands. Most come with a built-in grip—almost always on the right side—to help you hold them securely.

**FACT**

Because SLR cameras are modular—that is, you can purchase lenses separately—they offer the flexibility of allowing you to start with a reasonable investment in one body and one lens. Over time, you can purchase, rent, or borrow more lenses as needed. The design of the SLR also allows you to replace one part rather than the whole camera if it breaks.

Most SLR camera bodies are hinged on the back to facilitate film loading and unloading. On older cameras, the back might come completely off.

The bodies of SLR cameras sport a number of features. Here are some you can expect to find on most of them:

- **Accessory shoe:** A small bracket on top of the camera, used for mounting a flash unit.
- **Shutter release button:** Usually located on the right side of the camera—either on the front or on the top—as it's facing away from you.
- **Command dial:** For controlling automatic features and shooting modes.
- **Lens release button:** For using multiple lenses, in succession, on the same camera.
- **Cable release connection:** Used to fire the shutter from a distance to prevent vibrations during long exposures.
- **Tripod socket:** Used to attach the camera to the tripod.
- **Power switch.**

- **Self-timer button.**
- **Viewfinder.**
- **Built-in flash.**
- **Film cartridge information window.**
- **LCD panel:** Displays shooting information, including number of exposures taken, shooting mode, shutter speed, exposure, focus mode, and other information.

Again, the physical appearance and location of these controls and features will vary, depending on the camera model and manufacturer. You might find other buttons, controls, and other devices that govern such functions as autoexposure lock, red-eye reduction, film rewind, and more.

**ALERT!**

Never forcibly open the back of a camera. Doing so may damage the film loading mechanism. If you're not sure how to open your camera, review the manual or take it to a camera store and ask for help. Tell anyone who might try to open the camera if there is film in it.

One feature you'll find on the front of every SLR camera is the lens mount. As the term suggests, this is the place where the lens attaches to the camera. Most SLRs available today are equipped with bayonet mounts, which couple the lens to the camera together with just a quick turn. Other types of mounts that you might see, primarily on older SLRs, include screw mounts and breech-lock mounts, in which a ring on the lens is used to secure it to the camera. Some older lenses with screw mounts can be adapted for use on cameras with bayonet mounts.

On cameras with autofocus capability, you'll see a set of small pins just inside the lens mount. These are electronic contacts that transmit data back and forth from the camera to the lens, controlling such things as autofocus and aperture settings. Look on the back of an autofocus lens, and you'll see a series of flat contact points that fit precisely with the electronic contacts inside the lens mount when lens and camera are correctly coupled together.

# Inside the Camera

As previously mentioned, today's SLR cameras pack a lot of technology into their small bodies. They house multipart viewing and shutter mechanisms as well as a host of electronic components that make possible such features as automatic focus and automatic exposure. You can't see the mechanism for many of these features, and for the most part, you really don't have to worry about them. But it's a good idea to know where they are and what they do.

## Finding the View

Take the lens off an SLR camera body, and you'll immediately see the single-lens reflex mechanism. This is the technology that separates SLR cameras from all others. Consisting of a slanted mirror positioned between the shutter and the lens, a piece of translucent glass, and a five-sided prism, or pentaprism, it lets you see exactly what the image on the film will look like.

When you look through the viewfinder on an SLR camera, what you actually see is a reflected image that's been turned the right way round before it even reaches your eye. First, the mirror takes the image that shines through the lens and reflects it upwards to the translucent glass, which functions like a miniature projection screen. The pentaprism, located above or behind the glass, flips the image on the screen, making it appear right side up, and redirects it to the viewfinder window.

**FACT**

The clicking noise made by SLR cameras comes not from the shutter, as many people think, but from the mirror as it flips up and down during the picture-taking process.

When the shutter is clicked, the camera quickly flips the mirror out of the way so the image is directed at the exposed film. As long as the shutter stays open, the mirror, which is connected to the shutter timer system, stays up. Because the mirror is moved out of the way, the image can no longer be seen in the viewfinder, but this momentary blackout is barely noticeable.

Once the image is taken, the shutter closes and the mirror flips back down into place. This is the reflex motion that gives the camera its name.

On modern SLR cameras, viewfinder windows do more than simply facilitate framing and focusing. What you'll also see in the window, depending on the camera's particular features, are indicators for things like shutter speed, focus, red-eye reduction, flash, depth-of-field, and camera-shake warning, which indicates situations where handheld snapping will yield blurry images due to camera movement and slow shutter speeds.

## Snapping the Shutter

Most SLRs have what are called focal-plane shutters. These devices are basically a couple of pieces of flexible cloth or metal blades that expose the film by quickly opening and closing when the shutter is pressed. The shutter is positioned in back of the camera, just in front of the film.

## Storing the Image

SLR cameras all have internal film handling systems, consisting of a film holder to keep the film in place while it's being exposed and a film-transport system that controls how the film moves through the camera.

# SLR Features and Functions

SLR cameras fall into two basic categories: manual and automatic. Each type has its advantages and its drawbacks. With manual cameras, you set the focus yourself, and often the aperture and shutter speed as well. This can be great for people who know a lot about the technical side of photography, or who want to learn about it. It also lets you use a wider variety of lenses as you're not limited to those that only work on automatic focus cameras. However, the lack of automatic features makes manual cameras difficult for inexperienced users to operate.

SLRs with such features as autoexposure and autofocus take a lot of the guesswork out of photography, and they usually offer shooting modes

that let the user override the automatic controls for times when manual operation is preferred. Because they make the picture-taking process easier, most consumers prefer them, which means that there are far more automatic SLRs than manual ones on the market today.

The best source of information on your camera's specific features and functions is its instruction manual. Study it thoroughly, and reread it often. If you don't have it, buy one or find one to photocopy. Sometimes manufacturers have online versions of the owner's manual for all their products.

## Autofocus

This technology, which was introduced in the 1980s, helps eliminate blurry images and is probably the most popular feature on SLR cameras. There are two types of autofocus systems: active and passive.

Passive autofocus uses the light rays that pass through the lens to measure the contrast and adjust the focus until it's as sharp as it can be. The more focus points a camera has, the faster and more easily it will focus. Subjects that don't have an edge or line or other details for the sensor to grab onto will stymie cameras with less sophisticated passive systems, as these cameras have fewer focus sensors. When the number of focus sensors is increased, passive autofocus cameras can read input from more places in the scene; that is, it is easier for them to find something to focus on.

Active autofocus systems work by sending a beam of infrared light from an emitter on the camera body. A sensor then measures the distance from camera to subject according to the length of time it takes for the infrared light to bounce back from the subject. Active autofocus works in the dark and can handle pictures with few high-contrast areas to focus on, but it can also be fooled by objects closer to the camera and by reflective surfaces like window glass.

Most SLRs have passive autofocus capability, which you need to handle the variety of lenses that go on the camera.

**QUESTION?**

**Which focusing system is better: active or passive?**
In certain conditions, one might be better than the other, but generally you don't need to worry about which system the camera uses. What does matter is how accurately and quickly the camera focuses. Once you own the camera, you should know which subjects and scenes are most likely to fool your camera's focusing system. Then learn the techniques for handling the problems that your camera presents.

While autofocus is a wonderful tool, it does have its drawbacks. Because it depends on electronics, it can fail. Other drawbacks to autofocus systems include the following:

- **Difficulty operating** autofocus lenses by hand with the camera in manual focus mode.
- **Noisy camera operations** due to autofocus mechanisms.
- **Less durable lenses.** To cut down on the weight of autofocus lenses, which contain computer circuitry and other mechanisms necessary for the autofocus process, some manufacturers make them with plastic barrels.
- **Uneven operation in cold weather.** Low temperatures can affect the action of autofocus lenses. It also weakens the batteries that power autofocus systems.
- **Drains battery resources.**
- **Focus difficulty.** Can potentially focus in on something in the foreground or background if the photographer is not careful.

## Autoexposure

SLR autoexposure systems measure the brightness of the scene, and then set the shutter speed and the aperture for correct exposure. Some systems use a sensor on the front of the camera. Most SLRs, however, use through-the-lens—known as TTL—metering, which is more precise and increases the accuracy of the exposure.

TTL metering systems use several methods to measure light.

- **Center-weighted metering,** which takes a reading from the center of the viewfinder.
- **Matrix, or evaluative metering.** These systems divide the picture area into a grid and then analyze the contrast and brightness in each part of the grid to come up with a suggested exposure.
- **Spot metering,** which takes a reading from a small circular area in the viewfinder and sets the exposure for the entire picture based on this reading.

The specific metering system used varies depending on the camera model. Center weighting is most common, with matrix metering and spot metering usually available on more expensive models. Some cameras offer all three, allowing the photographer to choose the metering method that best suits the situation. Spot metering, for example, is great for scenes with lots of contrast, as it allows you to take a series of readings from specific areas of a picture and then decide which readings you want to use for the effect you're going for.

No matter how images are produced, the basic principles of photography—content, lighting, composition, dynamic range, color, contrast, and texture—will always be a part of the photographic process. The need and desire for photographs will never diminish, and the number of ways in which pictures can be created will only continue to increase.

When not in fully automatic mode, SLR cameras offer two different methods for setting exposure. Aperture priority allows the user to set the aperture, after which the camera automatically sets the appropriate shutter speed. This priority setting allows you to control depth of field. (See Chapter 5 for more information on shutter speed and aperture.)

Shutter priority lets you choose the shutter speed you'd like to use, and the camera takes care of the aperture. This priority setting is good for times when you want greater control over how action scenes are shot, such as using a fast shutter speed for stopping action or a slower speed to blur it.

Another feature on many SLRs is exposure compensation control. This allows complete control over the camera's autoexposure system and makes it possible to set the camera to over- or underexpose your film by up to two or three stops in either direction. Exposure compensation is good for working in backlit situations to shed more light on foreground subjects or for other times when you want to use a different exposure than what the camera's metering system suggests.

## Film Advance

Also called a motor drive, this mechanism automatically moves the film through the camera each time the shutter is clicked. On many automatic SLRs, it can be set to allow you to fire the shutter once every time you push the shutter release button, or continuously for several frames—as long as you don't run out of film—while you hold the shutter release button down.

## Auto Load and Auto Rewind

These are common features in automatic SLR cameras. Drop in the cassette, pull the film leader across to the correct spot (if necessary), close the back, and the film advances to the first frame. Most systems also set the film speed automatically to make sure it's exposed correctly (film cartridges are coded so that cameras can determine which speed the film is).

Auto rewind is activated when the roll is complete and the camera senses that it can't pull any more film out of the cassette. The camera then automatically activates a motor that rewinds the film. Film can also be re-wound before all the frames are exposed by pressing a film rewind button.

Make sure you know how much sound your auto rewind makes before using it in what could be an inopportune situation, like the middle of a wedding ceremony as the bride is saying her vows. On some cameras, the auto rewind is very, very loud, and it could be a major distraction in certain situations.

# Working with Automatic Programs

Another feature of automatic SLR cameras are preset shooting programs, or program modes. The most fully automatic of them, often referred to as full program mode, selects the aperture and shutter speed, switches on the camera's built-in flash unit if necessary, and focuses the lens. All you have to do is snap the shutter. In effect, this is a point-and-shoot program, useful for inexperienced photographers or for grabbing a quick shot when there isn't time to stop and think about it. Other common automatic program modes include the following:

- **Depth-of-field or landscape mode,** which automatically chooses the smallest possible aperture that will allow handheld photography.
- **Action or sports mode,** which evaluates existing light conditions and sets the fastest shutter speed possible.
- **Portrait mode,** which blurs the background on these shots by setting as large an aperture as possible.
- **Close-up mode,** which exposes only for images close to the camera.
- **Silhouette mode,** which underexposes a foreground subject against a brightly lit background to create a silhouette.

Some SLRs will automatically set different programs depending on the lens being used, choosing depth-of-field for a wide-angle lens, action or sports mode for telephoto lenses, and so on. Many of these cameras will also set the appropriate program modes for zoom lenses.

### Chapter 3

# Point-and-Shoot Photography

For photographers who want an easy way to capture great-looking images, there's another popular type of camera that's also based on the 35mm format. In this chapter, you'll learn more about the SLR's cousin, the point-and-shoot camera. Smaller, simpler, and generally cheaper, the point-and-shoot camera gives casual photographers an amazingly convenient tool that can handle most photographic needs.

# What Is Point-and-Shoot Photography?

"Point-and-shoot" is a broad term used to describe a class of cameras that can remove virtually all of the guesswork and a lot of the complexity from taking pictures. They range from inexpensive fixed-lens disposables to expensive miniature cameras with high-quality lenses capable of emulating images taken with the best SLRs. They all feature automatic controls that allow photographers to worry less about technical details and focus more on taking pictures.

Cameras that fall into the point-and-shoot category include single-use (disposable) cameras and 35mm compact cameras. While they're not technically 35mm cameras because of their smaller film size, APS cameras also fall under the point-and-shoot category. Digital cameras can also be of the point-and-shoot type.

**FIGURE 3-1**

*Photograph courtesy of Eliot Khuner*

▲ A selection of point-and-shoot cameras, ranging from an inexpensive disposable (top) to a midrange model with a zoom lens, auto focus, and several shooting modes (right).

# What Makes Point-and-Shoot Photography Different

Point-and-shoot cameras differ from SLRs in several significant ways. For the most part, they don't have interchangeable lenses, although some of the top-of-the-line models may offer this feature. They also don't focus through the lens as SLRs do, using instead a separate viewing window. Some better cameras use a separate viewing lens.

Since they don't contain the SLR mechanism, point-and-shoot cameras use a different type of shutter. And, of course, they're fully automatic, although some higher-end models have manual override features that offer more control over how images are made.

**FACT**

Point-and-shoot cameras are also called compact cameras or lens-shutter cameras, as their shutters are built into their lenses. You'll sometimes hear SLRs referred to as manual cameras.

# Advantages of Point-and-Shoot Photography

Point-and-shoot cameras allow virtually anyone to take good pictures with predictable results quickly and without much effort. Because they automatically control how images are taken, users don't have to worry about such things as focusing, f-stops, depth of field, or shutter speeds. Instead, they can concentrate more on other aspects of taking good pictures, such as point of view, anticipating the action, catching the decisive moment, finding the best direction and quality of light, and interacting with the subject. Many of these cameras have a tiny, built-in flash, which means that you don't even have to think about lighting.

Point-and-shoot cameras have fewer moving parts, which makes them cheaper than comparable SLRs as well as less likely to break and quieter to operate. They're lighter and more compact than their more complex cousins, which make them easier for kids—or, for that matter, anyone with small hands—to handle and work with. Their size and weight also makes them great choices for taking on vacations.

Because point-and-shoots are so small, they often look cheaper than SLR cameras do, which makes them less likely to be a target for thieves. They also have fewer parts that protrude from the main body of the camera, meaning you'd be less likely to break or snap something off.

Much of photography is about being in the right place at the right time. If a complicated camera intimidates you, or if you're worried about using one in certain situations, it will be in the closet instead of in your hands the next time you want to capture a special moment. Having a small, easy-to-use camera can do a lot to help this happen. With careful composition, close attention to light quality, a good connection to your subject, and a good idea of what the photograph is supposed to be about, the point-and-shoot could be the perfect tool, and it could be most likely to perform exactly the way you expect.

## Disadvantages of Point-and-Shoot Photography

Now, for the downside to the point-and-shoot method. With these cameras, you sacrifice the creative tools of selective focus and, with most point-and-shoot models, close-up photography. Cheaper models will not give you the satisfaction of sharp, dynamic enlargements, subtle use of low light, and other creative and esthetic aspects of photography.

Other downsides to point-and-shoot cameras include the following:

- **Inferior lens quality:** With the exception of the most expensive point-and-shoot models, the lenses on most of the cameras in this category are not the best money can buy.
- **Less accurate image framing:** Point-and-shoot cameras focus through a separate viewing window rather than through the lens, like SLR cameras do. This means you can't see exactly how the final picture is going to be composed. However, what you do see is pretty close.

- **Inaccurate viewfinders:** Viewfinders in point-and-shoot cameras may not be very accurate. Although you carefully center and compose your shot, the print may show the main subject too small and off to one side or too low in the frame.
- **Less sophisticated light-metering systems:** Exposures may be off in both existing light situations and with flash, resulting in badly exposed negatives that are harder to correct in the lab.
- **Lens-cap errors:** Because you're not viewing your subject through the lens with point-and-shoot cameras, it can be amazingly easy to forget to take the lens cap off. To mitigate the problem, some point-and-shoot cameras have a sliding cover over the lens that either automatically opens when the camera is turned on or that is opened manually.
- **Other image-loss problems:** Because point-and-shoot cameras are so small, it's very easy to cover up their sensors, flash, and even their lenses when held incorrectly.
- **Less creative range:** Photographers desiring to immerse themselves in the technical magic of photography will not get enough contact with it using a point-and-shoot.

**FIGURE 3-2**

Photograph courtesy of Eliot Khuner

◀ The incorrect way to hold a point-and-shoot camera. Here, the photographer has covered both the lens and several important sensors with his fingers.

## Problems with Parallax

Users of point-and-shoot cameras also have to deal with something called parallax error or parallax effect. Because the viewing frame is offset from the lens, the image you see through the frame is different from what the lens sees. The difference isn't great at normal distances—that is, about 10 feet or so away from the camera—but it intensifies as distances get shorter, making it increasingly difficult to see exactly what the lens will capture. You might think that you're getting everything you're seeing in your shot, when in reality you may end up with parts being chopped off.

Most point-and-shoot cameras get around the problem by marking the viewfinder eyepiece to indicate the area that will be included in a close-up. More expensive models sometimes have parallax correction or compensation features built into the viewfinder to guide close-up composition.

## Focusing Problems

Point-and-shoot cameras are somewhat notorious for fooling their users into thinking that images are in focus when they actually aren't. This happens because the viewing window is used for image framing, not for checking focus. (On SLRs, the viewing window does both.) Look near, far, or anywhere in between, and everything will look crystal clear through the lens in the viewing window. But due to the idiosyncrasies inherent in autofocus technology, what you'll actually see on film may end up being very different.

Unfortunately, there's not much you can do about this problem aside from knowing where the camera's focusing zones are and staying within them. More expensive point-and-shoot cameras do a better job of focusing because they feature more zones than less expensive models do.

# Basic Features of Point-and-Shoot Cameras

Because they substitute electronic circuitry for some of the mechanisms found in SLR cameras, point-and-shoot cameras are some of the smallest available on the market today. They're also lighter than their SLR counterparts. The less expensive point-and-shoots are usually made of plastic, which gets more durable as these cameras increase in price. Point-and-shoot cameras at the top end of the price range often sport durable titanium bodies.

One thing every point-and-shoot camera has is a manual. Read it, and keep it in your gadget bag along with your camera. You may not need it after you've used the camera for awhile, but it's essential if you're going to let someone else use it. Often items that seemed useless or too complicated when you first read about them become easy to understand after you master the basics.

## Autofocus

All but the cheapest point-and-shoot cameras have autofocus, which is activated by pressing down slightly on the shutter release. Most models use active infrared autofocus systems. These measure distances by shooting an infrared beam from the camera to the subject. A sensor then uses this information to move the lens into one of a number of focusing zones.

The simplest autofocus models generally have three zones that cover close-up (about 5 feet or so), medium-range (10 feet), and distance shots (20 feet and farther). More sophisticated point-and-shoot cameras have additional ranges to provide more precise focusing.

Most point-and-shoots also have focus lock, which allows for reframing the subject in the viewfinder after the focus has been set.

Autofocus isn't an option on the cheapest point-and-shoots, which almost always have fixed-focus lenses. Subjects within a certain range (say, 6 feet to infinity) will be in focus to a certain extent, but closer objects will be blurry.

## Autoexposure

Autoexposure controls determine how the camera handles specific lighting situations to yield images that aren't under- or overexposed. Most autoexposure systems on point-and-shoot cameras use a fairly simple setup, in which a front-mounted sensor measures existing light. When the shutter is pressed, the system reads the sensor and automatically sets the lens opening and shutter speed based on combinations already programmed in the camera's memory.

Some point-and-shoot cameras use through-the-lens, or TTL, metering, which is more precise and increases the accuracy of the exposure. Most TTL meters measure the overall light in a scene. Some more advanced TTL systems use center-weighted metering, which measures light at various points in the scene—such as the middle, top, and sides. The camera's electronics then analyze all the readings, usually putting more weight on the central portion of the scene.

**FACT**

The automatic exposure systems on point-and-shoot cameras aren't as sophisticated as those in SLR cameras. Color print film, which allows more exposure latitude than slide film, is usually the best choice for these cameras.

The least expensive point-and-shoot cameras use a fixed exposure, meaning that the shutter speed and lens opening never change. With these cameras, choosing the right film (high speed for indoor, slow speed for outdoor) is what it takes to get decent pictures. Some let you have a little control over exposure by flipping a switch between outdoor and indoor settings.

## Flash

Almost all point-and-shoot cameras have an automatic flash feature provided by a little electronic flash built into the front of the camera body. This guarantees that you'll get an image on film even in darkness. However, that's about all they guarantee. Camera-mounted flashes tend to do a poor job in most situations as they wash out and flatten detail.

(However, the same flash can be useful to even out the light in very contrasty situations, like on a very sunny day.) The flash units on point-and-shoot cameras also tend to be fairly limited in their range, resulting in underexposed images in dim lighting. Knowing the camera's range, and staying in it, is the best way to avoid this problem.

Red-eye reduction is a feature that minimizes the eerie effect that flash creates when people photographed in dim light or darkness look directly at the lens. This is another standard feature on most point-and-shoot cameras.

## Auto Wind and Auto Rewind

These two features are standard on almost all point-and-shoot cameras. As their names imply, they automatically load the film, advance it, and then rewind it when all frames are exposed. On some cameras, you may have to push a button to activate auto rewind. That same button will let you rewind film in the middle of a roll.

# Advanced Features of Point-and-Shoot Cameras

As point-and-shoot cameras move up in price, they offer both better technology and more features. Images taken with these cameras can, and do, rival those created with the best SLRs. For some users, the advanced features offered by top-of-the-line point-and-shoot cameras are well worth the four-digit price tags these cameras often come with. For occasional users, or those who want to buy a point-and-shoot as a backup for their SLR cameras, the additional bells and whistles on sophisticated point-and-shoots may not be worth the additional expense.

## Better Lenses

Instead of single-focal-length lenses, more advanced point-and-shoot cameras often have lenses that offer a choice of two focal lengths for more versatility. They might also have zoom lenses that offer even more opportunities to fill the frame with the subject.

Zoom lenses available on point-and-shoot cameras vary from doing a good job with portraits to being able to capture a crowd of people in a small space. Point-and-shoots with dual focal length or zoom lenses often have real image viewfinders, which move along with the lenses and provide a better idea of what the final image will look like.

**ALERT!**

The zoom lenses on point-and-shoots tend to be slower than those available for SLR cameras (meaning you won't be able to use a fast shutter speed to freeze an action shot), and they can produce soft pictures when taken at a distance.

## Flash Modes

More advanced point-and-shoot cameras often offer flash modes that provide more control over the camera's built-in flash. Flash-off mode lets you cancel the flash when you don't want it to automatically fire. It's handy for taking pictures at night or in places where flash isn't allowed. Fill flash fills in ugly shadows that shooting in daylight can cause, creating a more evenly lit image.

Nighttime-flash mode combines flash with a longer shutter speed. The flash lights up the objects close to the camera, and the longer shutter speed captures the ambient light in the scene.

## Shooting Modes

Many point-and-shoot cameras let you optimize their settings to match your general or specific shooting situations. These shooting modes are sometimes very specific. Single frame versus continuous shooting, for instance, lets you choose between a mode that fires the camera once each time the shutter button is pushed and one that fires the camera and advances the film as long as the shutter is held down.

Other shooting modes available on some point-and-shoot cameras include these:

- **Portrait mode:** Presets lens length and exposure for head-and-shoulder shots. It tells your camera that your subject is close to the

camera and that you want all the distant scenery to be out of focus. It does this by using a large aperture and focusing on the nearest subject.

- **Backlight mode:** Backlighting (in which the subject has a bright scene behind it) can fool an automatic camera into adjusting the exposure so that the background is correctly exposed but the foreground, where your main subject is, is too dark. This mode compensates for backlit scenes.
- **Panorama mode:** Sets the camera for wide-angle landscape shots or action photos.
- **Nighttime portrait:** Combines red-eye reduction with nighttime-flash mode.
- **Landscape mode:** Tells the autofocus camera to focus at infinity, no matter what. It won't try to focus on an unimportant object close to the camera. You would use this if people, foliage, or other nearby objects occupied a part of your frame that the camera would ordinarily focus on as the main subject.

An example of a situation that's perfect for nighttime-flash mode is an amusement park at night. Say you want your family, gathered 8 feet from the camera, to be lit by the flash, but you also want the scenery, the lights of the rides, to be bright and colorful. Nighttime-flash mode should accomplish this. Simply using flash mode, on the other hand, would give you a picture with a bright foreground and a dull or black background.

## More Options

Advanced point-and-shoot cameras may also feature these options:

- **Remote control:** Allows you to operate the camera from a distance. While a self-timer also works, a remote control lets the photographer choose the exact right moment to take a shot.
- **Auxiliary viewfinders:** Lets you focus, through a second viewfinder on the top of the camera, while you're aiming at subjects from waist

level. These can be great for capturing candid shots of your kids or at play, and, for that matter, for snapping candid shots of anyone at a lower level than you are.

- **Date imprint:** Prints the date the film was exposed on your negative, a feature offered by many point-and-shoot cameras. The date will also appear on your pictures. You can usually turn this feature off.

**FACT**

Viewfinders on the top of cameras are useful for photographers who prefer to "shoot from the hip." Shooting from the hip changes the perspective of the shot. This position also lets the photographer hold the camera more steadily and is more glasses friendly.

*Chapter 4*

# Buying Your Camera

Buying a camera means more than just walking into a store and snapping up the first one you like that fits your budget. With so many different types of cameras to choose from, figuring out what your needs are and finding a camera to fit them is definitely the better approach to take.

# Buying Basics

No single camera is the right choice for everyone, but if you know your tastes, can judge your aptitude for little dials and technical stuff, and have an idea of what you want to photograph, you can choose one that will give you many years of picture-taking pleasure.

The most important thing about the buying process is ending up with a camera that's right for you. Regardless of your individual needs, it should be a piece of equipment that does no more and no less than what you want it to do. Buying more camera than you need will not only break your bank, but also cost more money for features you may never use. Buying a camera that's less than what you need will frustrate you and put you in the market for a new one sooner than you should be.

**ALERT!**

Be aware that buying a camera almost always calls for some compromise. You may end up with one that exactly fits the bill but has a few more features on it than you need. If you can't afford one with all the bells and whistles you want, you may end up with a model that lacks a few of them but still meets your basic needs.

## Setting a Budget

One of the first things to think about is how much you want or have to spend. These days, it's possible to get a lot of camera for not a lot of money, but it's also possible to spend thousands on camera gear that sports the latest technology all the functions and features that go along with it. Having a general dollar amount in mind before you begin shopping in earnest will help you narrow your choices fairly quickly. It will also help you decide between buying new or used equipment, which you'll learn more about later in this chapter.

Whatever amount you decide on should cover the cost of a camera body and a lens (possibly two), along with some other necessary doodads such as a camera strap, lens hoods, a lens cleaning kit, batteries, and so on.

## Doing the Research

While it's possible to just ballpark a number that feels good when setting a camera budget, it's a far better idea to take the time and do some research to come up with a realistic figure rather than one you just plucked out of thin air. Photography magazines are a great place to start. Not only are they chock full of articles on camera equipment and how to use it, they also run lots of equipment ads placed by camera shops and mail-order houses. Most publishers of these magazines also compile buyer's guides, which are also excellent resources. There are several Internet sites worth checking out—check Appendix B for more information—that also provide this information.

**FACT**

Since there are so many lenses available, most SLRs are sold as a "body only," which means you'll have to choose a lens before you can start taking pictures. Moderate zoom lenses may be attractive, but a fast, fixed-focal length lens is sharper, lighter weight, and better in low-light situations. A 50mm *f*/1.8 lens, which gives you the same perspective as normal eyesight, is the best one to start with.

After you spend some time poking around these resources, you'll begin to get a general idea of the features and functions that are available within certain price ranges. Although it's impossible to list all the features available in each price range, here's a rough idea of what you can expect to find:

- **Under $100**—A basic point-and-shoot, most likely without zoom and possibly with a plastic lens instead of glass. Inexpensive construction.
- **$100 to $200**—Better point-and-shoots with autofocus zoom lens made of glass and more modes. Entry-level manual and autofocus SLRs. Durability can still be an issue.
- **$200 to $300**—Point-and-shoots with higher-quality lenses and more functions. Manual and autofocus SLRs with more features and more durable construction. Sometimes bundled with a consumer-quality standard lens or moderate zoom lens in the 28–80mm or 35–70mm range.

- **$300 to $400**—Point-and-shoots with even more features and better lenses. SLRs with more features, again possibly bundled with a moderate zoom lens. This is a good price range for most beginning photographers. It will usually cover a basic setup, with some room for expansion and upgrades over time.

Once you get above $400 or so, prices translate into both point-and-shoot and SLR cameras with more advanced features, such as titanium bodies. On point-and-shoots, lenses get significantly better as well.

## Determining How You'll Use Your Camera

Once you've set an estimated budget, it's time to hone the selection process further by thinking about how you're going to use your camera. This will give you a better idea of what features and functions you'd like your camera to have.

First, ask yourself what you want to take pictures of. Do you love capturing flowers kissed with dew at daybreak? Maybe you're a crafter, and you want to take good close-ups of your creations for promotional purposes. In both cases, you'd need an SLR equipped with a macro lens or a point-and-shoot with macro capabilities.

How much you're willing to learn about photography can have significant bearing on the type of camera you'll best match. If you'd rather that the camera did the work for you, the advantages of the point-and-shoot may seem ideal. However, if you're always trying to get a new gadget to do more than it was designed to, or you get frustrated if your tools are never quite flexible enough to match your vision, you'll probably prefer the flexibility and versatility of an SLR camera.

Maybe you're a fan of car racing, and you thrill to the sight of cars screaming around a track. You'll need a good long lens for this, one that can make it look like you're right next to the action. Once again, an SLR might be the best choice, but there are point-and-shoot models that can

capably capture such action as well. In either category, cameras with automatic functions will eliminate your having to set manual controls on the fly.

Want to be able to take casual snapshots of the kids as they're growing up? A point-and-shoot camera with its ease of use and automatic modes might be the perfect fit, but you might prefer the creative flexibility you'll get with an SLR camera.

## Point-and-Shoot Versus SLR

To get the best idea of the type of camera you want, you'll have to decide between point-and-shoot and SLR at some point. The following are situations in which a point-and-shoot makes good sense:

- High-theft areas.
- Travel requiring minimal weight and bulk.
- Well-lit scenes.
- Only enough time for two quick snapshots at a graduation ceremony.
- Unlikely to need print bigger than 5" x 7".
- Only moderate range flash needed, for example, 4 to 15 feet.
- Fear of gadgets.
- Photos needed only as a record of condition and appearance of subject.
- Toddlers likely to find and play with fancy photo equipment.

These situations make an adjustable single-lens reflex camera a necessity:

- Event photography for pay.
- Portraiture.
- Prints 8" x 10" and larger needed.
- Slides needed.
- Copy work.
- Close-up work.
- Precise composition and framing required.
- Extreme wide angle needed, such as in tight interiors.
- Extreme telephoto needed, such as wildlife or sports.

Aside from the quality advantages and adaptability of an SLR, a more complex camera may also meld more with your personality. Would you enjoy a camera that needs your attention and rewards your investment of time in making artistic decisions? Consider how you experience and relate to important moments in your life, the way you enjoy your quiet time, and how you participate in family life and parties. The adjustable SLR can require more time and thought than the point-and-shoot. Giving your camera that extra attention takes you out of the moment in some ways, but in another way it brings you more into the present. Operating your SLR camera can be an experience that seduces you, implores you to stop moving, and inspires you to pay attention to your surroundings, feelings, and perceptions.

For more shooting options without jumping to SLRs, consider buying two point-and-shoot cameras with different lenses. You might try one with a wide-angle option and the other with more of a telephoto option. Buy yet another, and you can be shooting both color and black-and-white! This combination gives flexibility without the cash outlay that a big 35mm system requires.

## Getting Specific

You've set a rough budget for your purchases, and you have a pretty good idea of your tolerance for technology and what you're going to use your equipment for. Now it's time to research specific camera manufacturers and models to determine which ones offer the features you want.

Be prepared for some sensory overload here. There are hundreds of cameras to choose from, and it's easy to get confused with so many choices.

## Comparison Shopping Function and Features

Once again, photography magazines and Web sites are great places to start. Check manufacturers' sites and independent sites that review equipment—you'll find several good ones in Appendix B, which lists resources. As you go through them, take notes on the different models.

You might find it easier to keep track of which camera has which features by charting the information on a simple table organized by the model and listing all the features and functions it has that you are interested in. Keeping notes on the prices and accessory options is another must.

| Sample Blank Camera Feature Chart | | | | | |
|---|---|---|---|---|---|
| Manufacturer | Model | Functions | Features | Price | Special Options |
| | | | | | |
| | | | | | |
| | | | | | |
| | | | | | |

Customize your table to reflect the features and functions you're most interested in, and leave enough room to write in all the information you find.

**FACT**

Cameras can vary significantly in their pricing, depending on who's selling them. While this isn't something to obsess over (for reasons explained later in this chapter), it's a good idea to get a general feel of the price range for the models you're considering.

## Understanding Gray-Market Merchandise

While you're doing your comparison shopping, you may see some camera equipment described as "gray market." This term refers to items that are sold overseas at low prices, then purchased and resold in other countries for a higher price, although still at a lower price than the going retail rate. This equipment often has no warranty coverage, or is covered by a foreign warranty, which means you'd have to send it back to the country of manufacture for any repair work covered by the warranty. Not only does sending equipment overseas for repair mean waiting months

for it to get back into your hands, there's no guarantee that you'll ever see it again. The shipping rates will also be higher, and many warranties require the consumer to foot at least half that bill.

The companies offering the lowest prices are often selling gray market goods. While there's nothing particularly wrong with this, there is a certain amount of risk involved in buying this equipment. Sticking to gear that's made for use in your home country is a far better way to go.

## Get a Camera in Your Hands

Now it's time to see what your dream camera looks and feels like. The absolutely best place to do this is in a good local camera store. Sales staff in the good stores go through not only hours of product training, they're also trained to help shoppers identify the right camera for their needs. If you're not quite sure what you're looking for, they know the questions to ask. Many are photographers themselves, and they are often more than willing to get you started out on the right foot and pass along advice based on their own experience. They are motivated to treat you well because they want your business, and they want to have satisfied customers who will continue to shop with them in the years ahead.

Try out every camera you're interested in. Let the salesperson show you how they work. Learn where the batteries go, how to open and close them, how to turn them on and off, and all the other basics. Even check to see how to change the date and time, if that feature is available. Spend some time just holding the ones you're considering. Cameras vary somewhat in weight and design; some will feel better to you than others. You want to find the body that feels best in your hands.

Don't immediately judge a salesperson by his or her age! The first thought that pops in your head when you see some sixteen-year-old behind the counter might be that it's just some kid who took the first retail job they were offered. This is not true in many, if not most, cases. Many people get into photography at a very young age, and once the passion strikes, it doesn't take long to collect an impressive quantity of information on the subject.

# Making Your Purchase

The time has finally come. You've done the research. You've price and comparison shopped, and you're ready to buy the camera of your dreams.

## Where to Buy

If this is your first camera purchase, think seriously about buying from the camera store with the friendly sales staff that gave you so much assistance when you were merely looking. You'll most likely pay more than you would through other sources, but the level of assistance and attention you'll get will be worth it. They'll also be a good source to tap for more information in the future about how to use your camera, what accessories are essential, and what can wait.

If there isn't a good camera store where you live, you'll be better off doing some comparison shopping online or through mail-order houses and getting the best buy on your equipment.

If you have to choose between putting money into a good lens or a good camera body, choose the lens. When you can afford it, move up to a better camera body, and keep the old 35mm body as a backup.

## Buying Through Online and Mail-Order Sellers

These sources are grouped together as there's not much difference between them any more. Almost every mail-order house has a Web site. You can call them on the phone or place your order through the site. Online sellers may or may not have an actual store, but you can (and most likely will) deal with them on the phone as well.

Both sources often offer better prices than brick-and-mortar camera shops, but they can be frustrating to deal with. Online sites sometimes don't work very well, which usually means you'll have to pick up the phone and call them anyway. When you do, you may sit on the phone forever waiting for an available order taker. That person may be pretty

knowledgeable about cameras or may be a complete dunce about them. Either way, be prepared for a hard sell. Some companies, and some sales staff, have honed this particular sales technique into a fine art, resulting in customers ending up with equipment they really didn't want but got talked into buying.

Here are some of the other problems with buying online:

- **Bait-and-switch:** They're out of the equipment you want but are more than willing to sell you something comparable—usually at a higher price.
- **Restocking fees:** If you don't like the equipment, you can send it back, but they'll charge you for putting it back into their inventory systems.
- **Differences in prices quoted live and on the Web site:** What you see on the site and what you're told on the phone should match unless there's a special promotion going on that hasn't been added to the site. Shipping costs quoted online and by sales staff should match as well.

If you're going to buy online, it's strongly recommended that you stick with one of the well-known camera retailers as opposed to some fly-by-night group. If you recognize the seller's name from an ad you've seen, you know you're in the right place. Another strong recommendation: go to one of the business rating sites on the Web and check their customer satisfaction rating.

## Buying New Versus Used

While it can be a real thrill to unwrap pristine new camera equipment, buying new isn't the only way to go. Used equipment can represent significant savings over new; choosing used over new also lets you buy more camera than what you might otherwise be able to afford.

Photographers often trade in their used equipment when they're upgrading or when they no longer need it for some reason. Whether it's worth buying has a great deal to do with exactly how much cheaper it is

and the condition it's in. Researching new equipment costs will help determine the current value for used equipment.

If you're buying really old equipment, say fifteen years or older, chances are very good that you won't be able to compare the selling price to what new equipment costs as it's probably not being made any more. If this is the case, try looking through old photography magazines to see if you can find an ad for the camera that lists its retail price. Or try contacting the manufacturer. In either case, the asking price should be significantly less than the original cost unless you're buying a rare camera.

Being assured that the equipment is in good condition can be a bit more problematic, but you can largely put your worries to rest if you buy from a local shop where you can see and test the equipment.

## Putting Used to the Test

Always examine used equipment thoroughly before buying. Check both condition and function. Don't expect perfection—after all, it's used—but don't buy anything that's excessively worn, either. Acceptable condition changes for used equipment include the following:

- **Edge wear on the camera body:** This occurs naturally when the camera is used on a regular basis.
- **Very small dents on edges of body or lens edge:** Again, these can occur naturally when the camera is used on a regular basis.

Here are a few unacceptable condition changes:

- **Large dents anywhere:** This indicates treatment more traumatic than just getting banged into a table or the edge of a desk.
- **Camera back doesn't fit exactly right when closed:** Again, an indication of a prior trauma. Plus an opportunity for light to enter the body.
- **Deep scratches on a lens or on the imaging mechanisms inside the camera:** Slight scratches on a lens usually won't significantly affect performance. Some parts of a camera's imaging mechanism can be replaced, but the repair can cost as much as the camera did.

- **Fogging on a lens:** This is an indication of a lens that has been improperly stored or that has experienced significant temperature variations. It may or may not clear up.
- **An autofocus lens that doesn't adjust smoothly:** This could indicate improper storage or trauma.
- **Other technical defects:** Look for things like zoom lenses that are too loose or too tight in their movement or focusing that doesn't feel right.

## Finding Used Equipment

There are many sources for used cameras and equipment. Many major camera stores sell consignment or rental equipment, and some mail-order houses specialize in used gear. Since they have their reputations at stake, they're usually the best choices for buying used equipment, but you may find that the amount you save doesn't justify buying used. Online auction houses, like eBay, are other popular sources. If you decide to go this route, make sure the seller offers a money-back guarantee. You may have to pay shipping and restocking fees, but it's better than being stuck with an inferior piece of equipment.

Even when buying used, keep a written record of purchase price and date. If there are any warranties associated with your used camera, or if there's a limited time for returning defective merchandise, mark those dates in your datebook.

**ALERT!**

Thinking about buying a used flash at a bargain price? You might want to think twice. Flash components, such as the flash tube and capacitors, do not age well. Capacitors weaken when not used for long stretches of time, so a mint condition four-year-old flash is still a liability.

Make a list of serial numbers of bodies, lenses, and flashes that you purchase, as well as the purchase date and price. If you ever go pro, this information will be useful on your tax forms.

## Buying Used Manual SLRs

If you want to learn all the ins and outs of photography through using a manual SLR, your chances of finding one will be greatly improved if you're willing to buy used. Most manufacturers no longer make manually operated SLRs, although there are some models that have manual override controls. Start shopping for used equipment, and you'll find perfectly serviceable manual cameras that will have some age on them but that will definitely put you through your paces.

# Your New Camera At Home

First things first: unpack your equipment! Check the camera inside and out to make sure you've removed everything that was used to pack it. If you bought new equipment, save all receipts and warranty cards. If you need to return the camera shortly after purchase, stores like to get the warranty paperwork blank, just the way they sold it to you. You're protected by the warranties whether or not you send in the cards.

Never touch any glass surface, the mirror, or the shutter curtain with your bare skin. The tiny bit of oil and moisture your touch leaves behind is damaging to fragile components.

Spend some time simply handling your equipment. Turn it around in your hands. Check out the various dials and buttons. Start reading your instruction manual—it's the best way to learn about everything your camera can do. Put the batteries in, load some film, and start shooting!

Chapter 5

# Getting to Know Your Camera

Whether your camera is brand new or just new to you, you'll need to get to know it. This entails learning about how cameras take pictures, how to use and manipulate the camera's controls, and the role you play in the equation. It also involves learning how to handle your camera correctly and how to take care of it to ensure years of picture-taking pleasure.

## Holding the Camera

There's no great secret to holding a camera, but it does take a little bit of practice to learn how to hold one for the best results. And it's a good idea to practice it, as silly as this may seem. If you're comfortable holding your camera you'll also be comfortable operating it. You'll be a far better photographer this way than you would if you feel like you're holding a foreign object in your hands every time you take your camera out of its bag or case. Fumbling with a camera you're not familiar with may mean missing the shot of your life. So spend some time on this simple step. Do it in the privacy of your own home. Pick a time when no one's watching. Watch yourself in a mirror—preferably full-length—so you can check your stance, how you use your arms, and how your hands cup the camera.

**FACT**

Cameras are designed for right-handed and right-eyed users, which is definitely an advantage if you're one of them. If you're not, you might find the layout awkward at first but you'll soon get used to it.

Here are the basics of camera holding:

1. Put both hands around your camera. Do it in a way that feels natural to you. Watch for fingers finding their way in front of the flash or the lens on tiny cameras. Check yourself in the mirror to see where your fingers naturally fall to see if they are getting in the way.
2. Press the camera to your face. Tight is good, but don't push it in so close that it's uncomfortable.
3. Drop your elbows down so they're against your body. This will help you steady the camera.
4. Plant your feet firmly on the ground, about shoulder width apart or slightly less. You can shoot from other positions, but this one is the most solid.
5. When shooting, take a breath, exhale fully, hold it, and then squeeze the shutter release button smoothly.

When you're using a long zoom or telephoto lens, use your left hand to support the lens by cupping it around the lens close to the camera body. Hold the camera in your right hand so you can activate the shutter.

## Steadying Your Camera

Small cameras are harder to hold than big cameras, and, without the inertia caused by the weight of larger cameras, they're more likely to move when you press the shutter. This can result in blurry pictures as the film captures both camera movement and the movement of your hands. The suggestions above will go a long way toward helping you keep your camera steady as you're shooting. For slower shutter speeds, or when you're not using flash, make sure you brace your elbows against your body. You can also lean on a steady support to minimize movement.

Here's another camera-steadying technique that sounds odd but works: Lean the side of your head against a wall while you press the camera up to your face. It's easier than it sounds.

Pictures are taken horizontally and vertically, so practice holding your camera in both positions as well. If you plan on shooting a lot of vertical pictures, see if there's an accessory grip available for your camera to make this position easier.

If you need to move closer or farther from a subject, take the camera away from your eye before you start to move. When you reach your new position, check to make sure it doesn't ruin the composition, then look through the viewfinder again. People walk with their cameras to their eyes all the time, but it's really not a good idea as it makes you a good candidate for tripping over something in your path. Only back up blindly if you are absolutely certain that there is nothing behind you.

## Adjusting Your Camera

Spend some time working with the various dials and buttons on your camera so you know how to operate them. Never force anything into position—this includes the camera back as well. Doing so may damage

your camera or your film. Camera controls should work smoothly, but if for any reason yours don't, take your camera into a good shop and have it looked at.

## Leaving the Automatic Zone

If you've bought an automatic SLR, you may be tempted to just leave the camera in fully automatic mode and snap away. This mode relies on the camera's light meter to adjust shutter speed and aperture, and it will automatically set the focus for you if you want it to. Most of the time, auto mode will deliver acceptable or better results. Objects will be in focus and properly exposed.

All of this is fine, and it's certainly easy, but it's not going to give you the best pictures possible every time. Sooner or later you might hear a pesky little voice in your head asking, "What would happen if?" Would the picture of the flowers in your garden be better if your camera hadn't focused on the wall behind them as well? Would the shot of your kids playing at the lake be better if you could see more details related to them and less of the lake's ripples and glints? Would the portrait you took of your sister look better if the flowers behind her weren't quite as distracting? Would the shot you took of your dog playing be better if he wasn't just one big blur surrounded by perfectly detailed grass?

The answer to all of these questions is, of course, yes. And that's why it pays to know how to take your camera off of auto mode and control such things as shutter speed and aperture by yourself. It also pays to know how such factors affect each other and how to select the best settings to render the images you want.

Be prepared. This discussion can get a little technical. If you're not particularly technically oriented, your head might spin. So take things slowly. Study each aspect thoroughly. Have your camera at your side so you can see what the various settings look like.

Also keep in mind that much of the information that follows is more suited to SLR users who have either automatic cameras that allow manual settings or fully manual cameras. If you have a point-and-shoot that allows some manual overrides, you'll find plenty in this chapter of interest as well.

Finally, this is all meant as an overview. The best way to learn more about the mechanics of picture taking is to take pictures. Lots of them. Use the information that follows to guide your explorations along the non-auto road. For specific help on leaving the mode for your own camera, read the instruction manual that came with your camera or a guide written specifically for it.

# Let There Be Light

Taking a picture in its simplest form means exposing the film to light. Two different devices—the shutter and the aperture—work together to determine how much light enters the camera and hits the film. When shooting in manual mode, they're the two things you adjust to get proper exposures.

**FIGURE 5-1**

*Photograph courtesy of Tom Minczeski*

▲ Controls on a manual camera. On the camera's right is a shutter-speed control dial. Other manual controls include (from left) film advance lever, exposure counter, shutter release button, aperture settings (first row of numbers on lens), exposure compensation settings (first group of numbers on right dial), and film speed settings (second group of numbers).

## Open and Shut Cases

The shutter controls the length of time that light is allowed to expose the film. On modern SLR cameras, shutter speeds are usually indicated on a display panel or a shutter-speed control dial. Some older SLRs have a shutter speed control ring on their lenses, which you turn to select the speed.

Shutter speeds are measured in fractions of a second. A shutter speed of 125 means 1/125th of a second; 500 is 1/500th of a second, and so on. Typical shutter speeds range from 1 second to 1/1000th of a second. The higher the number, the faster the shutter opens and closes.

Shutter speeds also allow for precise control over how long light enters the camera. A speed of 1/125 will let light in for 1/125th of a second. The next speed up, 1/250, lets half as much light in. Go down to a shutter speed of 1/60, and you'll be letting in twice as much light as you would at 1/125 and four times as much as at 1/250.

When working with shutter speeds, keep in mind that slow speeds—those of 1/30th of a second and longer—will require you to use a tripod or another very sturdy support. Slower speeds will capture every tiny movement the camera makes, so the camera must be held as still as possible. Some people with very steady hands might be able to take handheld pictures at 1/15th of a second, especially when shooting with a normal or wide-angle lens. Getting a steady shot with a zoom or telephoto at this shutter speed, however, would be close to impossible.

### Shutter Speed to Situation Table

| Shutter Speed | Useful For: |
| --- | --- |
| B (Bulb) | Taking pictures at night when you need lo-o-ong exposures, as this setting keeps the shutter open for as long as the shutter release button is held down. Must use a tripod or other sturdy support. |
| 1 second, 1/2 second | Shooting at night and some dim lighting situations using with narrow aperture settings. Good for photographing objects. Must use a tripod or other sturdy support. |

| **Shutter Speed to Situation Table (continued)** | |
| --- | --- |
| 1/8th second | Good at letting in enough light when needed for small apertures in dim light situations. Must use a tripod or other sturdy support. |
| 1/15th second | Taking pictures in existing light when using small apertures. While it's possible for some people to take handheld pictures at this speed, most still need a tripod or other camera support to avoid camera shake. |
| 1/30th second | Another good shutter speed for existing-light pictures. This is the slowest shutter speed recommended for handheld photography. |
| 1/60th second | Outdoor photography in overcast conditions and on brighter days when using a narrow aperture. Better than 1/30 for eliminating camera motion. |
| 1/125th second | Outdoor photography under bright light with wider apertures. Good for capturing moderate action. Also a good speed for using short telephoto or moderate zoom lenses. |
| 1/250th second | Outdoor photography with good light and wider apertures. Lets you capture faster action. Slowest shutter speed for hand-held telephoto sports shots. |
| 1/500th second | Even faster action shots. Needs good light and wide apertures. Good shutter speed for fast-action photography with a long lens. |

Once you get above 1/500th of a second, you'll be able to shoot even faster action. However, these shutter speeds require a lot of light or very wide apertures, which result in very shallow depth of focus.

## All about the Aperture

The aperture is the opening in the lens that changes in size to let in more or less light. Numbers called f-stops indicate how large or small the opening is. When dealing with f-stops, keep in mind that smaller numbers relate to larger lens openings. Larger numbers refer to smaller openings.

**F A C T**

Aperture numbers represent the ratio of the focal length of the lens divided by the diameter of the aperture. If a 200mm lens has a 50mm opening, you have a ratio of 200/50, and an aperture of *f*/4.

As you move up the f-stop ladder, each number lets in half as much light as the previous one. For example, *f*/8 lets in half as much light as *f*/5.6; *f*/11 will let in only half as much as *f*/8, and so on.

**FIGURE 5-2**

*Photograph courtesy of Eliot Khuner*

▲ This This is what the aperture openings look like on a 50mm lens. On the top row (left to right) are *f*/1.4, *f*/2, *f*/2.8, and *f*/4. On the bottom row (left to right) are *f*/5.6, *f*/8, *f*/11, and *f*/16.

All SLRs have identical f-stop numbers, but the settings you'll actually be able to use will vary depending on the aperture range of the lens

you're using. For example, the dial on your camera body may go down to $f/2$, but you might be using a lens that only opens down to $f/3.5$. In this case, although your camera can handle a wider aperture, your lens can't, and you'll be limited to what the lens can do. Many zooms change f-stop as you zoom, e.g., $f/2.8$ when at wide angle, but $f/3.5$ when zoomed to telephoto. There are also zooms that have a constant aperture at any zoom.

F-stops can be confusing. For example, it may seem that an f-stop of 4 ($f/4$) would be double the light of $f/8$. There's a long mathematical explanation for why it's not, and for why it's $f/5.6$ that's half of $f/8$, but it's perfectly acceptable—and easier—not to go into it. Just accept the settings for what they are, and understand how they relate to each other.

**What does it mean when photographers talk about opening up a lens?**

Opening up a lens refers to using a smaller f-stop number, which creates a wider, or larger, lens opening. The opposite is stopping down a lens, or choosing a larger f-stop number and a smaller opening.

**QUESTION?**

# Controlling Exposures with Apertures and Shutter Speeds

Aperture and shutter speed settings work together. Each approximately halves or doubles the light reaching the film. Because they work together, it's possible to get the same exposure with a number of different settings, like the combinations here:

| Aperture | $f/5.6$ | $f/8$ | $f/11$ | $f/16$ | $f/22$ |
|----------|---------|-------|--------|--------|--------|
| Shutter | 1/500 | 1/250 | 1/125 | 1/60 | 1/30 |

Each of these settings will deliver roughly the same exposure.

If your camera has automatic overrides for shutter speed and aperture control, you'll probably be able to see how these factors work together.

Set your camera for either aperture priority or shutter priority mode. Then manually adjust one or the other, depending on the mode you chose. That is, if your camera is in aperture priority, adjust the aperture (f-stop); if it's in shutter priority, adjust the shutter. As you move through the settings for the priority mode you've chosen, you'll see the factors for the other change as well in your indicator window. More open aperture settings (such as $f/2.0$) will show higher shutter settings, and vice versa.

## Why Exposure Settings Are Important

Choosing the appropriate pair of exposure settings not only gives you the proper exposure, it also helps determine how much of your picture is in focus (the depth of field) and whether moving objects are crisply rendered or blurred. A combination of $f/22$ for the aperture opening and 1/30 for shutter speed will give you greater depth of field and focus on more objects in the scene, but they'd better be perfectly still or you'll end up with substantial motion blur on the picture. On the other hand, an aperture of $f/4$ with a shutter speed of 1/500 will limit depth of field, but it will also freeze movement better.

Which setting takes priority depends a lot on what you're shooting. If the scene involves action, you'll definitely want as fast a shutter speed as you can use to capture all of it, so the shutter speed will be your first determination. To avoid underexposing the film, you'll also need to set a wider aperture to let more light in, or, if you need to shoot with a smaller aperture, you'll need extremely good light.

**FACT**

The film you use will also govern your choice of shutter speed and apertures. Slow film calls for slow shutter speeds and wide apertures. Faster film allows for faster shutter speeds and smaller apertures. More information on film speed can be found in Chapter 7.

If you're taking a long shot of a mountain scene, you'll care less about the shutter speed and more about the aperture, especially if you want to

make sure that as much of the scenery as possible is in focus. In this situation, you can use a smaller aperture and a slower shutter speed.

Another factor determining setting priorities is how the f-stop affects image quality. The largest f-stop for a lens will let in the greatest amount of light, but it will yield the minimum depth of field and the poorest image quality for the lens. Move up a stop, and image quality gets better. Go up even farther, to the middle of the f-stops possible on any particular lens, and you'll get the best image quality the lens can deliver. As you continue going up the f-stop scale to the smallest possible aperture for the lens, image quality will deteriorate again, primarily when it comes to sharpness, but not as much as on the other end of the scale. This is less of a factor in higher quality lenses and cameras.

# The Basics of Depth of Field

Depth of field is a term for describing how much of a picture is in focus. For general photographs, you want the subject in focus. "Depth of field" refers to how much of the scene in front of and behind your subject can also be seen clearly. Objects closest to the point of focus will look very sharp. Those farther away will be less sharp, but will still be acceptable as long as they're in the depth-of-field zone. The depth of field is shallower in front of a subject (in between the subject and the camera) than behind it.

Three factors determine depth of field:

- The lens's aperture.
- The lens's focal length.
- The distance from the camera to the subject.

## Aperture and Depth of Field

Wide aperture settings result in shallow depth of field. Pictures taken this way will have the subject in focus and the foreground and/or background out of focus. As apertures narrow, depth of field lengthens, resulting in more of the picture being in focus.

## Focal Length and Depth of Field

The depth of field rendered by each lens differs depending on its focal length, which will be discussed in greater detail in Chapter 8. For now, just remember that depth of field is inversely proportional to the focal length of the lens. In other words, shorter lenses have greater depth of field; longer lenses have a shallower depth of field A 50mm lens will capture more of the picture in sharp focus than a 100mm lens will with the same aperture setting.

Lenses are usually marked with scales that indicate their depth of field. (If your camera or lens doesn't have depth-of-field markings, see if there's a depth-of-field scale in your camera or lens instruction manual.) In manual mode, you can use these scales to determine how much of a picture will be in sharp focus from foreground to background.

**FIGURE 5-3**

◀ This image was shot with a 200mm lens, which resulted in a shallow depth of field and with a dark background that helps the subject stand out.

*Photograph courtesy of Eliot Khuner*

**FIGURE 5-4**

*Photograph courtesy of Eliot Khuner*

◀ A 105mm lens was used on this image, with the result that the background is more in focus.

**FIGURE 5-5**

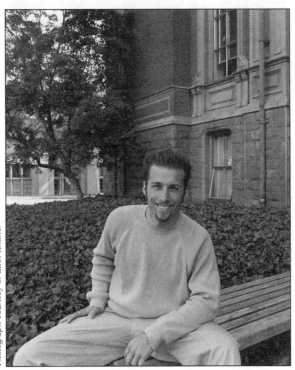

*Photograph courtesy of Eliot Khuner*

◀ This image was shot with a 24mm lens. Note how the greater depth of field brought all of the background detail into focus. It also created more visual interest by making the parallel lines of the bench into leading lines.

**FIGURE 5-6**

*Photograph courtesy of Eliot Khuner*

▲ Depth-of-field indicators on a manual-focus lens. As indicated by the arrow, this lens is focused at an object approximately 16 feet away and at a small aperture of f/16. The lines on either side of the arrow indicate that everything from about 8 feet to infinity will be in focus.

## Distance and Depth of Field

Depth of field is also directly proportional to distance. In other words, a subject that's farther away from your camera will have greater depth of field than one that is closer. Changing the aperture setting won't have a huge effect on the depth of field for a distant subject or if you're using a lens with a short focal length. However, it can make a big difference in close-up work, where you're dealing with a shallower depth of field, or when you're using lenses with longer focal lengths, which again have shallower depths of field.

# Focusing—Automatic and Manual

Autofocus is a common feature on most 35mm SLRs and on point-and-shoot cameras as well. There's really not much to using this feature, as the camera does the work for you. All you have to do is look through the viewfinder to check whether the camera has focused correctly on what you want in the picture.

Autofocus can be a wonderful tool, especially for photographers with less-than-perfect eyesight. But there are times when autofocus can be a drawback, especially when using long zoom lenses. A zoom lens's focusing mechanism can chatter back and forth rather loudly while it's determining its sharpest setting. When you're in situations where these adjustments may be distracting, such as taking pictures of wildlife or in other quiet settings, you'll want to focus manually.

There is really no great trick to this other than being able to see well enough to focus things yourself. Just adjust your lens from automatic focus to manual, and turn the focusing ring. The viewfinder will tell you when the image you're focusing on is clear.

**FACT**

If you don't want enlargements, you don't need to be as concerned with pinpoint, accurate focus. Many images that are blurry or out-of-focus are acceptably sharp when printed small. But if you like seeing detail, want to crop, or plan for 8" x 10" or larger, make sure your focusing is up to par.

Most autofocus cameras have a nifty function called focus lock that lets you try various ways of composing a scene without having to refocus all the time. To use it, get your subject in the center of your viewfinder, where the autofocus is located. When you have the focus set, push the shutter or focus lock button (depending on your camera's setup) to lock it into place. Then recompose the scene. Keep in mind, however, that your distance from the object needs to stay the same. If you move forward or back, you'll need to refocus.

# Camera Care and Feeding

Cameras are meant to stand up to some fairly rigorous use, but like all fine instruments they will perform much better if they're well cared for. Heat, moisture, dust, oil, and shock are your camera's biggest enemies. Keep it safe from them all, and it will deliver years of satisfactory performance.

## Cleaning

Cameras are pretty easy to keep clean, but they benefit from a periodic wiping down with a soft cloth to remove any oils, grime, or grit they may have picked up when being used. Some photographers polish up their cameras each time they finish using them. It's not a bad habit to get into, but less frequent cleaning won't hurt things either.

If your camera has been stored for awhile, it will probably get dusty. You can remove dust from the body by wiping it with a soft cloth. Be careful when wiping any sensors, the LCD screen, or the viewfinder.

If the inner mechanisms need to be dusted or cleaned, use a blower brush. These are usually available in camera-cleaning kits. If it doesn't do the job, take your camera in for servicing. Aerosol spray dust removers might pack too much of a punch for cleaning delicate mechanisms; check your instruction manual to see what your camera's manufacturer recommends.

For information on lens cleaning, turn to Chapter 8.

If you have to store your camera in the trunk of your car, get a cheap Styrofoam ice chest. Don't fill it with ice—just put your camera in it and close it up. Put your film in there too. If you can't find a Styrofoam chest, any type of insulated cooler works as well.

## Keeping Cool

Heat not only thins out the oils that lubricate a camera's moving parts, it also damages film, causing color film to shift in color and black-and-white film to fog. Film and camera manufacturers know that their

products will get hot, so don't worry if your camera occasionally gets toasty, but do try to avoid it. Protect your camera by keeping it out of the sun as much as possible.

Never store your camera in a hot car. It's just as bad as subjecting it to direct sun.

## Keeping Dry

Cameras aren't fond of moisture of any type, which is why you'll find little desiccant packs tucked into the box when you buy new equipment. Your camera store might even give you a couple when you buy your camera. These packs contain pellets of silica gel that soak up moisture from the air, which can get inside your camera's mechanisms.

Moisture isn't much of a concern if you live in a dry climate, but it definitely is in more humid spots, or when going from air-conditioned rooms into the heat in humid climates. In really humid conditions, moisture can even cause fungus and mold to grow on your camera lens, which can etch the surface of the lens and cause permanent damage.

Keep a couple of desiccant packs in your camera bag at all times. If you store your equipment somewhere else, throw a few in there too. If you're in humid conditions most of the time, it's a good idea to dry the packs out by sticking them in a low oven for a few minutes.

You can make your own desiccant packs with silica gel bought from a craft store (it's the same thing that's used to dry flowers), a garden store, or from the Web, for that matter. The best stuff has a pink/blue color indicator system that shows how much moisture is being absorbed. Put it in a small plastic bag that you've poked a couple of holes into. When the color changes from blue to pink, it's time to dry out the gel. It can be reused over and over again.

## Protection from the Elements

Although a little water won't hurt your camera, especially if you wipe it off right away, it's better to keep your equipment dry. Stick a few plastic bags in your camera bag for wrapping around your camera for the times when you're shooting in inclement conditions. A lens hood or UV filter

on your lens will help keep it safe as well.

Ocean beaches are not your camera's favorite vacation spot. Surf spray, even at 20 feet from the water, will coat your lens. The salt corrodes gears over the years, and the sand gets inside the mechanisms, jamming them and wearing them out prematurely. Sand can even get caught in the film path and cause scratches.

Wipe off any sea spray immediately with a clean cloth dampened with fresh water. Or, better yet, bring a disposable camera to the beach. If you do use your SLR, cover it with a plastic bag when not using it. You can even shoot through the bag if you cut a hole for the lens.

**ALERT!**

A short neck strap will keep your camera more secure and stop it from banging into tables and other things. If you lay your camera down, wrap the strap around the camera so that it doesn't get pulled onto the floor. Vibration caused by plane travel or bumpy car trips can loosen the screws on your camera equipment. Protect it in a padded camera bag.

## Batteries

Most cameras need batteries to operate. Some fully manual SLRs without light meters are fully mechanical, and require no power to operate. However, the vast majority of options out there, especially the ones you'll be looking at, require a power source. Your instruction manual will tell you which one your camera uses. Lithium batteries will last the longest, especially with power-hungry automatic cameras. Always keep a spare or two around as weak batteries will affect camera performance.

Keep your fingers away from the contacts when installing batteries. The oil from your skin may cause electrical or battery problems. ⓔ

**Chapter 6**

# Accessorizing Your Camera

Photography is definitely a delight if you're a gadget lover. There's a seemingly endless array of products and devices to choose from, all just begging to be bought. Some are essential. Others you can probably live without, but they might make your picture taking even more fun and enjoyable.

# Bagging It

Something for storing and carrying your equipment is at the top of the essential accessories list. You could use just about anything for this—a backpack, messenger bag, briefcase, tote, even a purse. But it's a better idea to invest in a good camera bag that's specifically designed for this purpose. It will do a better job of protecting your camera and other equipment.

Soft-sided camera bags are far and away the most popular ones out there. They come in lots of different shapes and sizes and are available in all price ranges.

Hard-shell camera cases offer the most protection for your gear, but they are heavy and often very expensive. They're also favorite targets for thieves. Unless you plan to travel a great deal with your equipment, there's little reason to invest in one.

## Bag Construction

Soft-sided camera bags are made out of several different materials. Heavyweight waterproof ballistic nylon is one of the most durable. A good choice is waterproof Cordura nylon.

All but the most basic camera bags have individual compartments or dividers to help keep your camera and lenses from rubbing together and banging into each other when you carry them. Higher-end bags often have adjustable dividers to allow for different camera bodies and lens sizes. Most bags also have at least one outside pocket for storing such items as lens covers, filters, instruction booklets, cleaning equipment, and so on.

## Bag Styles

Camera bags also come in a variety of styles. The most popular, and the one favored by most professional photographers, are shoulder bags. These bags feature zip-around tops that flip open to reveal the equipment nestled in the bottom of the bag. They can be easily accessed while still on your shoulder, and they are great for taking pictures on the fly, as you

can reach in and assemble your equipment while you're walking (or running).

Another popular choice, especially for hikers and other people who like to shoot in the field, are photo backpacks. They're similar to regular backpacks, but with more padding to protect your equipment. They also have compartments like shoulder bags do. Waist packs or hip bags are options for people who don't want to the weight of their equipment on their shoulders or backs.

## Choosing Your Bag

Just like there's no one camera that's right for everyone, no one camera bag will fit the bill for all. Go to a good camera store and test drive the ones that appeal to you. Look for bags with good, solid construction and tight, even stitching. Check out the divider system—it should offer enough compartments for your camera and the lenses you plan to carry most often. More expensive bags will have adjustable dividers so you can custom-fit the compartments to your equipment.

If you plan to keep your camera in a bag, you probably don't need a camera case. Some people like to use them to protect the camera from dings and scrapes. But they're a nuisance when you're in a rush to change film or mount your camera on a tripod as you have to remove the camera from its case first. If your camera comes with one, fine. If not, don't bother buying one.

Two-way zippers that let you access the bag from both sides are a good feature to look for. Here are some others to consider:

• **Waterproof material:** Unless they're designed for underwater use, cameras and water don't mix. If you're considering a bag made of waterproof Cordura nylon, which is notoriously tough on clothing, it should have a material protector on the back. Another good water protection feature is a rain flap over the zipper track. It'll help keep dust out, too.

- **Handle and strap:** Having both adds versatility to your bag. In a pinch, the strap on some bags can be used as camera straps.
- **Detachable film pocket:** Allows you to remove the film when your equipment goes through airport scanners. They're also handy for long-term film storage. Just fill it up and stick it in your fridge.
- **Exterior pocket:** Makes it easy to get at filters, manuals, cleaning supplies, and so on.
- **Tie-straps and d-rings:** Useful for carrying tripods and for attaching accessories like waist belts or backpack harnesses.
- **Reinforced sides and bottom:** Essential with larger bags.

Finally, pick a bag that will comfortably handle the equipment you plan to use regularly. It's always easier to pack a small bag with the equipment you want to carry and leave the other stuff at home instead of carrying a large bag that holds everything you own. Plus, if you should lose your bag or have it stolen, you won't lose all your equipment. If you can afford to buy two bags, get one with more capacity for storing all your equipment at home or to use when you need to carry more gear than your smaller bag can handle.

## Strapping It On

Most cameras come equipped with a camera strap. While this particular accessory can seem rather dorky at first, you'll soon find that its functionality far outweighs the "tourist with camera around neck" image. All it takes is one "Oops!" moment, like dropping your camera into a pool, to convert the strapless faction into the camp of the always strapped. Whether you use it to carry your camera around your neck, over your shoulder, or to secure it in your hand while walking or shooting, you'll soon find that a camera strap is an essential piece of camera gear.

If your camera came with a thin strap, say less than an inch wide, think about replacing it with a sturdier model that will do a better job of distributing the camera's weight on your neck or shoulder. One with rubber backing along the middle or with a rubber-backed shoulder pad

will lessen the chances of the camera slipping off your shoulder and banging into something.

If you plan on using heavy telephoto lenses on a regular basis, you may want to invest in a strap that's specially designed to make it easier to carry this equipment.

Regardless of the type of strap you use, make sure it's securely fastened to your camera. (The user's manual should have detailed instructions on how to do this.) If you're not absolutely sure how to do it, have a clerk at a camera store attach the strap for you.

# Keeping Things Steady—Tripods and Other Steadying Devices

When exposures require slow shutter speeds, or when you're using long telephoto lenses that greatly magnify images, it's almost impossible for even the steadiest hands to hold a camera still enough to avoid camera shake. You have three choices for eliminating the shakes: avoiding situations in which they can occur, using flash to freeze motion, or buying something to support your camera.

## Tripods

Tripods are far and away the most popular and most widely used camera support. They're made of various materials, ranging from wood to high-impact plastic to metals like aluminum or titanium. Depending on their construction, they can be light and portable or heavy and sturdy.

Keeping the camera steady is job number one for a tripod, which means choosing one that's rock solid regardless of what it's made out of. There are other considerations when it comes to choosing a tripod:

- **Weight:** Heavier tripods are definitely more stable, but they're also difficult to carry and set up.
- **Height:** You'll want a tripod that extends to your eye level and remains stable there.

- **Head style:** Both pan-and-tilt or ball-and-socket heads allow cameras to be adjusted in just about any direction. Some tripod heads have quick-release platforms with plates that can be screwed to the camera bottom.
- **Size:** Choose a tripod that folds down small enough for easy carrying.
- **Center post length:** The center post, which also raises and lowers camera height, is not as steady as the rest of the tripod. The shorter the extension, the steadier the camera. Use the legs of the tripod to get the camera at approximately the height you want, and use the center post only for precision or quick adjustments.
- **Leveling bubble:** Useful for keeping the center post vertical and avoiding tilt when you pan the camera.

**FIGURE 6-1**

*Photograph courtesy of Tom Minczeski*

◀ This tripod has a ball-head mount that allows the camera to be moved into virtually any position. The light-colored piece below the camera controls camera movement, which locks when the piece is released.

Avoid tripods that only allow you to aim the camera in one direction. They're often cheaper than tripods that allow greater adjustment, but their lack of versatility limits their usefulness.

Test drive any tripod you're thinking about buying by fully extending its legs and pushing down on its head with your hands. If you can move it easily, it won't be stable enough to support your camera. You can also test stability by sticking the heaviest lens you own on your camera, and mounting it to the tripod. Again, it shouldn't move or buckle under this weight.

Operate the locking action on the tripod head, legs and center column. All should firmly lock when you turn them finger tight. If you have to struggle to lock or unlock a feature, the tripod will become an unwelcome addition to your gear, and it won't get the use it should.

It's a good idea to get a tripod with a quick release camera mount (shown in **FIGURE 6-2**). As the name suggests, it lets you move your camera on and off your tripod pretty quickly—all you have to do is flip a lever and the camera pops out. If you have more than one camera body, get a tripod plate for each body.

**FIGURE 6-2**

*Photograph courtesy of Tom Minczeski*

▲ A camera mount. Screw it onto the bottom of your camera, then seat the camera on the tripod.

## Monopods

Monopods are similar to tripods. As the name suggests, they have only one leg instead of a tripod's three. They can be useful for steadying long and heavy telephoto lenses as they can be screwed into rings that many telephotos sport for this purpose. That's about all they're useful for, however. If you're in a situation where you need one, you can use a tripod with its legs collapsed.

## Bean Bags

Beanbags are inexpensive and passable camera supports when you don't have better ones handy. You can find them in hobby stores and toy shops, or you can even make your own out of canvas and any dry and granular substances you have on hand—rice, dried beans, even sand— check to make sure the seams are tight, however. If you have a tripod that's a little on the tippy side, or if the tripod needs something to stabilize it due to wind or other adverse conditions, you can also hang a heavy beanbag from the tripod's center column to stabilize it.

If you're really pressed for something to steady your camera with, fill a large plastic baggie about three-quarters of the way with rice, dried beans (lentils work particularly well), or even some sand. Choose a bag that seals tightly, and bleed as much air out of it as possible before you close it.

## Clamping It On

Camera clamps screw into the tripod socket on the camera and have jaws that can be attached to convenient objects, such as furniture, doors, posts, fences and other firm anchor points. Some camera clamps have suction cups for mounting on smooth, flat surfaces, such as a window.

## Please Release Me

A cable release, either electronic, manual, or remote controlled, will further insulate your camera from movement. Some cameras don't offer

this option, in which case using the self-timer function can give the camera and its support time to stop moving and then fire when everything is still.

# Lens Gear

Accessories for camera lenses run the gamut from things that protect to gadgets that enhance what the lenses do. It's always a good idea to buy a couple of spare lens covers, as they can easily get lost as you put them on and take them off, but there are other lens accessories that are also well worth considering.

## Lens Shade

Lens shades increase picture quality by cutting out extraneous light, which can do nasty things to your pictures. Some lenses come with a shade. If yours didn't, and you want to use them, you'll need to buy one that fits each lens, both in terms of the filter size of the lens (the diameter of the threaded front of the lens) and the focal length.

**FACT**

A wide-angle lens can only handle a shallow shade. If you put a telephoto shade on a wide-angle lens or wide-angle zoom lens, you are likely to experience vignetting, or a darkening of the corners of your picture. You won't see it through the lens, but you'll definitely see it on your prints.

## Filtering the View

Lens filters change the way in which light reaches the film. In so doing, they also change the way in which images will appear on film. Some filters simply enhance things, such as making colors look more true or eliminating glare and reflections from shiny surfaces. Other filters are used to created special effects such as turning light into stars or softening the focus on portraits.

The one filter that's a must-have is an ultraviolet or UV filter. Also

known as haze filters, they cut down the ultraviolet light, or visual haze, that you can't see but your film can. Even more important, they protect the delicate lens of your camera from dust and other elements that can harm it. They're relatively cheap, so buy one to fit every camera lens you own, and keep it on the lens unless you're using another filter.

Other filter types to consider adding to your gear bag include the following:

- **Polarizing:** Just like sunglasses with Polaroid lenses, these filters cancel reflections and glare caused by shiny surfaces and enhance blue skies on color film. The best ones rotate 360° in their mounts to control how much they cancel reflections or darken the sky.
- **Star filters:** These specialized filters have grids etched into them that turn light into stars. There are several different types available; the best allow you to rotate the grids to control how many points the stars have and their direction.
- **Light-balancing:** These filters reduce the amount of light coming through the lens or balance the color of artificial light.

There are literally dozens of different types of filters. The categories of lenses listed above cover only what your primary needs would be.

## Tele-Extenders

Also known as teleconverters or extension rings, these tube-like devices increase a lens's focal length and make it capable of greater magnification. Although the images they render aren't as sharp as those made with a true telephoto lens, they're a cheap alternative to buying an expensive telephoto lens, especially if you don't plan to use one very often. Tele-extenders also require you to focus manually in most cases.

# Improving Flash Photography

The built-in flash that's on most cameras makes quick grab shots easy and foolproof, but they're not much on delivering quality flash photos. Attaching a flash unit to the accessory shoe on top of your camera is

definitely a step up from using built-in flash. Putting that flash on a bracket, however, will yield even better lighting and better photos. (You can read more about flash photography in Chapter 10.)

A flash bracket is essentially an L-shaped piece of plastic or metal. One arm of the L screws into the bottom of your camera; the other arm holds the flash. Putting your flash on a flash bracket instead of mounting it on the top of your camera is one of the easiest ways to reduce and, in fact, eliminate red eye.

**FIGURE 6-3**

*Photograph courtesy of Tom Minczeski*

◄ This flash bracket allows the flash to pivot above the lens when the camera is flipped to the vertical position.

Not only does a bracketed flash prevent red eye, it also does great things for your lighting in general. When your gang of friends is 5 or 10 feet from you, the flash on a bracket produces more pleasing lighting

than the built-in flash. If your bracket holds the flash above (or at least higher than) your lens, the shadows will be less of a distraction.

You will probably find that a camera with a bracket and flash is clunky hanging from a strap around your neck. This means that when you aren't shooting you may want to put the gear down on a table. A few expensive brackets are designed to be set down with the camera and flash sitting upright, but most brackets will be most stable when the camera is laying on its front or back. You will want to find a spot where food and drink won't be spilled on it and where toddlers won't be able to pull it off the table. A tripod, out of harm's way, can be the right place to put the camera.

**ALERT!**

Holding a camera, bracket, and flash all in front of your face can put a strain on your wrists and hands. When you're not shooting, hold the camera in a way that rests them to avoid repetitive stress injuries and tendonitis.

## More Useful Gadgets

These items aren't essential, must-have products, but they can definitely make life easier for most photographers, especially those who spend a lot of time behind the lens.

### Film Changing Bags

These simple devices—basically, lightproof bags with enough room for your camera and your hands—let you open your camera in broad daylight. They can save the day when your film jams or the leader breaks and there's no dark place for you to safely open your camera and see what's going on. They can be one of the handiest things to have around, so buy one before you need it. You'll be really glad that you did. Many photography stores have changing bags on hand to help photographers in this situation. There are more stores, though, whose employees are quite willing to open the camera (without a changing bag) and risk ruining your film in order to figure out if there's film in the camera.

## Help for the Bespectacled

Photographers who wear glasses have some special challenges to overcome when taking pictures. If they want to wear their glasses while focusing, they often can't get close enough to the viewfinder to see all four sides of the frame at once. One way to get around this is to use a tripod, which will let you move your head up, down and sideways in order to see all four edges of the frame.

> If your SLR is not snapping into focus, it is very likely due to your diopter adjustment being set incorrectly. Adjust it by focusing your eye on lines or lettering visible in the viewfinder.

Some cameras are friendlier to the bespectacled than others. If you're farsighted and you wear glasses, you can find SLR models with built-in, adjustable diopters that will let you see through the viewfinder without your specs. Other camera manufacturers make separate eyepieces with various corrections that can fit into your camera's existing eyepiece.

## Reflectors

These handy devices are a photographer's secret weapon when it comes to dealing with tricky lighting situations. They're great for throwing light into shadows, for diffusing light, or for creating special lighting effects such as backlighting. Some have special coatings that change the color of light.

Portable reflectors are collapsible, making them easy and convenient to carry. There are also umbrella-style reflectors, which are more suited to studio work.

If you're going to invest in reflectors, buying a couple of light stands is a good idea. They can also hold additional lighting or backdrops. A light-stand bag, which should be big enough to hold your tripod and all the light stands you need when shooting on location, is also a good investment.

## Viewing Loupe

These devices are great for looking at the details in negatives and prints. All you do is put it directly onto the surface you want to look at. Light coming in from the transparent sides of the loupe illuminates the image when you're looking at prints. It's helpful to have a light box or table when viewing slides or negatives, but you can hold them up to a strong light in a pinch.

A loupe may not seem like an essential piece of equipment, but you'll be surprised at how much you'll use it if you buy one. Never again having to squint at a negative to figure out if it's really the one you want to print makes it worth the cost.

**FIGURE 6-4**

*Photograph courtesy of Tom Minczeski*

▲ A viewing loupe. This loupe was designed to allow the viewer to see the entire width of a 35mm negative or slide.

## More Gear to Think About

This category covers specialty items that most photographers would put far down on their "to buy" equipment lists. They're really not necessities,

so think twice before buying any of these things right away. The best rule of thumb is to wait and see if you can name a recurring situation where the piece of equipment would be useful.

## Photographer's Vests

Back a few years ago, photographer's vests enjoyed some popularity among those wishing to emulate the rough-and-tumble image of the photojournalist or outdoor adventurer. These once-trendy items seem to have lost their cachet for the most part, but they're still being made and they do have their fans.

Usually fashioned of cotton canvas and mesh, photographer's vests feature lots of inside and outside pockets for storing photo gear and other items such as compasses, water bottles, GPS devices, pens, maps, flashlights, and so on. Some people like them for shooting in the field as they lessen or eliminate the need to carry a camera bag; others find disconcerting the weighted-down feeling experienced when heavy lenses and extra camera bodies are loaded into the pockets.

Photographer's vests can also be problematic if you have a hard time remembering where you put things—some have so many different nooks and crannies that they come with a diagram to point them all out. And, of course, their functionality can decrease if you grow out of them for some reason.

If you think a photographer's vest is for you, see if you can borrow one for a test run before you buy. A hunting or fishing vest can also serve this purpose. Although they don't have nearly the number of pockets as photographer's vests do, you'll be able to store enough equipment in them to get an idea of whether you like how they feel.

## Data Backs

Most point-and-shoot cameras have a feature that automatically prints the date and time on photographs. If you love this feature, there are special camera backs that will let you do the same thing on prints from your SLR. The obvious question is why you'd want to do it as it makes SLR prints look like they came from a point-and-shoot.

**Chapter 7**

# Putting It on Film

If you've been taking pictures for any time at all, you already know that there are many different types of film to choose from. What you may not know is how to pick the right film for your needs. It's not rocket science, but it does involve knowing something about the various kinds of film and what they can do.

# In Black and White and Living Color

Until the 1930s, photographers could only work with black-and-white film. It was then that the technologies behind color film were perfected, which made it possible to record images in living color. Today, color film—and especially color print film—is the most widely used, with color slide film also a popular choice. Black-and-white film is still available, too. Each type has specific uses and attributes that make them all worth having in your camera bag.

Your choice of film might be determined by how the final images will be used, especially if you're taking them for someone else. For example, actors' headshots are usually done with black-and-white film. If you want to share color prints with your friends and family, color print film is perfect. If you don't need prints, nothing beats slide film for rich color and thrilling sharpness. It's also great for taking pictures that will be scanned into a computer.

# Color Print Film

Far and away the most popular film, color print film is versatile and easy to use, which makes it a great choice in almost any situation. It's widely available, cheap, and can be processed almost anywhere in less than an hour. If you need to see images fast, color print film is the way to go.

Many of the color print films on the market today create images with vivid color and lots of contrast. If you feel your prints have too much "oomph" to them, try professional color negative film. It's more expensive than the rolls you pick up at your supermarket check stand, and you'll have to search for it (pro labs, camera stores, and online retailers are places to look), but the results will be worth it.

One of the biggest advantages to using color print film is its versatility. You can under- or overexpose it to a certain degree, either intentionally

or by accident, and it will still come out looking pretty good. Because it's not very fussy, it works well in cheaper point-and-shoot cameras that don't have sophisticated metering systems. It also handles artificial light better than slide film, which means less fumbling with color correction filters. Many color and exposure problems can be corrected in the printing process. On the other hand, if the lab doing your work isn't up to snuff, your perfectly exposed images can come out too light or too dark or with unnatural colors.

# Color Slide Film

Also called color reversal, color positive, or color transparency film, color slide film delivers unbeatable color and sharpness and can render scenes that are more vivid than real life. Professional photographers ofen use slide film as it yields great color and sharpness and allows greater control for shaping images through the lens. It's a great choice for amateur photographers for the same reasons.

## More Advantages of Color Slide Film

Slide film also gives you complete control over the images you take. Slides are first-generation images—they're captured directly onto film instead of being printed to paper—which means they can't be corrected (or messed up) in the lab. When you shoot with slide film, what you see through your viewfinder is what you'll get on the finished slide.

Other reasons for shooting with slide film include these:

- **Lower processing costs:** Instead of printing an entire roll of film, you can pick only your best shots for enlarging.
- **Easier to store and file; take up less space:** You can easily fit over a thousand slides in a storage container about the size of a shoe box. This same amount of images in prints would require several full-sized albums.
- **Best choice for testing new gear or perfecting your exposures:** Not only will your lab correct exposure problems (or create them) with

print film, it's also very hard to judge exposure by eyeballing a color negative. Any problems will be immediately visible on a slide.

**ALERT!**

With slide film what you see is what you get. If you're shooting a particularly important picture, do what the pros do: Take the same shot with several different exposure settings (a procedure called bracketing) to ensure that you get the right one.

## Disadvantages of Slide Film

There are also a number of cons to shooting with slide film, including the following:

- **Less convenience for viewing images:** With slides, you need projection equipment, such as a slide viewer, a light box, or projector, in order to see your pictures. (You can make prints from slides, and they can be copied, but they won't be as good as the original.) You also can't get your hands on the images as quickly because slide film has to be sent to labs equipped for processing it.
- **Trickier to use:** Slide film is more sensitive to different kinds of light. If you're shooting indoors, you'll need to use tungsten film that will record indoor or incandescent light correctly. If you don't, you'll end up with a reddish or orange cast on your slides. Shooting outdoors calls for film that's balanced for daylight; using indoor tungsten film outside will result in slides with a eerie bluish tint. Color correction filters are available for converting indoor slide film for outdoor use and vice versa.
- **Very little room for exposure errors:** Mistakes can't be corrected in the lab.
- **Creating first-generation images:** Because the slide *is* the image, it requires more careful handling. Prints (whether made from negatives or slides) are second generation, meaning that you can handle your prints, give them away, let the dog eat them, and always have more prints made as needed from your pristine originals.

Slide film can also vary a great deal when it comes to tone and color saturation. Some types will make skin tones look cold, while others will deliver vibrant, saturated color that may not suit the situation or the subject.

Most photographers have their favorites when it comes to slide film. They also use different types of slide film depending on the situation. Try film made by different manufacturers in various situations and see what you like the best. For example, saturated film will bring colors out better on overcast days.

**FACT**

Some manufacturers use letters as part of their film's names to indicate the film's characteristics. "S" means saturated; "N" means natural; "VS" means vivid saturated; "SW" means saturated warm. You can also find this information on the film box.

## Black-and-White Film

Most traditional fine-art photographers shoot in black and white because they believe it's more expressive than color. Even if you're not interested in doing this kind of photography, black-and-white film can be fun to experiment with.

Shooting in black and white eliminates the distraction of unexpected or unwanted colors in a scene. Since color is eliminated, such factors as composition and contrast become more important. Special filters that lighten some tones and darken others can manipulate contrast while shooting. You can also play with contrast by increasing or decreasing the film's developing time, by using different exposures when printing it, or by printing it on different kinds of paper. Since black-and-white film records light in various shades of gray, it can be used with all light sources. Most black-and-white film available today is print, but slide film is also available.

### Making the Most of Black-and-White Film

To realize black-and-white film's greatest potential, most photographers who shoot it process and print it themselves, which gives them complete

control over how the final image will look. If you aren't the do-it-yourself type, or lack the equipment to do it, you can buy chromogenic black-and-white film, which can be processed using conventional color print chemistry. Prints from chromogenic film, however, will look a little different from those made with traditional black-and-white film in terms of contrast, sharpness, and grain. Some will even have a strange color. If you're going for the true black-and-white look, shoot with real black-and-white film.

Black-and-white prints can also be made from color negatives. If printed on paper made especially for this purpose, the tones of the original photographs will be accurately represented. If printed on paper made for printing black-and-white negatives, however, the tones won't be as accurate.

## More Advantages of Black-and-White Film

True black-and-white negatives and prints will last decades longer than color because they contain silver, which doesn't fade like color dyes do. However, they can be damaged by chemicals present in pollution or emitted by some storage materials, such as nonarchival mount board, cardboard, and wooden frames and drawers. Chromogenic black-and-white negatives and prints are more like color negatives and prints in that they can fade or change color over time.

# Special-Purpose Film

In a class by itself is a group of film types that are designed for special uses. This group includes infrared film, which records the invisible light that the eye can't see, often resulting in images with odd or false colors. Another special-use film is copy and duplicating film, which is used to make copies of color slides and negatives. It can also turn color negatives into transparencies, and vice versa.

# Film Speeds

A second factor determining film choice is its speed. This factor determines how sensitive the film is to light; the film's sharpness, or the amount of detail it can register; and its grain, which is the sandy or granular texture that's sometimes visible in prints (especially in enlargements).

In general, slow films are less sensitive to light but deliver sharper, more finely grained images. Fast films are more sensitive to light, but the images they produce will have more grain. They also won't be as finely rendered as those on slow film. However, if you can't hold the camera still enough or your subject moves during longer shutter speeds, your pictures will be blurry no matter how slow or fast the film is.

## ISO Numbers

Film speed is designated by an ISO number, which denotes a numbering system developed by the International Standards Organization. Because ISO numbers were developed to replace two older film speed rating systems – ASA and DIN – they're written as a combination of the older systems, such as ISO 50/18°, ISO 100/21°, or ISO 400/27°. However, most people use only the first number when talking about film speeds.

Film speeds fall into three categories:

- **Slow:** Rated at ISO 50 or less. Film in this category is not very light sensitive and is sharp and fine-grained.
- **Medium:** Rated at ISO 64 to ISO 200. More light sensitive and still sharp and fine-grained, but not as fine and sharp as slow film.
- **High (or fast):** Rated at ISO 400 to ISO 3200. Very light sensitive, not as sharp. Grain is larger and more visible, especially when enlargements are made.

The ISO numbers also indicate each film's light sensitivity when compared to other films. ISO 400 film, for example, is twice as fast as ISO 200; ISO 800 is four times as fast, and so on. While it's not extremely important to know all of this in great detail, these facts do come into play if you aren't shooting in automatic mode. Film speed

affects the two exposure controls on your camera: the shutter speed and the aperture, or f-stop. If you're shooting with slow shutter speeds, in bright light situations, and with your lens wide open, you can use slow film. Fast shutter speeds, low light, and narrower apertures, which allow less light to enter the camera, require faster film for good exposures.

To give you an idea of how film speed will affect your picture taking, here are some examples of common conditions and shutter speeds (with reasonable f-stop settings for each).

| Film Speed Chart | | | |
|---|---|---|---|
| Setting | ISO 100 | ISO 400 | ISO 800 |
| Church altar | 1/2 second f/4 | 1/8 f/4 | 1/15 f/4 |
| | (all these require a tripod) | | |
| Bright shade | 1/30th second f/5.6 | 1/125 f/5.6 | 1/250 f/5.6 |
| | (you may need a tripod at 1/30th) | | |
| Bright sun | 1/125th second f/16 | 1/500 f/16 | 1/1000 f/16 |
| | (all can be done handheld) | | |

For proper exposures, your camera needs to know what film speed you're using. Automatic cameras with built-in exposure meters (most cameras today) will electronically program film speed by reading the code on the film cassette. If you're using a manual camera, you'll need to set the film speed yourself.

## Choosing Film Speed

The best way to choose film speed is to know the conditions in which you'll be shooting. In general, the more light you have to work with, the slower the film can be. If you're shooting outside on an average day, medium-speed film—ISO 200—will probably be your best bet. If it's really sunny, you might want to switch to slow film, say ISO 100 or even ISO 64 if you're using a tripod. On overcast days, high-speed film—ISO 400 and up—will make the best of what light you do have.

Many beginning photographers are tempted to use the fastest film possible for its versatility. But increased light sensitivity comes at the cost of lower sharpness. In general, use the slowest film that allows a shutter speed you can work with.

## Slow Film Versus Fast Film

There's always something of a trade-off involved when choosing film speed. No one film will deliver everything you want in every shooting situation. Slow and medium-speed film need longer exposure times, which limits their use when shooting action or when using a telephoto lens. High-speed film is great for getting those action shots as it allows for faster shutter speeds, but it's also grainier and less sharp. If you're not going to make prints larger than 4" x 6", grain isn't a factor. If you are going to make enlargements bigger than this, it is.

Unless you're shopping at a pro shop, you'll usually see film with ISO speeds of 100, 200, 400, and 800. In general, 100 is a good selection for shooting nonmoving subjects, brightly lit outdoor shots, and for tripod work; 200 works for daylight print film; and 400 and up is good for indoors, outdoors low-light, and action situations.

**Will the X-ray machine at the airport affect my film?**
This is a question vacationers frequently ask. For the little X-ray machine that you put carry-on luggage through, no. However, checked baggage is subjected to a much more intense level of X-rays, which can be damaging.

## Pushing Film

There are times when even the fastest film isn't fast enough. You might be shooting with existing light that's too dim, using a small aperture for good depth of field in a low-light situation, or using a fast shutter speed with a small aperture. If this is the case, it's possible to make your film even faster by pushing it.

Film is pushed by setting your camera's ISO meter at a higher number than what's printed on the box, such as setting your camera to 800 for 400 speed film. You can also push film by setting your camera's exposure compensation dial to underexpose the film.

Film that has been pushed needs special handling when it's processed. If you're going to try this technique, be sure you mark the film's cartridge with the speed it was pushed to. Take it to a lab that will process pushed film, and be sure to tell them what speed you used.

Film that has been pushed will result in pictures with greater contrast and more grain. Colors are altered as well. Such changes aren't necessarily bad; in fact, many photographers push their film so they can achieve images with these effects.

Film can also be pulled, or shot at a slower speed than what it's rated for. Keep this in mind if you're using a manual camera and you've shot a roll of film at the wrong speed because you forgot to reset the ISO meter (which, by the way, can happen far too easily).

**ALERT!**

Never switch to a higher or lower ISO in the middle of a roll of film. You'll end up with some frames being developed incorrectly as the lab won't be able to process both speeds at the same time.

## Buying Your Film

It seems like film is available literally everywhere you go, which begs the question: Is it okay to buy it anywhere you see it? The answer, for the most part, is yes.

Film made for consumer use is designed to be relatively tolerant of condition changes, and it generally has a longer shelf life than professional film. About the only thing you need to worry about is its expiration date. All film deteriorates over time, and its light sensitivity and color balance changes. Out-of-date film isn't necessarily bad or unusable, but it may not deliver the results you want or expect. Check the box when you buy it, and use it before it expires for the best results.

The film box will also tell you what kind of film you're buying and what it's best used for. More information on exposure times and

processing data is generally available inside the box or on an enclosed data sheet.

Steer clear of film that's displayed in direct sun or that might have been exposed to extreme heat or humidity. These conditions can make the film expire before its time and are more likely to deliver far-from-desirable results.

## Brand Versus Brand

Professional photographers often favor one brand of film over the others because they've used their favorite enough to know what it can do and what they can do with it. For amateur photographers, brand isn't that big of a concern unless you're buying slide film. Since this kind of film varies somewhat significantly between manufacturers, buying by brand name will assure you of getting film with the characteristics you want.

Print film also varies somewhat between manufacturers, but the processing process will determine how your images turn out more than the film actually does. Unless you're looking for specific properties that only a certain film from a certain manufacturer can deliver, buy the stuff that's priced right.

It's better to know whether a film will work for you before using it for important pictures. Always test a roll or two of unfamiliar film—regardless of its type or who made it—to make sure it performs the way you want it to.

## Consumer Versus Professional

Camera snobs—and they're definitely out there, by the way—often swear by professional film even when they have no reason to do so. There's really not that big of a difference between the two types, and pros often shoot with film made for consumer use because they like its characteristics and its price.

What does distinguish pro film from consumer film is how it's

manufactured, which affects its shelf life. Consumer film is made to tolerate a certain amount of abuse, such as temperature variations, sitting on the shelf for a long time, delays between shooting and processing, and so on, and still deliver good results. Since pros often buy large amounts of film at a time, and shoot and process it relatively quickly, the film that's made for their use is manufactured to more exacting standards and isn't as stable as consumer film.

## Storing Your Film

Film is happiest when it's kept cool and away from direct light. Storing it in your camera bag is fine if it's consumer film and you keep your bag in your home instead of your car (never a good place for equipment or film for extended periods of time). Storing film in a refrigerator or freezer, as many professionals do, will slow down changes in its emulsion that can affect its performance. If you do store your film in the refrigerator or freezer, allow it to warm up to room temperature before putting it in your camera. Pro film, due to its shorter shelf life, should always be stored in the fridge or freezer.

**ALERT!**

Never leave film in a hot car or anywhere else where it can heat up. You might end up with some very strange colors on your prints or slides and with fogging or contrast shifts on black-and-white film.

## Loading Your Film

Most cameras on the market today have automatic film loading devices that make film handling a breeze. All you have to do is drop the film cartridge into the film chamber (located on the left side of the camera as it faces you), check to make sure the film is lying flat, pull the film leader (the part of the film sticking out of the cartridge) across to a mark on the opposite side, and close the back. The automatic film loader does the rest, at least most of the time. Film loading errors can happen, but they

are usually the result of the film's not being correctly caught by the sprockets in the loading mechanism. If your camera indicates that the film wasn't loaded correctly, just open it up and do it again. Don't worry about touching the leader with your fingers. It's only there to facilitate loading the film.

**FIGURE 7-1**

*Photograph courtesy of Tom Minczeski*

▲ When loading a camera that has an automatic film loading device, simply pull the tip of the film to the mark indicated in the camera.

If you're using a manual SLR, you will need to learn how to master the fine art of loading film manually. It can be a little frustrating, but with some practice you'll become a pro. Here's how you do it:

1. First, drop the film cartridge into the film chamber. You'll need to pull up on the film rewind crank (located on the top of the camera) to do this. When the film is in the chamber, push the crank back into place. Check to see if the film is seated correctly in the film chamber.
2. Next, pull the leader across to the film loading mark. (These steps are the same as above).
3. Rotate the film take-up spool (located on the camera's right as it faces you), until you see a slot in it. Insert the end of the film leader in this slot.

4. Check to make sure the holes on the edges of the film are lined up with the camera's sprockets. If they aren't, the film won't advance properly.

5. Manually advance the film forward a few frames by releasing the shutter. As you do this, watch the rewind crank to make sure it's moving. If it is, the film is loading onto the take-up spool.

6. Close the camera and continue advancing the film until the first frame shows up in the frame indicator. Keep watching the rewind crank—it should continue to move. If the back doesn't snap into place, you may need to reopen the camera and reseat the film cartridge.

7. Check to make sure there's no slack in the film by pulling up on the film rewind crank and giving it a slight turn backwards. If it won't turn, your film is tight. If it will turn, rotate the crank until you feel good tension on it, then put it back into place. Don't turn it too hard—doing so may break the film.

**ALERT!**

Be sure to turn the rewind film in the correct direction—in the direction of the rewind arrow, instead of the other way—when checking for film slack. Turning it in the wrong direction can kink or jam the film.

All cameras load pretty much the same way, but it's always a good idea to check your camera manual for specific instructions on loading your camera.

It's always best to keep film in its box until you're ready to load it. Not only will it stay fresher, it's less likely to be damaged when it's wrapped. If your camera has a film reminder holder on the back, you can slip the box top into it so you'll know what kind of film you're shooting.

Try to avoid loading or unloading film in bright sunlight. Put the camera in your shadow or go inside before you open it up. High-speed films are more sensitive, of course, and if you are doing lots of shooting in bright sun you might choose to work with a slower ISO film. Even so, get the film from the packaging to the camera and back in the shade.

# The World Through a Lens

It's often said that lenses are the eyes of the camera, allowing it to see up close, far away, and all points in between. You can create lots of good images with just one lens, but why stop there? There is a whole world of camera lenses. The variety goes far beyond the basics, making it possible to capture astonishing images and allowing for far greater creativity.

# Learning about Lenses

A lens in its simplest form is a pretty basic thing: a piece of transparent material, usually glass, with two polished surfaces that modify rays of light. Before the advent of SLR photography, most cameras had built-in lenses that captured images similar to what people saw when they looked through the viewfinder. Such things as making far-away images seem closer or larger wasn't possible with these lenses.

The ability to make images larger and smaller and to have greater control over such aspects as depth of field, angle of view, and perspective is what made SLR cameras popular when they were first introduced, and it continues to be a key factor in why more photographers use them than any other camera.

Today, there are four basic types of lenses for SLR cameras:

- **Normal, or standard:** Objects are similar in size to what your eyes can see (approximately 50mm for 35mm SLR cameras).
- **Telephoto:** Makes faraway objects appear closer.
- **Wide-angle:** Covers a wider angle of view than is possible with a normal or telephoto lens.
- **Zoom:** Combines the features of the first three types into one lens. Some zoom lenses operate strictly in the telephoto area. (For example, a common zoom lens size is 100–300mm, which even at 100mm is going to enlarge what you see.)

One special type of lens you'll read about often is the macro lens. It's a lens that allows close lens-to-subject focusing for close-up photography. You'll often see macro lenses described as 1:1, 1:2, and so on. A 1:1 macro lens will allow you, at a set focal distance, to capture an image on film at the exact same size it is in real life, so a bug that's a half inch long will produce a half-inch-long image on the negative. Basically, you can get extreme close-ups using a macro lens.

## Focusing on Focal Length

What distinguishes each type of lens is a factor called focal length. Expressed in millimeters, such as 50mm, 100mm, and so on, focal length describes the distance from the optical center of the lens to the film. It also determines the scale of the images in a picture. In general, lenses with short focal lengths make images look smaller. As focal lengths get longer, image sizes get bigger. If you were to stand in the same place and take a picture using lenses with different focal lengths, you would get the widest angle of view and the smallest images with the shortest focal length lens. As you went up in focal length, images in the scene will look bigger, but you would see less of the scene itself as the angle of view narrowed.

**FIGURE 8-1**

*Photograph courtesy of Eliot Khuner*

▲ This photo of the Golden Gate Bridge was taken with a wide-angle lens. Notice how much of the scene you can see in the photo.

**FIGURE 8-2**

*Photograph courtesy of Eliot Khuner*

▲ This photo was taken with a telephoto lens from the same spot as the previous photo. Note how much larger the image is.

You can usually check a lens's focal length by looking at the front lens ring, although some lenses have their length engraved elsewhere on the lens barrel.

If the focal length of a lens is about the same as the diagonal of a frame of the film the camera uses, it's called a normal lens. If it is longer, it's a telephoto; shorter, and it's a wide-angle. The diagonal of a 24 x 36mm image (the size of the image on 35mm film) is 43mm, so a lens with a focal length of 43mm or thereabouts is considered a normal lens for the 35mm format. If you're using a camera with larger or smaller film, the focal lengths used to classify its lenses will be different.

## Focusing on Field of View

Focal length also determines how much of a specific scene or area the lens can see. This is called field of view, or angle of view, and it is measured and expressed in degrees. Lenses with short focal lengths have wide

angles of view and cover more of a given scene. As focal lengths get longer, angles of view get narrower and you can see less from side to side.

Focal length and field of view are two of the most important factors to consider when choosing which camera lens to use. Together, they determine how much of a particular view you'll be able to capture on film, and what the size of the images will be. A short lens with a wide angle—for example, a 28mm lens—will let you photograph a large group of kids at a pretty close range and get them all in the picture. If you were using a lens with a longer focal length—let's say 50mm—you'd have to stand back about another 4 feet to get them all in since your angle of view is narrower. If you were just shooting one person, the same 50mm lens, with its greater magnification and narrower field of view, would let you to fill your frame with your subject better than the shorter lens would.

On the other hand, let's say you're standing on the sidelines of your daughter's soccer game and you want to take a picture of her as she's dribbling down the field. You'd need a 200mm or even a 300mm lens to fill the frame with her image without stepping into the playing area to get the shot.

Always use a lens that will let you fill as much of the frame as you can with your intended subject. The pros call this "cropping in the camera." Doing so will deliver much better images than those that are enlarged and then cropped in the darkroom.

## About the Aperture

The second factor governing lens choice is aperture, which is the adjustable opening that regulates how much light passes through a lens. You will usually be most concerned with the largest aperture (smallest number). The lower the number, the better that lens is for low-light or high-speed use. The range of apertures varies from lens to len, affecting exactly how much light they're able to let in. Some are able to let in a lot of light. Others, not as much.

## F-Stops

As discussed in Chapter 5, apertures are expressed in f-stops, such as $f/1.8$, $f/2$, $f/2.8$, and so on. This measure is a ratio that reflects the focal length of the lens ($f$) divided by the actual diameter of the aperture. The smaller the number, the more light the lens is capable of letting in. Lenses with extremely low f-stops, such as $f/1.2$, $f/1.4$, $f/1.8$, and so on, let in a great deal of light and can handle fast shutter speeds. They're often referred to as fast lenses. Slow lenses are those with higher f-stops, generally in the $f/5.6$ range and above.

Fast lenses are wonderful things to own, but they come at a price. Not only do they cost more than comparable (but slower) lenses, they're also bigger—they have to be to let in more light. They also weigh more and take up more room in your camera bag. While weight and room may not seem like important factors, they definitely come into play if you're lugging your equipment along on something like an all-day hike. That wonderfully fast lens that seemed like such a great thing to have when you bought it may end up being your worst nightmare after you've hauled it along a rugged trail for a few hours.

## All about "Normal" Lenses

Also called standard lenses, these are the lenses that were supplied with basic SLR camera setups for many years. The image a standard lens "sees" is about the same size in the viewfinder of what the human eye sees. In other words, the lens neither enlarges nor shrinks the image (however, the angle of view of the lens is smaller, thus cropping the image from what you see normally).

**FACT**

Normal lenses aren't the only prime lenses. Any lens with a fixed focal length is considered a prime lens, so wide-angle lenses and telephoto lenses also fall into this category. Compared to zoom lenses, they generally weigh less and are faster. They can be sharper than zoom lenses as well.

A standard lens for a 35mm camera is typically 50mm, although lenses that range from 45mm to 55mm are also considered normal or standard. A 50mm lens covers a 45° angle of view.

Normal lenses are also called prime lenses, which means they have fixed focal lengths.

## Advantages of Using Normal Lenses

In the hands of a new photographer, normal lenses capture the images without the distortion a wide-angle or telephoto lens causes. Pictures taken with them look very natural and familiar, which makes these lenses a favorite of many photographers.

Normal lenses are generally very fast and can have maximum apertures as large as $f/1.2$. This makes them great for low-light situations, especially for taking action pictures in less-than-perfect light.

## Disadvantages of Using Normal Lenses

Like all prime lenses, you can't adjust image size with a normal lens alone. To make images bigger or smaller, you have to move the camera closer or farther away from the subject. When shooting with large apertures, the depth of field on normal lenses is fairly shallow, so accurate focusing is essential.

# Wide-Angle Lenses

Wide-angle lenses have shorter focal lengths and cover a wider angle of view than normal and telephoto lenses do. For 35mm cameras, they range from 13mm to 35mm, with 28mm considered a standard wide-angle lens. The shortest wide-angle lenses have the greatest angle of view, starting with 118° for a 13mm lens and going to 63° on a 35mm lens.

There's also a special wide-angle lens called a fish-eye with an extremely short focal length (beginning at 6mm) and an extremely wide angle of view (220°). They create round images that look like they're viewed through the eyes of a fish (or how we might imagine). These lenses make distant objects appear smaller, near objects seem larger, and make the distance between them look greater.

**What lens do I need for close-up photography?**
Normal or telephoto lenses that can focus extremely close can be used for close-up work. You can buy macro lenses with focal lengths that can also be used as normal or telephoto lenses, or regular lenses with macro capabilities. You can also use an extension tube, which mounts between the camera body and the lens to move the lens closer to the subject.

## Advantages of Wide-Angle Lenses

Wide-angle lenses are definitely the lens of choice in cramped conditions, such as small rooms or other situations where you can't back up far enough to include everything you want in the picture if you used a normal lens. Their wider field of view makes them great for scenic outdoor photography as well, especially if your subject is a sweeping panorama and you want to get as much of it as you can in your shot.

Because wide-angle lenses make nearby objects look really big and distant ones really small, they're also great for creating images that take advantage of this aspect. The classic gimmick shot of a person holding a building in his or her hand is created with a wide-angle lens. For the same reason, they're good for times when you want to use perspective for emphasis, such as when exaggerating the space between objects will add to the picture's interest.

## Disadvantages of Wide-Angle Lenses

It is easy to get distorted images with wide-angle lenses, which makes them inappropriate for taking close-ups of people. Wide-angle lenses used for close-ups will distort the faces of your subjects. They make the features closest to the lens bigger (like noses) and those farther away from the lens smaller (ears, for instance). Because they capture more of a scene, people and objects at the edges of wide-angle shots can also appear distorted. This actually happens with all lenses to a certain degree, but it's not noticeable with telephoto and normal lenses. Wide-angle lenses make it more obvious to the picture-viewer's eye.

Another problem with wide-angle lenses is something called keystoning, a phenomenon in which parallel vertical lines on buildings or other subjects look like they're converging. You can avoid keystoning by keeping your camera facing straight forward—not tipping it up or down—unless you want to create this affect.

You can use a wide-angle lens to make people of different sizes look more similar in size. Let's say you're taking a picture of two people, and one of them, who is somewhat larger than the other, would like to look thinner. Place the thinner person nearest the camera and the larger person farther away.

## Telephoto Lenses

Telephoto lenses are basically the opposite of wide-angle lenses. Since they have longer focal lengths and smaller angles of view, they make subjects look closer and larger. They're great for when you want to get a good shot but can't get close enough to your subject to use a normal lens. Since they have shallow depth of field, they're also good for focusing more attention on the main subject of a picture by eliminating distracting backgrounds and foregrounds.

For 35mm cameras, telephoto lenses range from 85mm up to 2000mm, with corresponding angles of view from 28° to an amazingly small 1°.

### Advantages of Telephoto Lenses

The most obvious advantage of using a telephoto lens is to make faraway objects look bigger. A 100mm telephoto lens will double the size of the image produced by a 50mm lens; a 500mm telephoto lens will make the same image ten times larger.

Because they don't exaggerate the distance between objects—in fact, they compress it—telephoto lenses don't distort features, which makes medium-range telephoto lenses good for portrait work, because you can shoot at a greater distance.

**FIGURE 8-3**

*Photograph courtesy of Tom Minczeski*

▲ A comparison of 50mm *f*/1.4 (left) and 200 *f*/4 lenses. Note how the diameter of the lenses is almost identical.

With telephoto lenses, perspective is less apparent because of the narrow field of view. Distant objects, enlarged and more visible with a telephoto, show less divergence and convergence of lines, but the perspective, albeit reduced, is still there.

Telephoto lenses are often used to create photographic compression. Using an extreme telephoto on a distant scene of repeating, overlapping shapes, such as cars on a highway, telephone poles down an avenue, skyscrapers miles away, will make them look closer to each other than they actually are. The narrow angle of view on these lenses is great for cropping parts of a scene you don't want.

## Disadvantages of Telephoto Lenses

Since telephoto lenses magnify their subjects, they must be held perfectly still when the shutter is snapped. If they're not, pictures will be

blurry as the magnification of the lens also magnifies any movement of the camera. Getting good photos with telephoto lenses often requires using a tripod and a cable release—especially if the lens is longer than 400mm—or a self-timer if your camera doesn't have a cable-release feature. Using fast shutter speeds will also help minimize camera shake and subject movement, which is also exaggerated because of the magnification. Since telephoto lenses have shallow depth of field, it's important to focus them carefully.

## Zoom Lenses

These extremely versatile and popular lenses combine features of the other lenses into one handy piece of equipment. By adjusting a collar on the lens, or pressing a zoom button on a point-and-shoot model, you can change focal lengths, make images look larger or smaller, and change your angle of view. For example, a 28–70mm zoom will adjust from the wide-angle focal length of 28mm to a slight telephoto length of 70mm.

Early zoom lenses were notoriously awkward to use and heavy. They also weren't as sharp as fixed-focus lenses. Manufacturers now claim that advances in design and materials have made zoom lenses as sharp as primes. If you never enlarge your images to more than 5" x 7", you won't have to worry that much about the difference in sharpness between zoom lenses and prime lenses.

To figure out the slowest shutter speed at which you can take handheld shots, put a one over the focal length of the lens. A 100mm lens you can hold at 1/100 or faster (1/250, 1/500, etc). Macro work is more critical and needs even quicker shutter speeds for handheld work.

Zoom lenses come in various focal length ranges. The most common are 28–50mm or 21–50mm, covering a wide-angle to normal range; 35–105mm or 35–135mm, which increases the focal length to the telephoto range; and 80–200mm, the medium to full telephoto lenses.

Zoom lenses are labeled with their minimum and maximum focal lengths, followed by the largest aperture available at each extreme, such as 75–300mm *f*/4–5.6; or 20–35mm *f*/3.5–4.5. When you're zoomed out to 20mm (very wide angle) your largest f-stop is *f*/3.5. As you zoom in toward normal or telephoto, the largest aperture changes from *f*/3.5 to *f*/4.5, which means it lets in less light.

## Advantages of Zoom Lenses

The greatest advantage of zoom lenses is that they can keep you from having to buy lots of prime lenses. They also make it possible for you to make images larger or smaller without having to change lenses or change shooting position—all you have to do is adjust the focal length. This makes it easier to compose the perfect shot.

When you test a zoom lens, make sure the zoom mechanism is easy to operate. But also check that it's not so loose that the zoom moves when you point the camera up or down.

## Disadvantages of Zoom Lenses

Zoom lenses—especially big telephoto zooms—are heavier than other lenses. They're also more expensive—although expense is relative. It's cheaper to buy one zoom lens than several fixed-focus lenses.

Perhaps the most serious drawback to zoom lenses is that they're slower than other lenses. Buying a zoom with an aperture wider than *f*/4 usually entails a pretty hefty investment. Because the maximum aperture gets smaller as the focal length gets longer, it can be difficult to use fast shutter speeds. Focusing is also trickier because less light reaches the focusing screen.

Some zoom lenses can also change focus as you zoom. This means that if you zoom in (move to the telephoto setting) to focus and then zoom out, the image may need to be refocused at the new focal length. Autofocus zooms take care of this if there is enough light for the system to work.

# Choosing the Right Lens for the Right Job

Professional photographers generally have at least a couple of lenses in their bags that allow them to tailor their lens choices for specific situations or to create certain effects. While there is really no "best" lens to own, certain subjects or circumstances are easier to handle with specific lenses. Here's a look at some different situations and the appropriate lens choices for each.

## Photographing in the Wild

If you are out to photograph an eagle's nest in the wild, you will need to stay far away from the nest. A 200mm telephoto lens might work if you can get close enough. If not, you'll need an even longer telephoto lens, possibly 800mm or 1200mm.

If you're shooting a serene landscape scene, go for a wide-angle lens. A 20–35mm zoom will give you several composition options.

## Portraiture

Before you take a portrait, decide if the subject is "my mom" or "my mom in her kitchen." In other words, do you want the person to be the emphasis, or do you want to show how the person relates to his or her surroundings?

For the "my mom" picture, use a telephoto lens (95–110mm) for head and shoulders and to keep her separated from the background. Shooting with a large aperture ($f/1.4$, $f/2$, $f/2.8$) will throw the background out of focus while keeping her eyes (usually the most important part) in focus.

**FACT**

Using a telephoto in portraiture has the effect of isolating subjects from their environment. Using a wide-angle lens has the opposite effect, emphasizing the relationship between the subject and the environment.

For the "mom in the kitchen" picture, select the view you want of the kitchen and the lens that lets you fill the frame the way you want it.

Then position your mom so that her size and pose tell the story (who dominates—your mom, the stove, the table?). Use the combination of lens choice, camera placement, and subject position to tell the story.

## Athletic Events

The photographer on the sidelines at a professional sports event may need a 300mm lens, but if the amateur athlete you are documenting is more approachable, your lens of choice might be in the range of 85mm to 180mm. For sports photography from the sidelines, 200mm to 300mm is good.

## Indoor Architecture

To photograph interior architecture, select a wide-angle lens with a focal length of 24mm, or even 17mm, which is a super-wide angle. If most of your pictures will be taken inside your home or in a small backyard, you'll be happier with lenses in the wide-angle category.

## Stage Shows

Photographing stage shows, or any other dimly lit events at a distance, requires a lens that lets in a lot of light and that has a focal length of 100mm to 200mm.

## Groups

As a general rule, when photographing a group of people who are in several rows parallel to the film plane, a longer lens will produce a more honest picture. The wide-angle lens allows the camera to be closer to the group in order to fill the frame. The people closest to the camera are significantly closer than the people in the back row, so the front row people appear larger. Back away from the group, and switch or zoom to a longer focal length. The farther away you get, the more the people in the front row will be in scale with the ones in the back row. Even if you don't switch lenses, the more accurate scale provided by greater distance will still be apparent. The reason you switch lenses is to keep the frame filled with the people rather than unimportant surrounding scenery.

**QUESTION?**

**What would be a good starter set of lenses?**
You want a selection that will cover just about any shooting situation. One possible mix is a wide-angle lens covering about 19mm to 35mm, a medium-range zoom in the 28–105mm range, and a long telephoto zoom that goes from 100m to 300mm. Adding a 1.5 or 2X teleconverter will lengthen any of these lenses by 50 to 100 percent.

# Buying Camera Lenses

As when buying a camera, it's a good idea to research the kinds of lenses you're interested in before making a purchase. For the most part, lenses are divided into three quality categories:

- **Professional lenses:** More expensive, generally sharper, and better built. Faster f-stops, better mechanics, better optical qualities. You even get more contrast and better color from better lenses. The better lenses will stand out especially when the images are greatly enlarged.
- **Consumer lenses:** Might only be good enough for prints up to 4" x 6", or 5" x 7". Less expensive lenses are also not going to be as fast—their largest aperture may not be large enough—and may introduce distortions, like not showing parallel lines accurately.
- **"Pro-sumer" lenses:** Offer features and qualities that fall between consumer and professional, priced accordingly.

Learn about variations in model designations or lens series so you know what you are getting and what is a fair price. Don't pay pro prices for bargain lenses. Keep in mind, however, that price is definitely an indication of quality and performance. Lenses with better optical elements and larger maximum apertures will always cost more than lenses with lower quality optics and smaller maximum openings.

Be sure to buy the right style of lens for your camera. Manual-focus lenses won't always work on autofocus cameras and vice-versa, although they are sometimes semicompatible. A lens with a mount designed to work on one camera brand won't work on other brands.

## Name-Brand Versus Aftermarket

The same companies that manufacture camera bodies also offer lenses that match their cameras. These lenses are designed to work with the manufacturer's cameras only, so they can't be swapped between cameras made by different manufacturers. Buying these lenses will assure a perfect interface between camera and body and will virtually eliminate any performance errors that might happen with lenses made by another manufacturer. Professional photographers usually stick with top brand-name lenses that match their cameras.

Aftermarket companies make several versions of the same lens to fit different cameras. The difference between these versions is simply the physical and mechanical interface, which is different for each camera manufacturer. Like the major names, they divide their products into professionally oriented lenses and consumer lenses. Some individual lenses by these aftermarket companies are quite good.

Whether your equipment is new or used, be aware that there can be variances in quality between the exact same lenses. One 35mm *f*/2.8 Yukon may be sharper or softer than the seemingly identical 35mm *f*/2.8 Yukon sitting on the shelf next to it. A used lens may be on the market because it didn't measure up.

It's a good idea to buy a lens from a store that allows returns. After testing it by shooting a few rolls, which you should do with any new lens you buy, you might find that the lens is not as sharp as you had hoped, or that it has a focusing problem. Even if you don't need to return the lens, be sure to keep the receipt and the box it came in. If you ever want to sell the lens or need to have it serviced, it's a good idea to have both.

## Selecting a Zoom Lens

There is no ideal zoom lens that works for everyone. If you love taking group pictures inside your home, you'll want a zoom that stays in the wide-angle range, like a 24–50mm. If you like to do head-and-shoulder

portraits as well as shots of small groups indoors, then a 35–105mm is a large enough range. If you are into sports and outdoor activities, you will want a zoom that goes at least to 200mm. Keep in mind that the larger the zoom range and the longer the telephoto, the heavier the lens will be. This is a concern if you need to lug your gear around or if you suffer from carpal tunnel syndrome.

New SLR cameras sometimes come packaged with a 28–70mm or 28–80mm medium-range zoom. These focal lengths cover many picture-taking situations, but they may not be what you want. If so, ask about substituting a zoom that matches your needs, or see if you can buy the body and lens separately.

## Lens Care and Cleaning

Camera lenses are precision instruments. Like camera bodies, they'll perform better and yield better images when they're handled correctly and properly maintained.

Always protect your lenses against dust and other elements by keeping both ends capped when not in use. A UV filter is a great way to protect your lens when the cap is off. Buy one to fit every lens you have. If you don't store your lenses in a zipped and padded camera bag, put them in lens cases to protect them from shock and dust.

Always check your lenses before shooting to make sure they're clean and clear of dust and lint. If they're not, here's how you can clean them:

1. Get a lens cleaning kit with the following: a blower brush or another type of soft brush, lens cloth (preferably not eyeglass-lens tissues, which can scratch lens surfaces), and lens cleaner.
2. Use the brush to clear dust or other particles away from the lens. Some manufacturers say you can use compressed air, but it's possible to blow dirt and dust into the lens with it if you're not careful.
3. Place drop or two of cleaning fluid on the tissue or cloth and wipe the lens gently. Microfiber cleaning cloths are great for this as they're

soft and lint-free when cared for correctly. Turn the cloth frequently to make sure you're using a clean part of it every time you wipe. Use more of a lifting than a wiping action. The idea is to clear the lens of particles and fingerprints, not to rub them in.

4. Use another lens cleaning cloth to do a final wipe of the lens, again using only clean areas of the cloth for each wiping motion. Use a cotton swab to blot any cleaning fluid that may have worked its way into the edges of the lens.

Don't use lens cleaning cloths for anything else but cleaning lenses. Doing so might pick up debris that could mar your camera lens. When they get dirty, wash them with liquid soap or detergent, and hang them up to dry so they don't pick up dryer lint. Never use other things—shirttails, napkins, paper towels, and so on—to wipe your lenses. This is absolutely the easiest way to damage them. (E)

*Chapter 9*

# Struck by Lighting

Many different factors go into making a picture. Of them, light is most important. Without light, there's no picture. It's as simple as that. No matter what kind of camera you have, you can create great photographs if you study light and learn how to use it. Likewise, the wrong lighting can just as easily ruin what you thought would be a perfect picture.

## The Power of Light

Simply put, light is the make-or-break factor in every photograph. Focus is important, of course, and so is composition, but even the best composed and most finely focused images won't make a great picture if the lighting is off.

Correctly lit photographs go beyond snapshots. They use the power of light to create moods and evoke emotion. They contain details and tones that are only possible to create by knowing how scenes should be lit and the lighting angles that create the best results. Because of this, professional photographers devote a great deal of time to studying light's qualities and to learning how to use it. This can be a lifelong study, but understanding some basic aspects of light will give you a good leg up on using it to the best advantage in your pictures.

**FACT**

You can learn a great deal about lighting by studying the work of other photographers. Take a look at the images created by such luminaries as Ansel Adams, Yousuf Karsh, Dorothea Lange, Edward Steichen, and Alfred Stieglitz, who were masters of light and composition.

## Shining Brightly

Whether you're dealing with natural light or light coming from manmade sources like lightbulbs or floodlights, its brightness, or intensity, is one of your most important considerations. The amount of light (brightness or intensity) is not the same as the quality of light. Brightly lit situations, either indoors or outdoors, are wonderful for shooting sharp, clear pictures as you can use slower film, smaller apertures and faster shutter speeds. But once you have adjusted your aperture and shutter speed to match the brightness of the scene, the quality of the light becomes the most important factor in making a great image.

Dimly lit situations require faster film, large apertures, and slower shutter speeds, which often result in grainy images that aren't as detailed as those taken in bright light. Scenes that are naturally low in contrast,

say a sand dollar on a pale sandy beach, may appear too washed out in flat lighting. You might be after a washed-out look (that is, one with limited tonal range). Then again, you might not. The good news is that you can add more light if you want to.

Naturally low-contrast scenes can be photographed without additional lighting, or you can increase the contrast by adding a strong light from any position that adds shadows that the camera will record. In most cases, you'll want a full tonal range from black to white, which means both brightly lit and shadowy areas in your pictures. You can use light in many different ways to create them.

Regardless of the relative brightness of a scene, it will always be illuminated by two basic kinds of light. Each of these kinds of light can be effectively used to make different types of pictures, even different types of pictures of the same subject.

# Directional Light

Directional light, whether it comes from the sun, a flash unit, or a lightbulb, is strong and full of contrast. The direction of the light determines where shadows and highlights will be, and how much of each will appear in the final image.

This kind of lighting casts heavy shadows and can create forceful pictures with strong impact and deep mood. Because it creates so much contrast, it can be difficult to properly expose film to capture the details in both light and dark areas.

## Front Lighting

Light from the front is the type of lighting we're most familiar with as so many pictures are taken with it. Shots with this kind of lighting don't have shadows. Since shadows create depth, pictures lit from the front also tend to look flat. People in front-lit pictures often look uncomfortable and squinty because the light is right in their eyes.

You'll see a lot of front lighting in old photographs as lenses and films were substantially slower, and it took a great deal of light to render correctly exposed images. Early photographers were told to shoot with

the light behind them so it would illuminate the front of their subjects. Today, front lighting is no longer necessary with most cameras. (The cheapest point-and-shoots, however, often do best with it.) However, since it's the type of lighting we're most familiar with, you'll still see it used in many pictures, and you probably use it yourself.

**FACT**

Front lighting is often referred to as flat lighting, which refers to the flatness caused by the lack of shadows in this lighting style. Side lighting is generally preferred for the added drama it brings. An example would be a shot taken when the sun is partly rising or setting (midmorning or midafternoon) and directly to the left or right of the subject. This sort of lighting gives subjects lots of depth.

**FIGURE 9-1**

*Photograph courtesy of Eliot Khuner*

◀ This backlit silhouette was created when the photographer exposed the shot for the background instead of the subject. Notice how the man's head is disproportionate to his body, making it look like it's going to fall off his shoulders.

# Backlighting

Backlighting puts the main source of light behind the subject, shining toward the camera. Backlit scenes can be extremely dramatic and beautiful, but they can also be difficult to expose correctly. If the camera's light meter only measures the light behind the subject, the subject will be underexposed and will appear as a silhouette, which may be the desired effect. If it isn't, readings must be balanced between the subject and the light behind it so that the front of the subject is properly exposed.

**FIGURE 9-2**

*Photograph courtesy of Eliot Khuner*

◀ In this backlit image, exposures were balanced between the subject and the background, resulting in a picture that still has a great deal of impact but that also shows the detail in the subject's face, hair, and clothing. See how his body has been turned so that the shoulder and arm are wider than the head, which gives the head more support. The arm is also a leading line, directing the viewer toward the man's face.

## Side Lighting and Crosslighting

Also known as split lighting, this effect is created when you take a picture with the lighting source at one side or the other. Since it illuminates one side of the subject, it can create fairly dramatic effects. Side light also emphasizes texture, shape, and form.

Crosslighting is created by using artificial light to shine on an object from both sides. It's often used in commercial product photography.

**FIGURE 9-3**

*Photograph courtesy of Eliot Khuner*

◀ This image is an example of side or split lighting. This dramatic lighting style, which splits the face into a dark side and a light side, works well in some situations. In this shot, some light bounced around the room and filled in the shadow areas, which can be seen on the print.

## Up-Lighting

Up-lighting is created when the subject is lit from below. This can create dramatic images, but is usually the least flattering for pictures of people as the main light for portraits should not come from below the horizon. Sunlight bouncing up from the pavement or other sources is not flattering unless your subject is looking down in the direction of the light.

**FIGURE 9-4**

*Photograph courtesy of Eliot Khuner*

◀ In this example, the subject's face is tilted down toward the light source to create a dramatic portrait. This photo was lit with a 150-watt bulb in a reflector bought at a hardware store. The reflector was aimed at a piece of white foam-core board placed on the floor, which reflected the light up to the subject's face.

**FIGURE 9-5**

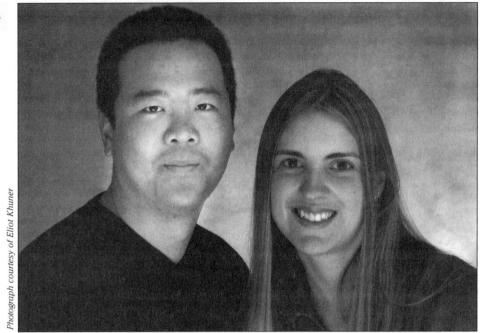

*Photograph courtesy of Eliot Khuner*

▲ An example of bad up-lighting. The up-light casts unflattering shadows on both faces.

## Down-Lighting

Down-lighting is created when the subject is lit directly from above. It's not flattering for most subjects, but some scenery, especially when captured from a distance, will look good with this type of lighting. When taking portraits, you'll find that down-lighting casts shadows under the subject's eyebrows and chin, making a person's eyes appear as dark splotches.

# Nondirectional Light

The opposite of directional light, nondirectional light is created when light comes from all directions and casts no shadows. It can be created naturally by mist or clouds in an overcast sky, or artificially, such as with

a sheet or a reflector covering the entire subject so that no obvious direction of light is evident in the scene.

## Diffused Light

Diffused light comes from a relatively large light source, such as window light, or light reflecting off your living room wall. Diffused light creates soft edges between shadows and highlights. It softens textures, lines, and contours. Don't confuse diffused light with nondirectional light. A diffuse light coming from the side is very directional and can produce deep shadows. But if you light your subject from the front with diffuse light, it fills in shadows, minimizes texture, and dulls highlights. The contrast in pictures taken in highly diffused conditions can be so soft that the images are almost dreamlike. This kind of lighting, since it softens features, can be useful for taking portraits of people who want to have their skin blemishes minimized.

**FIGURE 9-6**

*Photograph courtesy of Eliot Khuner*

▲ This touching image of a mother's hand holding her baby's foot was taken with sunlight that was filtered through a drawn curtain window, creating a diffused effect. The subjects were at floor level so that most of the light came from above.

### Disadvantages of Diffused, Nondirectional Light

As pleasant as diffused light can be for certain types of pictures, it can also produce dull images that lack detail. In extremely overcast conditions, the entire sky can act as the light source and completely remove shadows, causing images to look flat. Some shadows are usually desirable since they provide a sense of depth to images.

## Measuring Light

Automatic and point-and-shoot cameras usually have built-in light meters that will automatically measure the light's intensity and set the aperture and shutter speed to match it. These light meters are very good at giving you the right exposure in almost all situations. Your camera might not have a built-in meter, or the one it has might not work very well, in which case you'll want to use a handheld light meter. This is also a good option if you want to measure the relative brightness of different parts of a scene.

Light meters are about the size of a cell phone. They contain a light-sensing chip or cell, plus electronics that translate light intensity measurements into a display showing the correct aperture and shutter speeds. They meter incoming or incident light, reflected light, or both.

If your camera is giving you accurate exposures most of the time, you don't need a handheld meter. It will slow you down. On top of that, if you don't use it properly, your exposures may be less accurate than if you relied on your camera's meter.

### Metering Incoming Light

Incoming light, or incident light, is the light that naturally falls on a subject. To measure it, you put the light meter exactly where you plan to aim your camera. A light-sensitive chip, sitting inside a white translucent dome that looks like half of a ping-pong ball, measures the amount of light hitting the dome.

**FIGURE 9-7**

*Photograph courtesy of Eliot Khuner and Tom Minczeski*

▲ The light reading for this photo metered out at 1/125 and *f*/16. Note that the white sugar bowl photographed well, while the statue ended up too dark.

**FIGURE 9-8**

*Photograph courtesy of Eliot Khuner and Tom Minczeski*

▲ This is nearly the same photo except for having a black background. "F/13" means that the light meter wants the aperture set half way between *f*/11 and *f*/16.

Metering incoming light is a great way to preset shutter speeds and f-stops for action scenes. All you have to do is meter the scene before the action takes place. The meter will give you an f-stop and shutter speed that will correctly expose an average subject in the light you measured. If your subject is much darker than average, such as a black dog or a skier in a black suit, open your aperture a stop or two from the handheld reading. If the subject is very light, such as a polar bear or a skier in a white suit, you might stop down one stop or more from the incident light reading.

## Metering Reflected Light

This metering mode measures the light reflected from the subject. This is how all automatic cameras work, TTL or otherwise. Aim your handheld meter at the subject. If direct sun is hitting the metering cell, cast a shadow on it. The reading will be a combination of the amount of light hitting the subject, how much light bounces back from the subject to the meter, and how much of the scene the subject occupies. This is generally an accurate way to meter and set your camera.

There are times, however, that conditions can make a reflected meter reading inaccurate. Here are some situations you may encounter with the adjustments you can make to correct them:

- **Subject reflects light directly (like a window or a shiny surface on a building exterior):** Get closer, and either take an incident reading in the same light as the subject, or move to a spot where there is no direct reflection.
- **Subject is a very small part of the scene (like an actor in a spotlight on a dark stage):** Get closer, and use a spot or incident light meter.
- **Subject is backlit:** Get closer, and use a spot meter, an incident meter, or open up one to two stops from the initial reading.
- **Subject is dominated by black clothing:** Shoot as metered if the subject is the clothing, or take an incident reading if the subject is the person wearing the clothing.
- **Subject is dominated by white clothing (such as a bride wearing a**

**wedding dress):** Take a reflected reading of the dress only and open up one or two stops, or use the setting given by an incident meter held at the bride's position.

- **Subject is part in shade and part in sun:** The reflected meter should give an accurate reading if the meter is reading both the light and the dark parts equally. You might want to take incident or reflected readings in the shadow and the brightest portion, then set the camera halfway between them.

## Working with Directional Light

Directional lighting is great for composing photographs with lots of contrast. It's also useful for compositions in which shadows play a significant role. Any bright sunny day will yield all the light you need for directional lighting outdoors. The only problem might be that it may not be coming from the direction you'd like. In some cases, you can move the camera or walk around the subject to change front light to side light or back light. In others, you'll have to wait until the light itself moves before you can get the image you want.

**FACT**

Using directional light behind you (front lighting) is good for sports photography because there are no distracting shadows. Uniforms, not being shiny, will look wonderful, and the bright light allows a faster shutter speed. Sunlit scenery stands out against the sky, which appears a rich dark blue in relation to the brightness. Sunny cityscapes or landscapes often look their most colorful in early morning.

### Directional Light Behind Photographer

Putting directional light behind you in the morning or afternoon will give you scenes with the least amount of shadows. Contrast will come primarily from the natural contrast in the scene, rather than from the contrast between highlights and shadows. Matte surfaces, such as stucco, rough stone, or unpainted wood, may show more color saturation because direct, shadow-free lighting emphasizes color rather than texture.

Shiny surfaces, however, may have less color saturation as the direct reflections of the sun or light source dilutes the color with white light. You will get specular highlights (direct reflections of the sun or light source), which tells the viewer that the object has a shiny surface.

## Directional Light in Front of Photographer

When you face into the sun, you are looking at a backlit scene, which can be great for gardens, grass, and foliage in general. Backlit scenes are very dramatic, as the lines (such as hedgerows or roof lines) are lit up, emphasizing the lines and outlining objects. Because a backlit scene is naturally contrasty, backlit photos are usually not about shadow or highlight detail but about the quality of light.

This is a time of day when your metering can be inaccurate. If your camera does not have TTL (through the lens) metering, it may underexpose the scene, especially if the portion of the scene it is reading is significantly brighter than the subject. This is why some cameras have a backlight button, which increases exposure by one or two stops to make up for backlit subjects that would otherwise be underexposed.

In some cases, such as when taking pictures of scenes with water, a sun low in the sky creates strong, large specular reflections in the water and wet sand. If you expose for the subject, the strong backlighting will overpower the picture, causing flare. The solution here is to deliberately underexpose by taking a reading from the shiny part of the scene. You may want to overexpose one or two stops to keep the sun's reflection truly bright, but not so bright as to cause flare. This silhouettes (underexposes) backlit subjects and does so without losing the details on the bright surface of the water and sand.

If you're using an automatic camera and are photographing a scene dominated by the sky, set your exposure for the scene, not the sky and clouds. Use exposure lock while aiming your camera at the scenery, then keep it locked as you move the horizon to the one-third line in your frame. (The compositional "rule of thirds" is discussed in Chapter 11.)

## Directional Light to the Side

Morning and afternoon light appears as side light when you have your side to the sun. As previously mentioned, this type of directional light emphasizes texture, shape, and form. As you turn the way you point the camera, or walk around the subject, you can change the direction from which the light is coming to create the picture you want.

## Softening Directional Light

Directional light can be harsh, however, because it emphasizes texture and shine. Human skin tones, for example, are rarely flattered by direct light from the sun. Using a fill light (either a flash or reflector) will greatly improve your photographs of human subjects.

When you add light to a scene, whether by flash, reflector, or flood light, your pictures will look more natural if you don't create a second lighting pattern. One exception is back lighting, which is a very attractive and natural example of having two lighting patterns. Any subject that is lit from behind but still has light from the front is a candidate for a backlit shot. The viewer understands that one light source creates highlights from the back, while the front of the subject is lit by a second light.

Another way to enhance light outdoors is to bounce the sun off a piece of white board. You will get a more powerful bounce if you use a silver reflector, such as a board covered with foil or even a sheet of galvanized steel. Other options including stapling a white bed sheet or shower curtain to a fence or the side of a building, or hanging it from a rope or clothesline. All of these are dependent on direct sun hitting the reflector. If you can change the angle of the white or foil surface, you have more flexibility in where you place your bounce card and your subject. Human subjects will appreciate your using a white board instead of foil or metal, which can be almost as blinding as direct sun.

If you're working in sunlight with subjects that are close (5 to 15 feet) to the camera, use fill flash to put some light into the shadows. This

technique will let you properly expose for highlights, with the flash bringing light into the shadows.

## Working with Diffused Light

As previously mentioned, diffused light can be a benefit when shooting portraits. Softer light is almost always more flattering to people's complexions. However, because diffused light softens the edges of shadows, pictures taken with it also can end up looking bland. Along the same lines, because of its tendency to make objects appear less shiny, overly diffuse light can make human skin look deathly. When shooting outdoors, overcast or cloudy conditions will reduce color and contrast in most pictures. Any splashes of color, like a yellow raincoat or a brightly-striped umbrella, will stand out in these pictures, which can make for a nice image. Since large scenes shot with diffused, nondirectional light will lack impact, you might choose to devote any overcast days while you're on vacation to getting close-up detail shots.

**FACT**

There is a difference between diffused lighting and nondirectional lighting. All nondirectional lighting is diffused and low contrast. Diffused nondirectional lighting, such as foggy or overcast days, diminish contrast by eliminating shadows. Diffuse lighting coming from only one direction creates dark shadows with soft edges, which will make the image appear constrasty overall, but with a soft edge.

## Indoor Light

Indoor lighting differs from outdoor light in several ways. To use it well, you need to know how to work with these differences and use them to your advantage.

The most obvious differences between outdoor and indoor lighting are intensity and color. Without a flash, indoor light is usually five to nine stops darker than sunlight. This means that if you were using ISO 100 film outdoors, you'd have to use ISO 6400 film indoors with the same shutter

speed and f-stops. More likely, you'll use ISO 400 or 800 film for shooting indoors without a flash, which means larger apertures ($f/2.0$) or slow shutter speeds such a 1/15.

## Working with Ambient Light

Ambient light is the existing light in a room. It can be directional or not, depending on the source, and is created by lamps, ceiling lights, window light, light shining in from windows, and so on. Often, rooms are illuminated by several lights. Each casts its own pool of light, which means that each can serve as a main light if the subject is in that pool of light. The other lights then become fill lights or back lights for your subject.

You can choose how the various lights in the room will affect your picture through how you meter the scene. If you want to use one primary lighting source, and your camera is likely to include a source in the background, such as another light, a brightly lit wall, or a window, then either make a close-up reading of the subject with your camera and lock in the exposure, or take an incident light reading with your meter at subject position and set your camera manually. Make sure the shutter speed is fast enough for handheld work, or use a tripod or other object to steady the camera.

Classrooms and offices usually have overhead lighting, which is very even and often dull. Because of the lower contrast of this type of lighting, you're less likely to be aware of the shadows that it casts under eyebrows, and you may not see the generally muddy look it creates until you get your prints back from the lab. However, if you're photographing a large scene, such as an entire classroom or a large office space, you'll appreciate the evenness of the lighting. There will be no contrasty pools of light such as those you see in your living room.

## Throwing More Light on the Subject

Shooting with existing light both indoors and outdoors is called existing-light photography. You can also add artificial light, either with flash units or from other sources. For more on using flash for indoor photography, turn to Chapter 10. Lighting for formal indoor portrait situations is discussed in Chapter 16.

**FIGURE 9-9**

*Photograph courtesy of Tom Minczeski*

▲ A dark sculpture with a black background. Aperture and shutter speed were set automatically by the camera and resulted in a good shot.

## Working with Window Light

It's not totally accurate to characterize window light as indoor lighting. It's more like a specialized version of open shade. Window light is never direct sunlight streaming in the window. Your light will come from either the outdoor scenery or sky, or if there is sunlight coming in the window, you will cover the window with a translucent shade or curtain.

You can use color film and get accurate color with window light as long as no incandescent lights are overpowering the window light.

Control the quality of light by the distance of the subject from the window. The closer to the window, the larger the light source, thus the softer the line between shadow and highlight. As the subject moves away from the window, the contrast usually drops because the bright window light no longer overpowers the existing light bouncing around the room. But the main light becomes more directional because it's a smaller source of light.

# More Ways to Play with Light

Lens filters change the way in which light reaches the camera lens. They can be extremely useful for achieving better color, contrast, and detail in a variety of lighting situations. Some can be used to create special effects or even out lines and wrinkles in portrait work.

## Neutral-Density Filters

Neutral-density filters reduce light. They don't change the color of the light. Instead, they darken it by one to three f-stops, depending on the filter. If you're using fast film on a sunny day, and you're worried about overexposing a brightly lit subject, you can use a neutral density filter to control the exposure and still shoot with a slow shutter speed or a wide aperture. There's also a neutral-density filter that gradually goes from dark to light. You can use this to control overly contrasty scenes by toning down the difference between dark and light areas.

## Polarizing Filters

These filters make blue skies bluer, reduce and eliminate glare and reflections, and reduce haziness in both black-and-white and color shots.

**ALERT!**

Don't wear polarized sunglasses when shooting with polarizing filters. The polarized lenses in your glasses will interfere with the polarizing effect of the lens, and you won't be able to see how the image will look.

Polarizing filters come in two versions. The linear type is for use on manual SLRs. Circular polarizing filters work with the focusing and metering systems on automatic SLRs. Circular filters can also be used on manual cameras, but linear filters won't work with the systems on some automatic cameras. If necessary, you can use a linear filter if you manually set the exposure to compensate for it. (Instructions that come with the filter will tell you what adjustments you'll need to make.) You would also then focus the lens manually or use autofocus before attaching the filter.

## Enhancing Filters

Enhancing filters are used for enriching the saturation of certain colors, including reds, rust-browns, and oranges. They're specially designed to make these colors more intense while not affecting other colors in the scene.

## Color Filters

Primarily used when shooting with black-and-white film, these filters enhance certain colors in a scene by filtering out some colors and allowing others to pass through to the lens. Yellow filters, for example, darken the sky as they absorb the color blue. They also add definition and contrast to clouds. Red filters, which absorb both blue and green, make skies and clouds look even more dramatic. Color filters can be used with color film to create special effects. Color-balancing filters are also used to warm up or cool down the overall colors when shooting outdoors in certain situations. There are also color-balancing filters that let you use daylight film in unusual ways, like indoors without a flash or under incandescent light. Color-balancing filters would conversely also allow you to use indoor film (designed for use with floodlights) outdoors in sunlight.

**FACT**

Since the colors on print film can also be corrected to a certain extent when the film is printed, many photographers only use color-balancing and color-enhancing filters when they're shooting slide film. However, using color filters with print film will give you more control over the colors you get on the front end, lessening the amount of correction necessary after the fact.

## Star Filters

Star filters have etched lines on them that convert points of light into stars. Depending on the filter, the effect can be dramatic and very noticeable or finer and less obvious. They're useful for adding sparkling effects to water scenes or for calling attention to a specific aspect of an

image, such as the light reflecting off a motorcycle helmet or a crystal goblet.

## Soft-Focus Filters

These filters contain a special element that scatters the light reaching the camera lens. Images taken with them are in focus, but the details are softened, hence the name "soft focus." This effect is widely used in wedding and portrait photography to enhance complexions and smooth out wrinkles. They come in various strengths, ranging from subtle to dramatic.

You can make your own soft focus filter by putting a nylon stocking over your lens. Petroleum jelly also creates soft effects—put it on a clear lens filter instead of your lens. Some people even create soft images by breathing on their lenses and fogging them up.

## Chapter 10

# Flash Photography

Using a flash unit means more than shedding light on a dark subject. Not only does the light from a flash make it possible to take photos when the light is low, it can vastly improve the images you shoot in other situations. Many photographers tout flash as their favorite light source. Learn how to use it, and it might become your favorite as well.

## Learning to Love It

While many experienced photographers love using flash and use it all the time, many amateur photographers are less enamored with this particular piece of equipment. Such feelings are perfectly understandable when you consider how tricky it can be to learn how to use flash well.

Flash can make great photographs because it eliminates blur due to motion, and, important for shooting with color film, it has the same color balance as daylight. But it can also ruin pictures for two reasons: It only lights the scene for an instant, and (thus) it doesn't allow you to adjust the lighting or the scene to your taste. Unlike existing-light photography, you won't know exactly what the effects of using your flash will be until you see your pictures. In addition, camera makers place on-camera flash too close to the lens axis, which causes red eye when you're shooting people or animals. It also creates harsh shadows and high contrast, and often gives you overexposed subjects in the foreground while leaving things behind them cloaked in darkness. However, all of these problems can be overcome with some practice, thought, and extra equipment. Spend the time learning about flash. Practice using it, get the equipment necessary to use it well, and you'll make flash the best and most consistent lighting for your photographs.

**FACT**

Electric flash units vary in power. The more powerful the unit, the larger and heavier it will usually be. Flashes also range from the very inexpensive to quite pricy, so be sure to know what you want before paying for something you may not need.

## How Flash Works

Electronic flash units are fairly simple devices, consisting of a capacitor and a gas-filled tube. Batteries provide the power, which is stored in the capacitor until the shutter is snapped. Then, an electrical charge travels through the tube and makes the gas inside it glow bright white. At the same moment that the flash fires, the camera's shutter opens up, so that light from the subject (a mix of existing light and the flash) can flow

through the lens and onto the film. As soon as the capacitor recharges—usually in just a couple of seconds—the flash is ready to fire again.

The burst of light made by an electronic flash unit lasts only about 1/1000th to 1/10,000th of a second. This makes flash great for delivering sharp photographs as it eliminates blur caused by motion—either your own or the subject's. The light created by an electronic flash also has the same color balance as daylight, which is an important consideration when you're using color film.

# Types of Flashes

Most SLR cameras—especially automatic models—come with built-in flash units. When shooting in automatic modes, the flash generally switches on automatically when conditions are too dark for handheld shots or when a scene is backlit. In some modes, the flash has to be turned on by the user. Most also have a function called red-eye reduction, which shines a quick spot of light into the subject's pupils and makes them contract a bit before the flash goes off.

## Advantages of Built-in Flash

Built-in flash is handy to have, which is why most camera manufacturers include it. It guarantees that you'll have some flash capabilities no matter where you are. It's definitely the fastest and easiest way to capture fleeting moments. It also works well for balancing the light when taking portraits outdoors by filling in or adding light to shadows caused by the sun (that is, by acting as a fill flash).

## Disadvantages of Built-in Flash

Unfortunately, there are probably more disadvantages than advantages to built-in flash. While it's better than not having any flash at all, it's barely so. Here's why:

- Limited operating ranges, usually between 3 to 12 feet, mean that anything farther than the flash's maximum range will be underexposed.

Objects that are too close will be overexposed.

- Light is projected directly onto subjects, making them look flat and harshly lit.
- Mounted so close to the lens axis, they're notorious for creating red-eye.
- Can't be adjusted to create more pleasant illumination, such as bouncing the light off the ceiling to lessen shadows.
- Light reflects directly off subjects, meaning they often create flash glare from glasses or even skin if it's shiny enough.

## Going Beyond Built-in Flash

An accessory flash unit is a must-have if you're serious about taking good pictures. This unit attaches to the accessory shoe (also called a hot shoe) on top of a camera or to a flash bracket that attaches to the camera. Accessory flashes are not only more powerful than built-in units, they're also vastly more versatile. You can make their light more diffuse by aiming them upwards or sideways. You can take them off the camera and move them anywhere you want. They also make possible a variety of special flash techniques that are far beyond the capabilities of built-in flash.

There are three different types of accessory flash units:

- **Manual:** As the name indicates, these flash units require you to figure out the correct exposure for your shooting conditions. Because the duration and intensity of the flash from a manual unit doesn't change, you have to adjust lens apertures to control the amount of light that reaches the film. Aperture settings are determined by dividing the flash's guide number (which indicates the flash's light output) by the distance to the subject. The resulting number is the correct aperture. Most manual flashes have calculator dials or scales for making these calculations.
- **Automatic:** These flashes use automatic sensors to control light output and duration based on the distance from the camera to the subject. When you set the aperture you want to use, the flash will automatically calculate how much light is needed to illuminate a

specific distance range, such as 3 to 15 feet. Or, the flash unit will have an electric eye that reads the amount of light bouncing back from the subject. When the correct amount of light has been reached, the flash is turned off. Most automatic flashes have several different range and aperture settings and can be set manually as well.

- **Dedicated flash units:** Want to remove virtually all the frustration from flash photography? A dedicated flash will do this and more. They're made to work with your camera's specific electronics (hence the name), and they'll do all the thinking for you, automatically setting the correct shutter speed and aperture and controlling the exposure by regulating flash duration (that is, its intensity).

## QUESTION?

**If I'm using an automatic or dedicated flash, do I need to know how to calculate flash exposures?**
It may seem like an archaic skill in our automatic world, but even the automatic exposure controls on the most sophisticated flash units aren't perfect. There will still be times when you'll use your flash's manual setting, which is when understanding factors such as distance-to-subject and f-stops will definitely come in handy.

Many photographers prefer to keep their flash units on top of their cameras when using them. It's faster, more convenient, and it guarantees that some image will be captured on film every time you squeeze the shutter button. However, using your flash like this usually doesn't result in the best images. In fact, unless you redirect the flash head away from your subject, your pictures will look very similar to those taken with built-in flash.

There are times when shooting with the flash on-camera can work pretty well, such as in situations needing fill flash or, as mentioned, when you diffuse the flash by aiming it at the ceiling or a wall. However, you'll get better pictures if you move the flash away from the camera lens. If you have a flash cord, you can take the flash off the hot shoe, connect it to the camera with the flash cord, and hold it anywhere you want. You can attach it to a light stand, a clamp, or even have a friend hold it.

Mounting the flash on a bracket that attaches to the camera is another popular option. This also requires a flash cord to synchronize shutter and flash operation.

## Synching Up

As previously mentioned, the burst of light emitted by a flash unit is exceedingly short, ranging from 1/1000th up to 1/10,000th of a second and even faster. To capture such quick bursts of light, the shutter's operation must be synchronized with the flash so that it's fully open at the exact moment that the flash goes off. If it isn't, only part of the image or nothing at all will be captured on film.

Cameras with focal-plane shutters (almost all SLRs are in this category) only sync at certain speeds. (Cameras that use leaf shutters, which expose the film in a different way, work with flash at all speeds.) This doesn't mean you can't use shutter speeds other than the sync speed when shooting with flash. The flash will also sync with slower shutter speeds than the sync speed. Using those speeds will let in ambient light in addition to the flash. Higher speeds, however, will be out of sync with the shutter.

**FACT**

Some dedicated camera/flash combinations will work together even at very high speeds. The flash fires several times during the exposure, with each flash exposing a new sliver of film showing between the two shutter curtains, creating the image slice by slice.

If you're using a dedicated flash unit, you don't have to worry about flash sync as the system will do it for you. Most systems will choose the fastest possible shutter speed to lessen the amount of ambient light hitting the film. You'll have to manually set the shutter speed to override this if you want exposures with ambient light as well. With automatic flash units, just attach the flash to the camera and set the shutter speed dial to the proper sync speed (you'll find it in your camera's manual).

Dedicated flash units can have a number of special functions, including high- and low-speed sync, automatic fill flash, repeat flash, exposure bracketing, remote flash, and so on. Reading the instruction manual thoroughly—and often—is essential for learning how to use all of them.

## Using Your Flash

As previously mentioned, a good accessory flash unit can be used in a variety of different ways. It can improve lighting conditions in virtually every situation and allow you to create some special effects as well.

## Flattering with Fill Flash

This technique adds light to shadows to create more balanced exposures. It also throws light onto the foreground of backlit areas to keep images from appearing as silhouettes.

The secret to good fill-flash photography is to balance the light from the flash with the existing or ambient light. The ideal fill flash setting will provide just enough light to bring the shadows within one or two stops of the highlights. Good flash and camera systems will automatically do this, or you can do it yourself.

You can use fill-flash techniques in a couple of different ways to augment or correct existing light. The following sections provide some tips on how to do it.

### It's a Bright Day

You're taking a picture of some kids at a school picnic. The sun is directly overhead, lighting up the tops of their heads and casting unflattering shadows under their eyebrows, cheeks, and noses. Set the camera to expose the sunlit faces correctly, and set the flash to go off about one or two stops less than the ambient light. This technique fills in the shadows but isn't the main light source.

### Backlit

You're taking a picture of your aunt and cousin while they're visiting San Francisco. The Golden Gate Bridge is sunlit in the background, and your relatives are in a shady spot. Set your camera to expose properly for the bridge, and the flash to expose properly for them. You may want to bracket your exposures by slowing the shutter down one stop to make the background brighter, and then, if you can, bumping it up to a faster setting to darken the scenery. Changing the shutter speed won't change the lighting on your relatives because they're only being lit by the flash. In this case, the flash fills in the entire subject but is equal to the ambient light. Because the subjects would otherwise be in shadow, the flash is the main light for the subject.

### Indoors with Nice Lighting

You're at an evening wedding reception in a hotel ballroom. The bride and groom stop to visit at your table, and you want to take their picture. The room is comfortably lit, but not bright. You're shooting ISO 400 film. You want the shutter to stay open long enough to capture some of the warm ambient light in the room. Choose a large f-stop, say $f/2.8$ or $f/4$, match the flash to the f-stop (which an automatic camera will do), and make sure the shutter stays open for 1/15th or 1/30th of a second. The room will not come out bright but will look warm and friendly. The happy couple will be properly exposed by the flash and not blurred despite the long shutter speed. The reason is that most of their image was put on the film by flash illumination, which will be much brighter than the ambient light.

You can use an accessory flash or a built-in flash for fill-flash pictures. Check your camera manual for information on how to adjust exposures when using built-in flash.

## Bouncing Off the Walls (and Ceiling)

Accessory flashes are adjustable, which means you can change the direction of the flash by tilting or rotating the flash head. This technique, called bounce flash, eliminates the flat contrasty "deer in the headlights" look that direct flash so often delivers. You'll still get good illumination,

but the light will be indirect and softer, which makes for much more pleasing pictures.

To set up a picture with bounce flash, rotate the flash head up toward the ceiling or to the side so it faces a wall. Low ceilings work best for this; so, too, do walls that are close to your subject. If either is too far away, the bounced light might not be strong enough to provide adequate illumination. (Using bounced light always requires that you increase exposures by several stops as some of the light is absorbed or scattered when it hits the other surfaces.) If this is the case, you'll need to use a wider aperture or faster film. If you have a connecting cord, you can take your flash off the hot shoe and move it closer to the reflective surface.

**FIGURE 10-1**

*Photograph courtesy of Eliot Khuner*

◄ Image taken with direct flash. Note the harsh lighting and the strong shadow behind the subject.

**FIGURE 10-2**

*Photograph courtesy of Eliot Khuner*

▲ Aiming the flash up towards the ceiling to achieve a bounce flash.

**FACT**

You can also bounce flash by attaching a bounce light reflector to the head of your flash unit. The flash will then bounce off the reflector onto your subject. In a pinch, a white card taped to your flash will also work as a reflector.

It's important to aim bounce flash correctly so that the light falls on your subject, not behind it. If you aim the flash at the ceiling directly above your subject when taking a portrait, you might create "raccoon" shadows under his or her eyebrows.

**FIGURE 10-3**

*Photograph courtesy of Eliot Khuner*

◄ Image showing the results of using a bounce flash off the ceiling.

## Using More Than One Flash

You can use multiple flashes to light a picture. A photo slave, which costs as little as $20 to $30, senses another flash firing and instantaneously triggers the flash it's plugged into. If you have a flash meter you can measure the output. Or, if you use a second flash that has its own sensor, you can aim that second flash at the subject from just about any position that lights up the subject well. Set the off-camera flash at say *f*/8 or *f*/5.6, and set your on-camera flash at one to two stops less.

A photo slave will fire every time it senses a flash going off, so if your camera uses a flash burst to reduce red-eye, the slave flash will also go off too soon. If you're not the only one in the room with a flash, it will fire whenever anyone else takes a flash picture.

**FIGURE 10-4**

Photograph courtesy of Tom Minczeski

▲ Photo slaves. They detect any nearby flash and set off the flash units they're plugged into.

## When a Good Flash Goes Bad

Because flash is too brief for us to see how the illumination will look in the photograph, it's easy to take bad flash pictures. When the flash is much more powerful than the ambient light, backgrounds go dark. Mess up an exposure calculation, and subjects nearest the lens are blown out (overexposed). Strange reflections creep into shots when you least expect them. The nice portrait of your mom ends up making her look like a raccoon. The long shot of your friends at the beach that you thought your flash was powerful enough to illuminate instead features an out-of-focus blob that was probably the sand dune in front of them.

The solution to bad flash pictures like these is to keep taking them. Practice means everything with flash photography. Over time, you'll learn what works and what doesn't work. You'll hone your techniques and learn how to move your flash around or adjust its settings to take better advantage of what it can do.

In the meantime, here are some suggestions for troubleshooting some of the more common problems that erupt with flash photography.

## Bad Reflections

Flash travels in a straight line in all directions and bounces off objects, walls, mirrors, and windows. If you're shooting a subject in front of a window, or through one, you must move up, down, right or left until the flash doesn't reflect back into the camera. If you can set off your flash without taking a picture, look through the viewfinder and pop a flash. Watch for reflections in windows, glasses, framed pictures, and even glossy paint.

Generally, you can avoid these sorts of reflections by not photographing straight into a wall. Set your subject up so that you are shooting at a 30–45° angle to any reflective surface. If you absolutely have to be directly in front of a window, try lowering the camera to see if you can get the subject to block the reflection. When two mirrored or shiny walls meet at a right angle, they will always reflect directly back to the camera, no matter what angle you select.

## Eyeglasses and Flashes

Some people wear glasses with special nonreflective coatings. If the person you're photographing wears the old-fashioned reflective type of lenses, try the following:

- Lowering or turning the subject's head until the reflection disappears.
- Raise the arms of the glasses, which will tilt the lenses down without the subject having to drop his or her chin.
- Taking the glasses off.

You can prevent some conflicts by making sure glasses are pushed all the way on so the top rim doesn't cast a shadow on the eyes. After you pose your subject, set off a test flash while you look through the viewfinder for objectionable reflections. This may take a few tries if you're shooting multiple subjects wearing glasses.

## Incorrect Exposures

Automatic cameras that sense the flash coming back from the subject can be fooled by subjects that are very light or very dark. This cannot always be prevented, but one simple trick will give you a better chance of getting it right: Eliminate any large gaps between your subjects if you're using an automatic flash. The sensor might be aimed at the empty space between your subjects. If that's so, the sensor will tell the flash to stay on until that faraway empty space is properly exposed, baking (overexposing) your intended subjects in the process.

However, if you try to block the gap by putting your subjects against a wall, you'll get dark shadows behind them, courtesy of your flash. No matter how high or low you place the camera, there will always be a shadow behind the subject that the camera will probably pick up. This a good reason for using a slow enough shutter speed so that the ambient light can fill in the objectionable shadow.

It's generally not a good idea to put a wall closer than 4 feet behind your subject, as the texture and shadows on the wall compete with the subject. Placing your subjects away from a wall will allow the flash to fall off (decreasing the contrast of the shadows) and will cause the wall to go out of focus.

## Weak Lighting/Flash Fall-Off

Automatic flashes work best over a certain range that varies depending on the speed of film used, the largest aperture of the lens, and the power of the flash. The reason many flash pictures don't work is because the photographer underpowered the flash as a result of having the wrong combination of film speed, aperture, and power for a great distance. If you want to double the effective power or distance, you have to get a film that is four times as fast. Changing from ISO 200 to ISO 800 doubles the distance at which your flash will work.

The light from your flash diminishes (falls off) as it travels away from your flash. This means that a point far from the flash will get less light

See pages 251–253

See pages 57–60

See page 176

See pages 232–233

See pages 214–215

See pages 184–187

See pages 161–162

See pages 155–158

See page 212

See pages 121–122

See page 117

than a point near the flash. If a subject is beyond your flash's range, chances are you won't see it at all in the picture. The best way to avoid these shots is to know what your flash's effective range is and staying in it. If you know your flash is too weak for a certain situation and you can't move it closer, try using a slower shutter speed to allow more ambient light to enter your lens.

## Using a Flash Meter

If you're using a manual flash or you're not sure that your automatic flash is giving you consistent exposures, you might find a flash meter very useful. A good flash meter will cost $200 or more. Don't waste your money on an inexpensive model. Your flash meter should also be able to function as a regular light meter, so you are getting two meters in one. Make sure it uses a penlight or nine-volt battery, not some expensive battery only available at camera stores.

## Buying a Flash

If your camera has a lot of automatic flash functions, get the matching brand name flash. Owning that matched flash allows you to get all the benefits of investing in that automatic camera. It is worth the extra money. Also, if your camera-flash combination isn't working, you only have to turn to one warranty service center for the fix. Flashes made by the camera's manufacturer for your automatic model are the best bet. Instruction manuals for your camera probably will include references to specific flash models that work with that body.

If you lean toward manual functionality, get a simpler and more powerful flash made by any manufacturer.

## Flash Care and Feeding

Flash units, just like cameras, should be kept in cool dry places when not in use. If you're not planning on using your flash for a few weeks or

more, take the batteries out to avoid damage from battery leakage. This doesn't happen very often, but when it does it can cause serious damage to delicate equipment.

If for some reason you won't be using your flash for a longer period of time, keep the capacitor working properly by firing it up once a month and discharging the flash a few times.

**FACT**

A flash unit with properly charged batteries should be ready to go fairly quickly after you turn it on. If yours doesn't perform properly, try cleaning the contacts on the batteries and the flash—if they're dirty or corroded, they can affect performance.

*Chapter 11*

# Taking Good Pictures

Good pictures might look effortless to create, but they very rarely just happen. More often, they're the result of some careful planning and knowing what goes into making a good photo. Learning these techniques allows you to express yourself and make pictures that people want to look at.

## What Makes a Good Picture?

Good pictures have an impact on the viewer. They express feelings and tell truths. Through such factors as good lighting and composition, they clearly express their meaning as well as the intent of their creators.

You communicate meaning and intent by how you use such elements as color, contrast, shapes, lines, perspective, light, and texture in your pictures. In a good picture these elements work together to tell your story, your idea, and your emotions. When they're not in balance, you can't tell what the picture is about. When a picture has a mistake in its composition, looking at it is like listening to a sentence in which the speaker accents the wrong words, misplaces punctuation, mispronounces words, or ends abruptly. You may not know exactly what's wrong, but your senses tell you something's not right.

Learning the techniques behind the creation of good pictures expands your creativity and expressiveness. Think of it as learning a new language that gives you the tools to say exactly what you want to say and new ways of expressing who you are and what you think—through the lens of your camera.

**FACT**

There is never only one way to take a picture. Learning to express yourself as a photographer means experimenting with all aspects of picture taking. You can choose to use good technique or deliberately abandon it.

## Basic Elements of Composition

Composition is the arrangement of shapes and lines within a two-dimensional image. If you're taking a picture of a lamp you want to sell on eBay, you'll want to use the simplest composition possible. You're not trying to communicate how you feel about the lamp, you're just presenting information. So you center that lamp right in the middle of your frame. This type of composition is static. It doesn't move, it doesn't coax the viewer to look at it or explore it. Nor is it particularly pleasing.

Good composition makes photographs more attractive and compels others to look at your pictures. Get to know the basics of good composition well, and you'll automatically use them every time you look through your viewfinder.

# Center of Interest

The most successful pictures are composed around one main point of interest. Whatever it is—a group of trees, your best friend shooting pool, your daughter playing with her new kitten—it is the main subject of the photo.

Having a strong point of interest or main focal point in a picture draws the viewer's attention and focuses it on the point you want to make. Compose a picture with more than one strong focal point and you'll confuse the viewer and make the picture's message and meaning less clear.

The point of interest doesn't have to be just one person or one object. However, the other objects in the picture shouldn't detract from it.

## Placing the Center of Interest

Putting the center of interest smack in the middle of a picture is an effective way of focusing the viewer's attention on the picture's subject, but it's also just about the most boring way to compose a picture.

It's almost always best to put your center of interest somewhere else besides the center of your frame. Simply moving your subject off-center is one way to create a pleasing composition. Putting it at one of the power points of the frame is even better.

## Going to the Points

This is a very simple compositional tool. Imagine a tic-tac-toe board on your blank composition that divides the frame into thirds horizontally and vertically. The four intersections where the lines cross are your power points.

A single object can go at one of the power points. Place a vertical object (a seated or standing figure, the doorway of a building, a tree) on either of the two vertical lines. A horizontal form (long building, horizon, reclining figure) goes on one of the horizontal lines.

If you have two subjects—a car and its owner, or a distant mountain and a nearby hiker for example—use one power point for the main subject (what the picture is about) and the diagonal power point for the secondary subject. This is a simple example of composition expressing a definite relationship between objects.

**QUESTION?**

**Can I put two unrelated objects on two diagonal power points?**
Yes, but you might want to think twice about it. Doing so can make a photo that doesn't succeed. However, this type of composition can also tell the viewer that you see a relationship between two seemingly unrelated objects and want to express it.

## The Rule of Thirds

Dividing the image area into thirds for the purpose of placing the center of your subject is also called the rule of thirds. This rule also governs where you should place your horizon line in scenic pictures. Putting it at the center is just like putting your main subject there.

Your picture will be vastly improved if you move the horizon to the upper or the lower third of the frame. Avoid cutting your pictures in half by having the horizon in the middle of the picture. When you want to accent spaciousness, keep the horizon low in the picture. When you want to suggest closeness, position the horizon high in your picture. Also, make sure it's level.

If your composition includes strong vertical lines, such as the edge of a building, it's better to place them off center. Use the rule of thirds to guide their placement as well.

The rule of thirds can also be used to compose pictures when subjects are moving. You typically want anything that's moving through the frame—a car, a running animal, a cyclist—to have space to move into.

How much space will depend on the overall composition of the picture, but you don't want the object to be so close to an edge that it looks like it's moving right out of the frame. Use the rule of thirds to put space in front of the subject to move into. Subjects moving towards or away from the camera also need room to walk into.

**ALERT!**

It's also generally a no-no to have a single subject looking out of a picture frame. When your single subject is not looking directly at the lens, she will need room in the frame to "look into." Put the subject off-center to leave room for the subject's gaze.

## Following the Lines

Lines in a picture can be used to draw the viewer to the subject or to create feelings and moods. Lines can be as concrete as the corner of a building, a footpath across a lawn, a long brick wall, the broad steps of a public building, architectural columns, an overpass, a bridge, the top of a tennis net, or the banister of a stairway. Lines can also be created by allowing the viewer to visually connect a repeating pattern in the image, like looking down a row of trees, a row of people watching a sporting event, or a row of chess pieces.

Body parts form lines. Arms akimbo are compositional diagonals. Arms hanging down create vertical lines. A subject standing with feet together creates a single vertical block, while a figure standing with feet far apart creates two diagonal lines.

### Static Lines

Static lines are straight lines placed either horizontally or vertically in a picture. They denote stability, lack of change, and lack of movement.

Horizontal lines suggest peace and calm. Vertical lines suggest elegance, strength, and majesty. Architecture with strong and long vertical lines, such as the Gothic cathedrals of the sixteenth century, suggests a connection with heaven above that was permanent. When viewed from the ground the parallel lines converged, implying that being in or near the church moved you toward heaven.

**FIGURE 11-1**

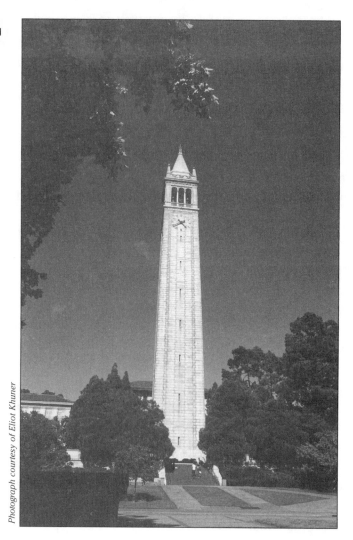

*Photograph courtesy of Eliot Khuner*

◀ This picture of Sather Tower at the University of California, Berkeley, is composed statically with the tower in the center of the picture. Framing the image by including the limbs of a tree in the foreground improves an otherwise boring composition.

If you photograph a square or rectangular building straight on, keeping the vertical lines parallel will create a picture composed mainly of vertical and horizontal lines. It has no movement. It tells the viewer that there is no change happening, that this building has been here a long time and will stay a long time, which is often exactly what the picture is meant to suggest.

Straight lines become less static when they converge. Forcing the perspective by tilting your camera makes the lines come together and gives your picture movement and depth. Changing your shooting angle can also make horizontal lines converge to convey perspective and depth.

**FIGURE 11-2**

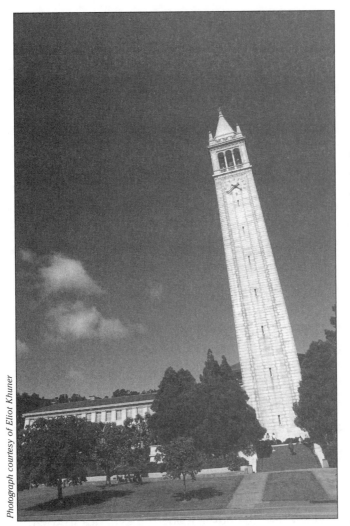

*Photograph courtesy of Eliot Khuner*

◀ Another view of Sather Hall, taken from a slightly different perspective. In this shot, the tower is positioned off center, and the camera was tilted to make all parallel verticals converge at the top. If the tower were straightened and kept on the right side of the picture, the other buildings would have a distracting tilt.

## Dynamic Lines

Dynamic lines move on the diagonal and suggest movement and energy. They also suggest tension and distance (think of diverging parallel lines that show perspective). They may appear naturally in a picture, or you can create them by changing camera angles. Shadows can form diagonal lines, which you can use to show relationships and bring the viewer into the picture. They also occur when you place subjects on two diagonal power points in a frame.

## Graceful Lines

Curved lines are graceful and often restful lines. They lead the eye into the picture gently and gracefully. If you want to show a baby at rest and being nurtured, photograph the baby in a parent's curved arms, a very natural position and composition.

"S" curves are probably the most visually pleasing elements you can capture in a picture. Keep your eye out for these classic "S" curves:

- **Roads:** Highways and byways often create "S" curves as they meander through landscape shots. An "S" curve in a road viewed at a distance from a hill is a photograph waiting to be captured.
- **Bird necks:** The curve of a bird's long neck is a good example of an "S" curve eager to be photographed.
- **Farm fields:** Furrowed fields, rows of corn, acres of sunflowers—there are "S" curves to be found here as well.
- **Streams and rivers:** Waterways often form natural curves. If they're slight, you can try emphasizing them by using a telephoto lens, which will compress the distance between the curves.

An "S" curve is strongest when elongated and perhaps tilted, producing a diagonal line that has two curves in it, such as the view of a edge of a nicely shaped swimming pool as seen from one end.

If you're fortunate enough to find an "S" curve to photograph, put your subject where the curve leads the eye, not in the middle of the curve itself.

## Finding the Golden Triangle

As previously mentioned, lines can also be created when the viewer visually draws them between points in a picture. When the lines connect, they create geometric shapes that can also affect a picture's composition. The photographer's favorite is a triangle.

A compositional rule called the golden triangle is another that results in good pictures. It's generally used to compose portraits although it works equally well when photographing groups of people or objects.

Let's say you're taking a picture of three people. Elevating the middle person forms a triangle. This is good. What if you instead you were to elevate one end person. Does this create a triangle? Not really. It makes a bent line or an "L," generally not pleasing shapes.

Now imagine photographing four people. If you put them in a straight row, you'll create a static composition. If you raise the first and third person you create something that looks a lot like two connected triangles or even a flattened "S" curve, which are also pleasing arrangements.

When you photograph groups of objects, look for imaginary lines to connect them into triangles—not right angles, vertical lines, horizontal lines, or a jumble of shapes. One easy rule for groups is to never position two heads at the same level.

**FIGURE 11-3**

*Photograph courtesy of Eliot Khuner*

◀ This picture of a bride and her flower girl is a perfect example of how lines can be used to create balanced, pleasing pictures. The outline of the subjects creates a triangle, which focuses the eye in toward the picture's main focal point. The placement of the flower girl's arm also draws the eye away from the bouquet, which could have been a distracting element if the picture had been composed differently.

## Leading Lines

FIGURE 11-4

*Photograph courtesy of Eliot Khuner*

▲ In this portrait, the musician's bow forms a leading line that brings the viewer's eye to where the face and violin meet.

A leading line is a very powerful compositional element that leads the viewer's eyes into the picture and to the subject. It can be a structural line, such as a long curb, a wide staircase, the top of a wall, or the planks of a park bench. Or it can be something more bucolic, such as a plowed field, the stem of a flower, or even lines of breakers at the beach. Strong shadows can also create leading lines.

A good way to envision the power of leading lines is to analyze their opposite. Visualize a person standing in front of the camera, arms at his side. The vertical lines of the arms lead your eye down, out of the picture. Vertical lines that drop down from a subject and lead to the bottom of the frame draw a viewer out of the image, draining the energy out of your picture.

Place your subject at the end of a leading line for the greatest visual impact. Avoid putting your subject in the middle of the line—this bisects the line and diminishes its strength.

**ALERT!**

Avoid stacking people in front and behind of each other when you're taking group shots. This "totem pole" posing creates an unpleasing vertical line. You can improve it by creating a triangle— one person in front, two behind, and so on.

## Working with Repetition and Texture

Multiple parallel lines that converge on your subject lead the viewer powerfully into the image. Parallel lines that converge at a distant point create perspective. What about parallel lines that don't converge and don't lead out of the composition? These are examples of textures or repeating patterns.

Like other compositional elements, textures can be the subject or theme of a photograph, or they can be the background of a picture. Repetition, which could almost be thought of as texture on a different scale, generally pleases the eye. A distant view of a plowed field might show texture, but a closer view might become a repeating pattern, while closer still might become texture again.

As you read in Chapter 8, a telephoto lens can capture repeating shapes, such as several ridges of mountains, cars in a traffic jam, or distant skyscrapers receding from the camera while minimizing perspective-inducing converging parallel lines. Because the telephoto lens enlarges these distant similar objects, you don't perceive depth but instead enjoy the repetition of shapes.

Textures and patterns can also be distracting. If their shape causes a lot of contrast, they can overpower pleasing compositional elements such as triangles, similar shapes, and curved lines. In portraiture especially, clothing with a strong pattern distracts unless the picture is about the clothing.

Look for repetitions and textures when you're shooting. Consider how they can strengthen or distract from the picture. If the picture is about these elements, think about ways to emphasize them, including the following.

- **Perspective:** Where you shoot from can greatly change what patterns and textures look like. If you happen across a shot that looks just right, take it from that spot. But don't stop there. Move in, move out, move your camera up or down to see what other pictures you might be able to capture from different perspectives.

- **Lens selection:** Just about any lens will work for capturing patterns and textures. As previously mentioned, a telephoto lens will compress the distance between objects and make patterns appear more distinct. Shooting with a telephoto zoom lens will allow you to crop the frame without having to move your shooting position.

- **Lighting:** The direction of the light affects the appearance of texture and pattern. Light coming from the back or the sides will emphasize both. Front lighting tends to reduce texture and pattern as it flattens the light and erases shadows. Bright daylight also helps accentuate textures and patterns as it creates stronger shadows than diffuse light.

**FACT**

As a photographer, you look for and/or create the elements of light and contrast that will show the shape and form of three-dimensional objects in your pictures. By changing your position relative to the object, you change the direction of light in your photograph as well.

## Using Color Effectively

Color can either be a picture's best friend or its worst enemy. Bright colors can attract the viewer, but having too many different colors in a picture can disrupt its balance and rhythm. Pictures can be about color, just like they can be about texture and pattern, but color can also interfere with these elements and confuse the viewer.

A color photograph is usually a more accurate portrayal of your subject as an observer would see it. Use color film when color is the subject of the picture or reinforces the theme or subject. If color will detract from these elements and distract the viewer, think about switching

to black-and-white film, which will put more emphasis on other compositional tools to help you tell a subtler, more personal, or more direct story.

# Using Point of View Effectively

The components of a good picture include composition as well as light and form. By choosing where you put your camera, you modify them to tell your story.

The perspective, or point of view, that you choose for taking your picture can mean the difference between a snapshot and a picture that involves and moves the viewer. It can alter the scale of a picture and change how images and elements are emphasized.

You may need to move your camera only a few inches or a few feet to change the composition. Imagine being at a baseball game, photographing the pitcher from the sidelines. Choosing a low camera angle would emphasize the rise of the mound, while the rest of the setting—the field, the stadium, the surrounding scenery—would be a small part of the picture. Choosing a different point of view that takes in these other elements minimizes the impact of the pitcher's mound.

Don't just walk up to a subject and snap. Walk around and look at it from all angles, then select the best camera angle for the photo.

Here are just a few ways to alter point of view:

- **Shoot low:** Lowering your camera to ground level creates a worm's-eye view that can suggest a subject is larger than it is. Outdoors, this can provide an uncluttered sky background. Shooting buildings from a low position will cause their lines to converge and make them look more imposing.
- **Shoot high:** Shooting from a high angle will keep most or all of the sky out of your picture.

- **Horizontal versus vertical:** The vertical/horizontal question affects the lines, the sweep, and the size of the sky. Vertical composition, by showing more foreground, can emphasize perspective. But horizontal composition, with a different foreground and a lower camera angle, does it too. Always ask yourself which orientation crops out distractions.

**FIGURE 11-5**

*Photograph courtesy of Eliot Khuner*

▲ This horizontal composition of the Golden Gate Bridge emphasizes the length of the bridge and how it sweeps across the water.

**FIGURE 11-6**

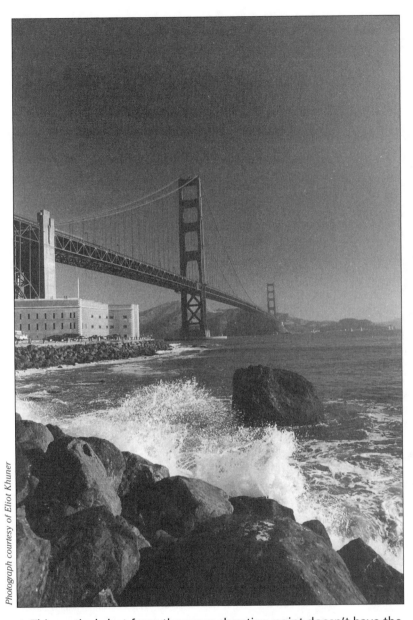

*Photograph courtesy of Eliot Khuner*

▲ This vertical shot from the same shooting point doesn't have the same power as it truncates the bridge. Note that both this and the previous image were taken with the camera held level and with the horizon positioned at the halfway point. This keeps all the vertical lines parallel.

**FIGURE 11-7**

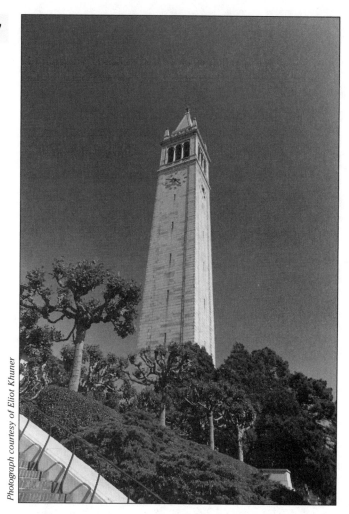

Photograph courtesy of Eliot Khuner

◀ This photo of a tower taken from a lower point of view emphasizes its height.

Even if you're limited to shooting from a single spot, such as a vista point along the highway, you still have options for your point of view. Placing the horizon very close to the top of the frame expresses your point of view that the land is large and the sky is small. Swinging your camera from right to left as you frame the photo also changes your point of view. Ⓔ

## Chapter 12

# Improving Your Images

Sooner or later, the day comes. You look at some of the pictures you've taken and you think you can do better. And you're right; you can. One of the best ways to learn how, of course, is to keep taking pictures. But looking at what you've already shot with a critical eye will also help you learn what you can do to get those better shots the next time you have your camera in your hand.

## Taking Your Pictures to the Next Step

While there are techniques that produce more pleasing images than others, there really is no right or wrong way to take a picture. However, as your photography skills evolve, you'll probably find that your taste will change, and compositional, contrast, focus, lighting, and cropping decisions that you make today might seem stale or downright primitive.

Photography is very much a "learn by doing" process, and many of the changes you'll want to make in your images will come naturally as you continue to snap that shutter. Here are some things to keep in mind as you do.

## Fill the Frame

Most beginning photographers, and, frankly, even a fair number of photographers who have been taking pictures long enough to know better, don't get close enough to their subjects when shooting. As a result, their pictures have too much space around the subjects.

If you practice cropping through your viewfinder, you can overcome this problem pretty quickly. This practice will also result in better quality negatives that are easier to print because you won't have to enlarge your pictures and then physically cut them down to create the images you want.

The next time you're shooting, take an extra moment before you press the shutter button. Check all four edges of the frame in the view-finder. Crop out distractions at those edges. Move or zoom in so that the subject fills up as much of the frame as possible.

You can see the effects of cropping on your pictures without actually cutting any of them. Make two L-shaped pieces of poster board or another type of flexible cardboard (such as an old cereal box). Use them to form opposite corners of an adjustable rectangle. Place them over your 4" x 6" prints to see how making changes to the way you take your pictures might improve them.

It's possible to get a little overzealous about getting close to your subjects. Avoid getting so close that you crop either animal or human

subjects precisely at a joint—neck, wrist, knee, ankle, or elbow—or through the eyes. It makes the viewer feel squeamish.

It's always better to crop your picture before you take it. Cropping "in the camera" uses the maximum film area, which means that very little is wasted on things you don't want to show in the final picture.

## Horizontal Versus Vertical Pictures

Compare pictures you've taken that are oriented horizontally with those you've composed vertically to see which tells the story better. Does the composition you've chosen enhance the picture? Did you use the rule of thirds and power points? Use your cropping L's to see if a vertical composition could have improved a horizontal shot, and vice versa.

**FACT**

Another trick to deciding on whether to compose your photo horizontally or vertically is to pretend the "lines" of your photo are moving. Is the motion up and down or sideways? People and trees go up and down, so most often a vertical composition will work best. Landscapes go sideways, so a horizontal format is appropriate.

## Framing Problems

Filling the frame with the image is a key element in improving your pictures. So is filling the frame properly. Many inexperienced photographers make framing mistakes, resulting in pictures that range from being visually confusing to downright funny.

Here are some of the more common framing mistakes along with some suggestions on how you can avoid them:

- **Big scenery, little person:** If you're photographing scenery and want to include a person clearly in the picture, frame the scenery in your viewfinder first, then bring the human subject (your second subject) close enough to the camera to be clearly identified. Put the person on one of the tic-tac-toe lines.

**FIGURE 12-1**

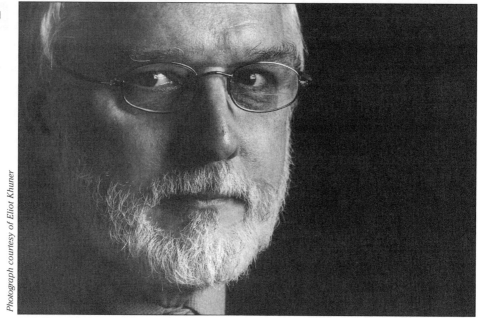

*Photograph courtesy of Eliot Khuner*

▲ Most portraits are shot vertically, but horizontal composition can work as well. Here, horizontal composition and tight focus simplify the picture and make the face the only subject. Artful framing, using power points and the rule of thirds, further increases the visual impact. Note how the subject's eyes are perfectly positioned one-third of the way down from the top of the frame.

- **Eying the horizon:** If you put your subject's eyes at or below the horizontal middle of the frame, your image suggests that your subject wasn't tall enough to reach the camera level. As you frame your subject for a head-and-shoulders portrait, position the eyes one-third of the way down from the top of the frame. This works for vertical or horizontal framing and for close-ups or full-length portraits. For a powerful horizontal close-up, get close enough so that when you put the eyes at the one-third line, you crop out the top of the head. Don't let either of the eyes come closer to the top of the frame than that one-third line.
- **Wrong-way gaze:** It almost never works to have your subject looking out of the frame of a picture. Turn the subject's body towards the center of the picture and have him or her look at the camera, at the scenery or into (toward the center) of the scene.

- **Walking, we're walking:** Mobile subjects (a person walking across the picture) in a static scene leave the viewer unsure what the picture is about. If the picture is about the scenery, don't have people walking across it. On the other hand, if your picture is about the people, and the scenery is merely a beautiful backdrop, then having them moving across the scenery works. Putting the direction of travel on a diagonal from one power point to the other projects more energy.

## Tilted Images

Images that cut diagonally across the frame or horizon lines are the result of tilting the camera while framing the image. It can easily happen if you're distracted by other aspects of what you're trying to shoot. It can also happen if you're shooting with your camera on a tripod that isn't sitting exactly level.

If you're not deliberately after the tilt effect, always check to make sure that the center of your image is square and level before snapping the shutter.

## Tree Growing out of Head Syndrome

Framing errors that result in odd occipital growths are a common mistake. Normal and wide angle lenses used for photographing more than 6 feet from the subject are very likely to have enough focus (that is, depth of field) behind the subject so that pieces of the background, such as telephone poles, buildings, and trees look like they're sprouting out of the subject's head. Another head-sprouting problem, although often less obvious than the first, happens when you accidentally frame a subject with the horizon line poking into one ear and coming out the other.

The easiest way to avoid this error is to make sure that the area around the subject's head has minimal details. Put the person against the most boring part of the scene, and make sure the horizon is well above or below ear level. Watch your leading lines too. They shouldn't poke into the subject's face unless they're enough out of focus that they're clearly not part of the subject. Another way to get rid of head appendages is to move the camera up, down, or sideways to remove distracting objects that seem to be growing out of the subject. Shooting with a wide

aperture can also work, but only if it's wide enough that the background is completely blurred.

## Exposure Problems

Prints that come back from the photo lab too dark or too light are often the result of negatives that are exposed incorrectly. These are common problems, especially for inexperienced photographers, and especially for anyone learning how to use new equipment.

If you're shooting with an automatic SLR, one of the best remedies for poor exposures is to read and reread your camera's instruction manual. Learn how to use your camera's metering system and its various modes—center-weighted, spot, or zone—if it has them. Find challenging lighting situations—backlit shots, shots with extreme ranges in contrast, anything that you consistently have problems exposing—and shoot a number of images using various metering modes.

Becoming a good photographer takes practice. While it's comfortable to take pictures that you know how to do well, work on your technique by seeking out situations that challenge your abilities. No one but you has to see the results of your practice sessions.

Also learn how to adjust exposure by using your camera's shutter, priority, and manual modes. Shooting in auto or program mode works well for quick snapshots, but it doesn't always deliver the best exposures. By learning how to adjust apertures and shutter speeds yourself, you'll have more control over how your pictures are exposed.

Bracketing your exposures—that is, taking shots with settings that are over and under the correct exposure—is one of the best ways to insure a correctly exposed image, especially in difficult lighting situations.

If you're confident that you're exposing your images properly and they're still not turning out correctly, there may be a problem with your camera's metering system. Take your camera into a good shop and have it checked out.

# Sharpen up Your Images

Pictures that look pretty sharp when they're printed snapshot size can look decidedly unclear when they're enlarged. If your images look blurry, regardless of the size of your pictures, here are some tips on making them sharper.

## Don't Outshoot Your Conditions

Shooting with a too-slow shutter speed is a common cause of camera movement. For pictures of still subjects, use a shutter speed no slower than 1/30th of a second for handheld shooting. For fast-moving subjects, use the fastest shutter speed possible, usually no slower than 1/250th of a second.

## Don't Depend on Autofocus

Autofocus is a great tool for people who have trouble doing the job themselves, but it's not foolproof. If you're shooting with autofocus, check your viewfinder to make sure the lens has focused exactly where you want the focus of your photograph to be. When shooting with a zoom lens, you might find it easier to adjust the zoom (telephoto, normal or wide angle) first, then focus the lens. If your lens does not change focus as it zooms, you can focus first at telephoto, then zoom to the composition you want.

## Get Rid of the Shakes

On cloudy days, or when you're using slower (ISO 200 or less) film in your camera, it's especially important to keep the camera still when you squeeze the shutter because these conditions can produce blurry images. Brace your hands or your head against a solid object and breathe slowly as you squeeze (rather than push) the button.

If you're using a telephoto lens, remember that the magnification of these lenses will emphasize camera movement. Unless you're shooting with fast film and fast shutter speeds, count on having to work with some sort of a camera support if you're using especially long telephotos.

**ALERT!**

Don't take pictures when you're driving. Using both knees to steer while you take a picture out an open window is a sure road to an accident, not to mention a great way to create blurry photos due to camera motion and vehicle vibration.

## Bringing Life into a Cloudy Day

Cloudy days can be some of the best for taking pictures of people as the light is soft and flattering and doesn't throw harsh shadows. On the other hand, overcast conditions often produce dull pictures because there isn't enough difference between the shadows and highlights. Switching to a warm and saturated slide film can help liven things up. Or you can put your subjects under a tree or some overhang that will force the light to become more directional. You'll need a fast film for this, and it might still be possible that there won't be enough contrast to make the picture interesting.

If you have to take pictures on a dull day, you'll generate more interest by capturing strong lines and diagonals. You won't be able to rely on scene contrast to keep the viewer's interest. Or, take pictures that project a mood or a feeling that matches the directionless light. Large scenes can be made incredibly boring by dull lighting. Try moving closer and capturing the details instead.

## Balancing Contrast

Sunny weather or working indoors with exterior scenery visible through a door or window can produce photographs in which your subject and background vary greatly in brightness levels. Pictures like these are about the contrast in the two areas, not about the subject. If the subject is bright and the background dark, this may not be objectionable unless you've lost much of the detail in the background. To improve these images, try lessening the contrast by moving the subject into the shade. Or, try changing camera position until you find a brighter background that you can place behind the subject.

Many photographs don't work because the subject doesn't stand out from the background and foreground. Here are some remedies to this problem:

- Move the subject into light that is closer in brightness level to the scenery.
- Use flash to bring a dark subject (if within flash range) up to near the brightness level of the scenery.
- Change your camera position until you've lined up the subject with a background that better matches it.
- Use a longer lens and larger aperture to pop the subject out of the picture.

You do want a difference in tone between your subject and the background. If you're shooting black-and-white film, you're limited to making sure there's enough difference in tones so that the subject stands out as being separate from the background. Color film allows differences in color to separate subject, background, and foreground.

## Masking a Busy Background

Good images are often weakened by busy or distracting backgrounds. You can eliminate them by switching to a long lens (85mm or longer) and shooting with a large aperture (*f*/1.4 to *f*/4). The closer you get to your subject, the more out of focus your background will be.

Many familiar objects are still discernible even when out of focus. A distracting cityscape in the background of a picture will usually remain a cityscape in the viewer's perception unless you use a very long lens (150mm or more), use a very wide aperture (*f*/1.4 or *f*/2), or get very close to the subject so you can take a tight head-and-shoulders shot.

Switching to black-and-white film will disguise possible distractions such as the obvious colors of taillights or corporate logos that have distinctive colors.

When you switch to a long lens, keep in mind that changing your position up, down, or sideways even a few inches will make dramatic differences in the background. Move the camera before you take the picture, not while the shutter is open.

Look through your photographs to see if you have captured repetition and texture. Have you (on purpose or accidentally) used them as compositional elements? Do they strengthen the photo or distract? Are they the theme of the photo or the background?

## Gaining Perspective in Scenic Shots

The grand scenery that takes your breath away when you view it in person rarely looks as beautiful when you photograph it. Unfortunately, those vistas that unfold in many layers in real life end up flat and two-dimensional unless you take certain precautions:

- Include objects in the foreground to add a sense of distance, depth, and dimension.
- Include a person, which will also give a sense of scale.
- Find a frame, such as a door or the limbs of a tree, to shoot through. This gives the picture depth and keeps the viewer's eyes on the main subject.

Being able to distinguish foreground from background orients and reassures the viewer that all is right with the world. You can differentiate the foreground frame from a distant subject with the following techniques:

- Selective focus (foreground frame out of focus, subject sharp).
- Contrast (foreground lighter, darker or low contrast, subject correctly lit with good contrast).
- Scale (nearby frame is clearly closer because leaves and branches are discernible, but distant subject has different texture because it's farther away).

# Bad Group Pictures

Do your friends and family members wince or moan when they see the pictures you've taken of them? During fun times with friends and family, it's easy to forget that camera angle and subject placement affect how people will look in your pictures. They also change the meaning of the pictures you're taking. If you're after better-than-snapshot pictures of the people in your life, try these techniques:

- Seat subjects only when needed to keep a group from being too wide. Seated bodies are apt to look heavy.
- Avoid shooting from a low camera angle if they're sitting. This emphasizes the size of their thighs and foreshortens their torsos and upper bodies.
- Use a normal or telephoto lens instead of a wide-angle lens.
- Put larger people in back to both hide and minimize their size.

Pictures of groups illuminated with flash often result in some people looking too bright (too close to the flash) and others being too dark (too far away from the camera). To avoid this, position your camera so that every member of the group is about the same distance from it. If necessary, stack some of the group between and above the others—you may have to ask the front row to sit or squat to do this. Have the back row lean forward toward the camera. This will bring them almost as close to the flash as those in the front row. It will also do a good job of getting everyone in focus and eliminate boring composition caused when people pose in straight rows.

# Going Full Tilt

Changing horizontal or vertical lines to diagonal lines can add visual interest and improve the composition of otherwise boring images. There are several ways you can do this:

- **Turn the camera around the lens axis:** The lens axis is the line from the center of the subject to the center of the frame. This

technique, called a "Dutch tilt," turns vertical and horizontal lines into diagonals, making the image more dynamic. However, if the scene doesn't have any obvious verticals or horizontals, the tilt may not be obvious. Do use a tilt to create a leading line from one corner of the frame to the subject.

- **Tilt the camera up or down:** Changes the placement of the subject in the frame and alters the perspective. In other words, you increase or decrease the convergence of vertical lines. Horizontal lines roughly parallel to the lens axis (such as a railroad tracks running along the horizon) also show a change in the amount of convergence depending on how much up or down you tilt the camera.
- **Pan, or turn, the camera to left or right:** Also changes the apparent direction of nonvertical parallel lines such as floor tiles, the path you're standing on, the roof lines of buildings, and so on.

**FIGURE 12-2**

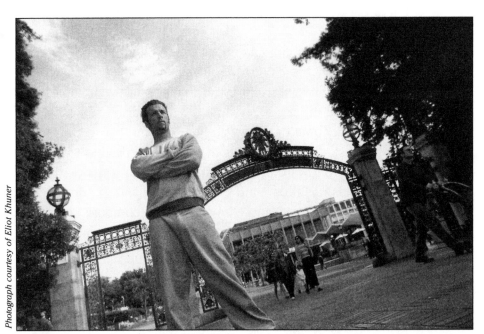

*Photograph courtesy of Eliot Khuner*

▲ Using a wide-angle lens and a low camera angle emphasizes the subject's strong pose in this shot. Dutch tilt was used to create strong diagonal lines and to remove all true verticals from the image.

## More about Panning

A wide-angle lens, by virtue of its wide field, will emphasize the effect of panning. As you pan with a wide angle, you'll see the vertical size of objects change. If they're in the center of the field, they'll appear smaller, and if they're toward the edges, they'll appear larger. They may also look distorted, but if you keep your film plane parallel to your subject there shouldn't be any distortion with a good, typical wide-angle lens.

Panning causes some of the subject's lines to converge and diverge, which goes hand in hand with an apparent distortion in the shape of the building. This distortion can make your visual message stronger or distract your viewer from the point of the picture. You can minimize this apparent distortion (which results from the film plane's not being parallel to the subject) by increasing your distance from the subject.

## Tilting Considerations

When a subject already has a tilt to it, rotating the camera to match the angle has the unfortunate effect of nullifying that dynamic line. Instead, rotate the camera in the direction that increases the tilt. The diagonal of a vertical 35mm frame is about 55°.

Avoid cutting your image in half by creating a strong line running from one corner to the other. While it's a dynamic line, it makes a static half-and-half division in the picture. Change the framing so that the diagonal falls on a tilted tic-tac-toe division of thirds.

Keep the subject on a one-third line or on a power point as you Dutch tilt the camera. Avoid being at or close to a 45° rotation because it won't be clear if the image is a horizontal or a vertical. If the Dutch tilt is less than 10° and is obvious, it will look as if the tilt was a mistake.

Practice tilting. Shoot straight for a few frames, then with a right tilt and a left tilt until you develop a feel for it. Tilting works well with some subjects. With others, it will make them look like they're asleep, drunk, reclining, or falling over.

# Testing, Testing

Sometimes images fail through no fault of your own. Instead, your equipment doesn't work properly. New cameras and lenses can arrive with defects or quirks. Old cameras that have been in a closet for a while might have shutter speeds that are way off. Lenses that have been in extreme climates might have sticky diaphragm blades.

## Testing New Equipment

You can prevent equipment failures and surprises by testing all new equipment when you buy it. If it's a new camera body, load the film you know the best and feel most comfortable shooting. Test out elements such as the built-in exposure system and various shutter speeds and settings.

Talk to other owners of the same model of camera and lenses. They may have discovered bugs or tricks that will be useful.

Some lenses are more prone to flare from bright light hitting the front glass of the lens and causing streaks or blobs of light on the film. Test by shooting in the direction of bright light to find out which lenses are more forgiving. Wide-angle lenses will often let you put a bright object directly in the image with no problem. Some telephotos just go nuts if you even think about doing a strongly backlit picture. The solution is to only use backlight-friendly lenses when the backlight is intense or to position the camera so that the front of the lens is in the shade.

## Testing Existing Equipment

Before any important shoot, visually inspect the inside of your camera body for film chips or other foreign objects that may have fallen into it. Check both body and lenses for lint and other matter that might obscure the picture or scratch the film.

Run a roll or two of film through your camera. Test the lenses you're planning to use. Also check flash sync. Even if you don't plan on using an accessory flash, it never hurts to fire it regularly to keep the flash capacitors in good working order.

**QUESTION?**

**What's the best way to test a new camera?**
Test your equipment with color slide film. You'll be able to see problems more clearly by examining slides (the developed film) than by viewing prints. Both camera and hand-held light meters may produce exposure errors in very bright light or very dim light. Test your equipment at both extremes.

## Testing New Film and New Labs

If you plan on shooting film that you haven't used before or that you are not familiar with, shoot a couple of test rolls to get a feeling for it. If you'll be having your film processed at a new lab, find out what film they like to work with. Then take an entire roll with a mix of correct exposures, overexposures, and underexposures to find out which turn out best. If you know what your negatives are supposed to look like, and what you get back doesn't look right, the lab might need to adjust its developing time to give you the results you're after.

While color processing should be uniform at a good lab, black-and-white processing is another story. Many labs are not black-and-white specialists and will overdevelop this film. The film processor's choice of black-and-white chemistry—and there are many—and processing techniques determine the quality of the negative, and of the final print image as well.

If you plan on shooting black-and-white film, seriously consider having the lab process a few shots under the conditions you're anticipating so you can determine the film speed and lighting that will produce the best images with that lab. If the roll comes out okay, then you have a green light. If it doesn't, discuss the problems with the person developing the film. It might be necessary to increase or decrease developing times, or it may be better for you to switch to a different lab. (E)

*Chapter 13*

# Photographing the Outdoors

Capturing the world around you on film offers limitless opportunities to get outdoors and enjoy gorgeous scenery. Some vistas are so breathtaking that they'll look great no matter when or how you photograph them. Others you'll have to work at to unlock their full beauty.

## Getting the Big Picture

Outdoor photography is a subject that's, well, as big as the outdoors itself. It includes landscape photography in its purest form—scenic shots in which people, animals, and manmade structures don't appear—as well as pictures featuring a combination of landscape and other elements. It also includes other types of photography where the outdoors plays a role—such as nature, wildlife, cityscape, and seascape photography.

Anyone can take pictures of scenery. But it takes some practice to turn three-dimensional images into two-dimensional ones and do it well. It also takes some skill to render the sweep and scale of these often bigger-than-life subjects on tiny frames of film.

**FACT**

Eliot Porter was a master at capturing the splendor of nature on film. If you're in search of inspiration for your own work, or you just want to see how a master worked with his surroundings, study any of the books that feature his work. A classic is *In Wilderness Is the Preservation of the World*, published by the Sierra Club.

## Choosing Outdoor Subjects

There is no lack of interesting outdoor subjects with which to fill your viewfinder. And there really aren't any hard and fast guidelines for choosing what to shoot. A vista that makes you sit up and take notice may not excite the next person, and a wildlife scene that takes the breath away from others might not thrill you at all. Follow your heart, and find the images that speak to you.

Although it's possible to stumble on a perfect setting that's just begging to be shot, most outdoor photographers spend a great deal of time seeking out their subjects. Patience is definitely a hallmark of this type of photography. Not only can it take some time to find a subject you want to shoot, it also takes time to figure out how you're going to shoot it. Getting the perfect shot often means returning to your subject more

than once if you're trying to capture it in specific light or atmospheric conditions.

## How to Evaluate Subjects

When seeking out potential subjects, think about the different ways in which you could shoot them. Consider what the scenery will look like at various times of day and from different perspectives. If you have your camera with you—and you should, as you never know when a great outdoors shot might crop up—look at subjects through the viewfinder to get an idea of how you want to frame and compose your shots. Also keep a notebook with you so you can take notes on the location, the things about it interested you, potential shooting angles, and the quality of light.

If you go location scouting without your camera, use your fingers to get a rough idea for how to frame subjects. Make L's of your thumb and forefinger on both hands and put them together to make a rectangle—thumbs and forefingers opposite each other.

If you have a digital camera, you might want to use it to capture a visual record of the setting for future reference.

## Consider the Colors

Also think about how the scenery will look at different times of year. A forest scene awash with the lush colors and deep hues of thick summer foliage might also make a great shot in the winter with slanting, low afternoon light casting deep shadows on tree limbs, bark, and snow.

## Following the Light

How a scenic shot is lit can make the difference between a good picture and a great one. The sun's placement in the sky will light scenes differently and cast different shadows. One day bright light might bathe your intended subject, the next it might be lit softly by an overcast sky acting as a giant diffuser. It may be necessary to visit subjects more than

once to get a feel for how they look at various times of the day and under different lighting conditions.

In general, outdoor photography depends a great deal on being in the right place at the right time. While composing your images well is always key to taking good pictures, getting good outdoor pictures also heavily depends on knowing how to work with the light and the weather. The times of day that are most convenient for shooting are often not the best times for getting great pictures. You may not like being outdoors when it's cold and foggy, but you'll miss some great shots if you stay holed up indoors.

In most daytime scenes, the light source (the sun) is not a part of the picture. The exact opposite is true in nighttime scenes, in which the light sources are often part of the story. This makes for a very large dynamic range, from the absolute black of the shadows to the brightness of streetlights and headlights.

At night, with no ambient light to fill in the background or shadows, artificial lighting outdoors will look artificial. You can avoid using it by shooting with high-speed film, a wide-open lens, and a long shutter speed (1/30th, 1/15th, 1/8th of a second), which will capture background lights if you're shooting a cityscape.

## Consider Point of View

Outdoor shots can be taken from a variety of points of view—close up, at a distance, through a frame of trees, shooting upwards, shooting downwards—all are possible, and none is necessarily better than any other.

Choosing a shooting position that shows scale and perspective can help classic landscape pictures seem less flat. Including a focal point, such as a tree or a rock, will give the viewer a sense of the landscape's scale.

## Scouting Wildlife Subjects

Although you can't ask wildlife subjects to perform on cue, you can plan for action by knowing where to find them. Parks services, local nature clubs, and nature guides are just some of the sources for learning what kind of wildlife is in the area and where the animals tend to hang out. They also might be able to tell you when you can find your potential

subjects. Animals follow fairly regular routines, especially when it comes to seasonal activities like mating, migration, and hibernation. They also eat at certain times of day, and they often come to the same place to do it unless they deplete the food supply there.

Patience pays off when shooting all types of wildlife, and this is especially true of more elusive mammals like otters and mice. Be prepared to sit and wait for a long time to get a shot of these critters. When they do pop their little heads up from wherever they are, be ready to shoot them by having your camera in position and focused on the spot where you think they'll appear.

Always consider your safety as well as the safety of the animals you're shooting. It's never a good idea to get too close to animals in their habitat—especially during mating season—which is why you need long lenses to shoot them close up. If you don't have a telephoto lens with you, shooting with a shorter or wide-angle lens will let you also include some of their natural surroundings.

It pays not to be too picky when photographing wildlife. If you're after a shot of a moose, and all you're seeing are deer, don't ignore nature's message. It may not be a good moose day. Settle for the deer, and try for the moose another time.

## Working the Seasons

Avid outdoor photographers will tell you that there's no best season for taking outdoor pictures. Each offers its own take on Mother Nature's glory and provides unlimited opportunities for you to capture its beauty on film.

### Spring

Wildflowers poking their heads through carpets of leaves, baby birds begging their mothers for food, trees with buds just waiting to burst—this is the stuff of spring photography.

Spring weather can be raw and blustery but with an overlayer of soft, warm air carrying promises of the summer to come. The scenery in

spring often contains glimpses of seasons past—snow hiding in the shadow of a ridge, brown leaves drifting down mountain creeks.

Because the land is still in its winter coat for the most part, your surroundings may look somewhat drab and uninteresting at first glance, but look closer and you'll find plenty to shoot—a bird's nest tucked into the crook of a tree, worms and insects chewing on tender young leaves, the patterns made by groves of fir trees among aspen and oaks just beginning to leaf out.

Rainy days are a given during spring. They might result in delicate low-lying clouds that obscure the tops of mountains, fog that drapes everything in a diffused mist, or merely in wet conditions where the moisture deepens the intensity and hue of the colors around you.

**FACT**

When shooting sunrises and sunsets, set your exposure level to underexpose the scene by one f-stop, which will produce strong, well-saturated color. Underexposing rainbows will produce saturated hues as well.

## Summer

There isn't much not to like about this season. Trees are lush and green; flowers are in full bloom or getting ready to be. Forests are full of animal activity. Lakes shimmer with light.

The sun is high and direct during the summer. It's best to avoid it at its highest—between 11 A.M. and 3 P.M.—when shooting outdoors. Pictures taken before 11 A.M. and after 3 P.M. will feature more pleasing shadows. Get up early, and your shots will benefit from the rich, warm hues of the early morning sun. Late afternoon to dusk is also a great time for capturing scenes bathed with the reds and golds of the setting sun.

## Fall

Capturing trees and bushes as they change color is irresistible to almost every photographer. It's hard not to get great scenic shots in the fall, but they'll look even better if you deepen their color with polarizing and warming filters.

It's easy to get swept away by the majesty of the season's brilliant colors and miss the finer details of your surroundings. But there are a lot of great detail shots than can be taken during this season—the patterns made by field grass heads dancing in the breeze, low-lying plants kissed by early morning frost, even fallen leaves scattered over the ground.

## Winter

Cold weather often acts as a deterrent to taking pictures outdoors, especially if you aren't terribly cold tolerant, but if you stay inside you'll miss some great shots. This is a fantastic time of year for taking dramatic landscape pictures, shots of birds busy at work at your backyard birdfeeder, animal tracks in the snow, even frost patterns on windows.

It's important for both you and your camera equipment to stay warm when the thermometer drops. Carry your camera underneath your coat or jacket between shots to keep it warm. Cold temperatures also sap battery strength. Be sure to carry a spare battery with you, and be prepared for some of your camera's automatic functions to work more slowly.

**ALERT!**

If it's extremely cold and dry out, wait until you can get to a warmer place to auto rewind your film. Cold and dry conditions can cause static electricity to build up on the film as the camera rewinds, and this can deposit lighting-bolt streaks on your negatives. If your camera has manual rewind, crank the film back slowly.

Light in the early morning and late day is best for capturing winter shots. Bright sun on snow can cause underexposures if you're shooting in automatic mode, which will make the snow look dingy gray instead of bright white. To bring out the snow's detail when taking these pictures, meter the scene, then adjust your exposure one or two f-stops higher than what the meter indicates.

Winter skies are often cloudy and somewhat lackluster. If the conditions are too gloomy for your shot, try brightening the sky with a graduated color filter. You can also work around cloudy skies that lack interest by shooting from angles that reduce their prominence in your composition.

Another way to get accurate exposures when shooting in the snow is to use a gray card—a piece of gray-colored cardboard that reflects the same amount of light that meters are calibrated to read. Focus on the gray card when setting your exposure, and your camera won't be tricked into underexposures or overexposure caused by subjects that reflect more or less light.

Moonlight shots, when exposed properly, can look just like daylight images unless lights are in the frame. The longer shutter speeds necessary for moonlight pictures will allow the movement of the water, trees, and moon to blur. The warm color of the artificial lighting of cars, cities, or lit-up windows will make a beautiful contrast to the natural "daylight" balance of the moonlight. To photograph just the moon requires a much faster shutter speed for correct exposure and to freeze the moon's (earth's) motion.

## Lenses for Outdoor Photography

Many outdoor scenes are taken at a distance as it's often difficult to get close to outdoor subjects. Zoom lenses are ideal for changing composition and perspective and still keeping your feet in one place. If you have two zoom lenses—a short zoom of 28–85mm or so and a longer one of 80–200mm or 100–300mm, you'll be covered for most outdoor shooting situations. If you're planning to take close-ups of such things as flowers, patterns in tree bark, and other things of nature, lenses with macro capabilities are good all-around choices.

The subtle hues of rainbows are often difficult to capture on film. Try using a polarizing filter to bring out their colors.

Polarizing and color enhancing filters can be an outdoor photographer's best friend. Warming filters are great for removing blue casts on snow when shooting color film. If you're shooting black-and-white film, you may want to consider using filters to add contrast to sunlit scenes

and improve the details in clouds. A red or yellow filter will darken the sky.

# Other Equipment for Outdoor Photography

A tripod is essential for capturing many good outdoor shots. Yes, they can be bulky and cumbersome to carry, but you'll miss some great pictures if you don't have one. You'll also lessen the quality of many pictures that you do take. Carry your tripod on your shoulder with your camera body and lens mounted so you don't have to spend precious moments putting everything together each time you want to stop and take a picture.

Here are some other handy items for outdoor photography:

- **Food and water:** Essential for all-day hikes and field trips.
- **Insect repellent:** Choose one that also repels biting flies.
- **First-aid kit:** For the obvious reasons.
- **Good hiking boots:** Waterproof boots are preferable.
- **Sunblock:** Again, for the obvious reasons.
- **Field guides:** For identifying local flora and fauna.
- **Extra socks:** You can change into them if your other socks get wet. They also make decent hand warmers in a pinch.
- **A lightweight rain jacket or poncho:** For the unexpected shower or snowstorm. A poncho will also help protect your camera gear from the elements.
- **Cell phone:** Yes, they're irritating and annoying, but you'll be so glad to have one with you in case of an emergency. Keep it turned off unless you need it.
- **Tripod Quick Release:** Allows you to carry tripod and camera separately, then work quickly when you stop to shoot.

Most outdoor photographers find camera bags and backpacks cumbersome and prefer to wear photo vests that keep their lenses and other equipment close at hand. A waist or hip pack is another option for carrying your gear.

Sunlit buildings or snow against a blue sky makes beautiful pictures. To get deep blue skies and bright white buildings with no loss of highlight detail, expose using the Sunny Sixteen Rule—set the shutter speed to the ISO of the film you're using and the f-stop to *f*/16. If the sun is particularly bright, stop down to *f*/22. Deep shadows will go black under these circumstances, but that's in keeping with the contrasty mood of the subjects.

## Realistic Versus Interpretive Photos

Most outdoor photos, and especially landscape shots, are pretty straight-forward. They portray their subjects realistically and from perspectives that are familiar to the viewer. Others take a more interpretive or impression-istic approach through exaggerated perspective, depth of field, and other techniques. These pictures are less about documenting specific infor-mation about a subject and more about conveying a mood or feeling about it. Objects may be recognizable, or they may be taken in ways that isolate specific facets or details that tell you more about the subject than about its surroundings.

Both approaches have a place in outdoor photography. Most photo-graphers find that shooting a mixture of realistic and interpretive pictures is a great deal more enjoyable than sticking to one style or approach. The great thing about outdoor photography is that nearly every subject you shoot will lend itself to both approaches in some way. Get accus-tomed to seeing the big picture as well as nature's more finite brush-strokes, and you'll never run out of great subjects to shoot. Ⓔ

Chapter 14

# Object and Still-Life Photography

There are lots of reasons to take pictures of the things in your life and just as many different ways to do it, ranging from snapping a quick close-up of the details on a piece of furniture to creating a beautifully composed still-life that exhibits all your artistic talent. The better these photographs end up, the more likely they are to become precious treasures that will be handed down in your family.

## Objects of Attention

Object and still-life pictures differ from other photos in several important ways. They're generally taken from a fairly close distance, which separates the objects from their immediate surroundings. In some cases, the distance is so close that an object's patterns or texture become the subject of the shot. And, although these pictures might look unstaged, in reality they rarely are.

In most cases, the photographer has had at least a slight hand in creating them by controlling the setting, moving objects around, adding and subtracting them, trying different angles, and using different lighting schemes until the image tells the intended story or evokes the right feeling or mood. Even a seemingly casually composed shot taken in natural surroundings has probably been improved by moving a twig just so or brushing aside a distracting leaf or two.

FACT

Getting good object and still-life shots requires both good technical abilities and an artist's eye for composition. They're like painting a picture using film as your canvas and your camera as your brush.

## Where to Shoot

Lots of still-life pictures are taken indoors, which allows virtually complete control over arrangement, lighting, backdrops, and props. There definitely are advantages to shooting in controlled conditions: You won't have to worry about things being blown away by a random gust of wind or soaked by a sudden cloudburst when you're shooting inside. You also won't have to deal with variable light conditions unless you're relying on window light to illuminate your picture.

But taking good still-life pictures by no means limits you to shooting indoors. You can also create beautiful images outdoors. In fact, many photographers prefer shooting outside so they can take advantage of what the outdoors has to offer, such as warmer, more subject-flattering light and natural settings. With a little advance planning, you can troubleshoot

the problems that outdoor shooting can present and end up with perfectly composed images that will make you proud.

# Essential Equipment

Some of the equipment used to shoot objects and still-lifes is pretty standard stuff that you probably already own. However, certain shots will require some specialized equipment. If your dream is to enter the world of product photography, you'll need a highly specialized setup that goes way beyond the basics. This kind of photography is beyond the scope of this book as well, although you'll find some resources to help you (should you want to go this direction) in Appendix B.

## Lenses

You can use lenses you already own for most object and still-life shooting. Telephoto lenses will let you shoot from greater distances, which is often desirable when shooting closer up might throw shadows on your subjects or otherwise disturb them. Wide-angle lenses exaggerate perspective but let you work closer.

Many object and still-life pictures are taken with a fairly wide aperture to knock out foreground and background images. You can avoid using an artificial backdrop by using a long lens (135mm and longer), and a large opening ($f/1.8$, $f/2$, $f/2.8$), which will drop the background completely out of focus. Close-up shots are taken with smaller apertures ($f/16$ to $f/32$), which provide some depth of field for these highly magnified images.

Shooting objects from close up requires lenses with focusing ranges that allow you to fill the frame. Macro lenses are designed to render life-size or nearly life-size images on film by making it possible to get super close to your subjects. They come in focal lengths ranging from 50mm to 200mm, which means they can also be used for regular photography. Macro lenses with longer focal lengths let you work at a greater distance.

True macro lenses will produce life-size images on film (meaning that a half-inch bug will measure half an inch on the negative). This one-to-one reproduction ratio, however, comes at a price. Less

expensive are those lenses that reproduce images at one-half to one-fourth of life size. You can still get life-size images with them by using the following accessories:

- **An extension tube:** These devices mount between the camera body and lens and let you focus more closely by moving the lens farther away from the film inside your camera.
- **An extension bellows:** Extension bellows work along the same principle as extension tubes, but you adjust them by turning small knobs. They're more expensive than extension tubes and can be difficult to use.
- **Close-up lenses:** These accessory lenses screw or snap onto the front of your regular lenses. They are labeled by strength, with the weakest being +1 diopter. Usually a +1 or +2 is all you will need.

If you love photographing flowers as you hike through the countryside, using a true macro lens is far more convenient than using close-up attachments. You might take a picture of a large plant and then quickly come in for a macro close-up to capture just a single flower. Having one lens that does both easily is a plus.

If you don't have a macro lens, you can shoot close-ups by reversing a normal or wide-angle lens. Simply reverse the direction of the lens and attach it to your camera body with a special lens reversing ring or macro adapter. You can also try holding it in place in very stable conditions, such as indoor shots with the camera set on a table.

## Matching Lens to Subject

If you're not taking a super-close shot, a 100mm lens will allow a working distance that minimizes perspective distortion. If you don't have a lot of room and you're shooting a large object, a wide-angle lens will work. However, shooting too close to the object (less than twice its depth) with a wide-angle lens will result in forced

perspective. This means that the parts of the object closest to the lens will loom large while those farther away will seem to recede into the distance. This produces a dramatic image, useful in some cases, but not as factual as an image in which a normal perspective produces more realistic lines.

Your lens choice will also help you avoid distortion in object or still-life shots or add it should you want to. Using a wide-angle lens and backing away from the subject will let you place the camera higher (to show the top surface of the object) and keep the camera closer to level (pointing towards the horizon rather than down). If necessary, you can crop out the top of the picture when you have the image printed. Distortion can also be lessened by moving farther away from the subject and using a longer lens (longer than 100mm) to keep the frame filled. These seem like contradictory solutions to the same problem, but both methods are based on the physics of perspective.

**FIGURE 14-1**

*Photograph courtesy of Tom Minczeski*

▲ A picture of a model taken with a wide-angle lens. Notice how the image curves toward the end, creating an artificial depth called "forced perspective."

**FIGURE 14-2**

*Photograph courtesy of Tom Minczeski*

▲ The same model truck taken from a distance with a 300 mm lens. As a result the entire image has a flat appearance to it.

**FACT**

A little distortion can be a good thing. If you're photographing a model car, getting close with a wide-angle lens will mimic the distortion that viewers expect when seeing a photograph of a life-size car, with the near fender and headlight noticeably larger than the distant one. Viewers also expect to see a life-size car sharp from front to back, which means that you'll also have to stop way down (*f*/11 or smaller) to increase your depth of field.

## Camera Support

A tripod or another sturdy camera support is essential for object and still life photography. First, it minimizes camera motion and makes your images sharper when you're shooting with narrow apertures and slow shutter speeds. In addition, a nonmoving support allows you to set up your shot, check it through your viewfinder, and adjust the lighting

without continually having to reframe and refocus each time you make an adjustment. If you're shooting a series of similar objects, using a tripod will ensure the same camera angle and relative size just by placing each successive object on the same spot. If you have a series of objects to photograph, sequence them in order of size.

## Illumination Equipment

An accessory flash unit will let you try various lighting schemes—side lighting, top lighting, backlighting, bounce lighting—when taking object and still-life shots. Flash also freezes the action when you're taking pictures of flowers and other natural objects outdoors, and it pops them out of their surroundings by darkening the background. If your flash has variable power control, you can also use it for close-up work. If it doesn't, and you plan on doing a lot of close-up shots, you might want to buy a ring light or macro flash. These special flash units circle the lens and provide uniform, shadow-free illumination.

White cards are useful for reflecting soft light onto the front of objects or for lighting transparent or translucent objects from the rear. When shooting larger items, larger reflective devices will provide more even lighting. Professionals use large softboxes with strobes or hot lights, but you can achieve a similar effect with a much less expensive setup. A white shower-curtain liner, lit by sunlight, flash, or good old-fashioned floodlights, can make a very good large, diffuse light source. White foam-core board is another good reflective device.

## Backdrops

Many object and still-life pictures are taken with the objects in their natural surroundings or posed in settings that are arranged to look natural. There are times, however, when you don't want the background to distract from your subject. Depending on the size of the objects and the effect you're after in your picture, any of the following will work as neutral backdrops:

- **Poster board:** It's cheap, widely available, and flexible. Choose a piece that's long enough so you can scoot some of it under whatever

you're shooting. Then curve the rest of the piece upward so that the top of the board is higher than your camera angle. Making the curve tighter and bringing the board closer to vertical will change the gradations in the backdrop. When photographing close-up objects, such as flowers, a small piece of colored poster board can be held by an assistant behind the subject to isolate it from a distracting background.

- **Countertop material:** The laminate material widely used on countertops is also flexible but far sturdier than poster board, so you can use it over and over. It's also available in some interesting colors and textures. Check with a local fabricator or a large building supply store—remnant pieces are often available for a song and perhaps for free.

- **Fabric backdrops:** These range from manufactured backdrops made of muslin or canvas used by professional photographers for studio work to household linens and shower curtains. If you take the time to get them positioned correctly, there's no need to buy expensive background things. You can even buy canvas or muslin and paint it if you like the look of those expensive backdrops.

You can avoid having to use a backdrop by shooting with a long lens (135mm or longer) and a large opening (*f*/1.8, *f*/2, *f*/2.8), which blurs the background nicely. This is an excellent way to isolate your subject from any distracting surroundings. The effect it creates is what distinguishes the images of many professionals, who can invest in long, large-aperture telephoto lenses, from the photos taken by amateurs who use the wide-angle or normal lenses that come with their cameras.

You can use a piece of white material or shower curtain liner over a window to diffuse too-direct light coming in. Poster board also makes for a cheap reflector in a pinch.

Be sure to anchor your backdrop securely, especially if you're shooting fragile objects. Clamps, tape, even rocks—if their shadows won't show up in the picture—will all work. Don't use anything that will ripple or cause humps in the board; you want a smooth, seamless surface.

**FIGURE 14-3**

*Photograph courtesy of Eliot Khuner*

▲ The simplest materials can make great diffusers. In this picture, a white shower curtain liner was used to diffuse overhead light shining on the objects below.

**FIGURE 14-4**

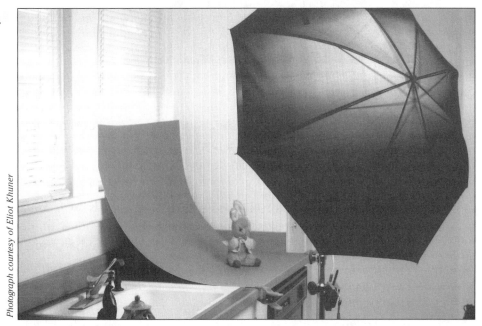

*Photograph courtesy of Eliot Khuner*

▲ This simple tabletop setup shows how poster board should be curved behind the object being shot.

**FIGURE 14-5**

Photograph courtesy of Eliot Khuner

◀ The result of shooting with the curved poster board as the backdrop.

## Other Accessory Items

It often takes some creative sleight-of-hand to get good pictures of objects both in the wild and in controlled settings. Photographers who specialize in object shots rely on items like these:

- **Tweezers:** For rearranging or removing things like leaves, twigs, and pieces of hair. Long tweezers are often easier to work with than short ones. You can find them at hobby stores and some hardware stores.
- **Soft paintbrushes, makeup brushes, cotton swabs:** For removing such things as dust, dirt, and crumbs.
- **Double-sided tape:** For sticking things together and stabilizing small objects. Fine-art clay is also a good thing to have on hand for keeping objects in place.

- **Duct tape:** Where would we be without the stuff? Not only will it adhere to almost everything and stick almost anything together, you can use the roll to elevate objects in a still life.
- **Water bottle:** For spraying flowers or adding condensation to other objects like glasses and bottles.
- **Paper towels:** For drying objects off or mopping up spills. You can also use paper towels for handling shiny objects without leaving fingerprints.
- **Small butterfly clips or straight pins:** For holding fabric folds in place.

**FACT**

The tonal range (from white to black) of light-colored flowers is a fabulous palate for creating black-and-white images. Start with a flower that's not fully open. Keep it alive in a vase, and photograph it over the time it takes to open, capturing it in a variety of lighting and phases. Or, select several blooms in various stages to see which gives you the most creative possibilities.

# Film Choices for Object and Still-Life Pictures

As finicky as color slide film can be to work with, it's ideal for taking object and still-life shots where color is a critical element in the composition. Nothing beats slide film for rendering crisp, sharp images, especially when shooting outdoors with wide apertures and slow shutter speeds (with a tripod-mounted camera, of course).

If you're going for a grainy, more painterly effect, switch to fast color print film, which is also a good choice for shooting indoors in artificial light. You can use color slide film indoors as well, as long as you remember to select the right film for your lighting conditions. (You'll find more information on film selection in Chapter 7.)

Black-and-white film can yield some fantastic images when photographing things like flowers. Because color balance doesn't matter, you can bring flowers inside and use photofloods or window light to create wonderful shadows and highlights.

# Putting Together Your Shot

One of the really fun things about object and still-life photography is being able to create a variety of images simply by moving your camera around. This kind of photography will let you experiment to your heart's delight with camera angles, lighting, distance, framing, and composition. Some of the shots you come up with may not be the greatest. Others might be fantastic.

Always keep your eyes peeled for found objects to use in still-life shots. Old pieces of wood, rocks, tin cans, shells, and other such objects can all be used to add character, texture, and color to these pictures.

## Angles of Approach

Shooting straight on when taking object and still-life shots is often not the best approach. Try shooting from a variety of angles—as you change the camera's position, the relative sizes of your objects will change, and the distances between them will appear differently. Shooting from different heights will do the same. You can even place objects on a piece of glass or a glass tabletop and shoot them from below.

## Focusing

Shooting close-ups requires some special attention to how images are focused. When you're shooting at normal focusing distances, your depth of field (the zone in which images are their sharpest) extends one-third in front and two-thirds behind your point of focus. With close-up shots, however, it only extends one-half in front and one-half behind your focus point. In addition, since you're working at such high magnification, depth of field is extremely shallow. The difference between being in focus and being out of focus can come down to millimeters, even if you're using a small lens opening.

You can't rely on autofocus lenses to create well-focused close-up shots. Set your camera for manual focus, and choose your point of focus carefully.

## Composition

If you're staging a still-life shot, keep in mind that the best ones usually take some maneuvering to make them come out right. Choose a dominant object and arrange the other objects you want to use around it. Pay attention to how the objects relate to each other, how their colors and shapes either enhance or detract from the picture you're trying to create. There's really no right or wrong way to arrange these shots, although it's always helpful to follow basic compositional techniques such as power points and the rule of thirds. You may have to elevate some of the objects to create the most pleasing arrangement.

Photographing flowers, mushrooms, leaves, and such brings you close to nature. Shooting these pictures requires a good eye for finding objects that are already arranged fairly well since creating these compositions usually looks artificial. If you get used to looking through your viewfinder when you're hiking through woods and fields, good nature shots will just about jump out at you. The best subjects are in settings with strong compositional elements, such as leaves, branches, rocks, streams, or pools of water.

**FIGURE 14-6**

*Photograph courtesy of Eliot Khuner*

▲ A 105mm lens with a close-up attachment produced this photograph. The flowers were sprayed with water before the photo was taken.

When shooting flowers in the wild, keep in mind that they will sway with the slightest breeze, which will cause problems when taking close-up shots. If the flower or flowers move out of your depth of field, you'll get both motion blur and out-of-focus images. Shooting with a small f-stop will increase your depth of field, but it will also bring distracting scenery into focus. However, if the subject is brightly lit either by flash or sun, and the rest of the scene is in shadow, your subject will stand out from the background.

**FIGURE 14-7**

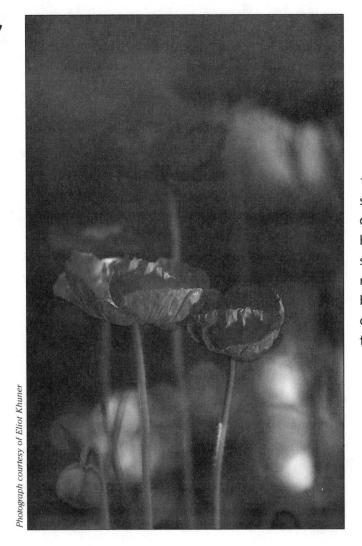

*Photograph courtesy of Eliot Khuner*

◀ This image was shot using limited depth of field in a backlit garden. A small square of silver mount board bounced the sunlight onto the flowers from the side.

*Chapter 15*

# Getting into Action

Taking pictures of moving objects frustrates many amateur photographers. Subjects can be blurry beyond recognition, and peak moments may have happened before the shutter actually opened. Whether your goal is to capture that game-winning play at your daughter's soccer game or the excitement on your family's faces as they watch it happen, learning the techniques behind action photography will greatly enhance your chances of getting great action shots.

# The Art of Shooting Moving Objects

Taking good action pictures basically requires three things: the right equipment, being in the right place at the right time, and knowing the photographic techniques that are specific to this type of photography.

The equipment part is relatively easy. The other factors can be a little more difficult to master, but the challenge is not insurmountable. Like all types of photography, taking good action pictures requires some practice. And, as is the case with most types of photography, the best shots are often the result of careful planning done ahead of time.

## Getting Equipped for Action

One of the most difficult aspects of action photography is the distance at which many of these shots have to be taken. It can be extremely tough to get close enough to the action to fill your frame with it, which makes shooting with a long lens essential. Low light situations will also call for a telephoto with a wider maximum aperture unless you decide to use slower shutter speeds to blur the action.

Lenses with long focal lengths not only increase image size, they also increase the effect of the subject's movement. If a shutter speed of 1/250th of a second freezes the action when you're using a 50mm lens, you'll need double the shutter speed to 1/500th of a second to achieve the same results with a 100mm lens.

If the telephoto or zoom lens you already own isn't long enough, consider punching up its focal length by using a teleconverter. If you're serious about action photography, a fast, medium-range telephoto lens with a maximum aperture of at least $f/2.8$ or an 80–200mm zoom lens with as large a maximum aperture as you can afford will be a worthwhile investment.

Wide-angle lenses have their place in action photography too, especially if you want to show more of the surroundings.

Other essential equipment for action photography include the following.

- **Tripod:** Helps you keep the camera steady while panning and lets you follow the action when using slow shutter speeds.
- **Electronic flash:** Useful for freezing action both indoors and out.
- **Lens hoods:** Shades your lenses from the glare caused by bright lights.

## Scoping Out the Action

One of the reasons that professional sports photographers get such great shots is because they usually know in advance the conditions they'll be shooting in. (They also use extremely long, extremely fast lenses, but that's besides the point.) While they can't control the weather or the lighting when working outdoors, they do know the best vantage points for capturing the action, whether indoors or out. This lets them get their equipment set up in advance so that when the action comes to them, they'll be ready to shoot.

Being able to anticipate where and when the action will take place is a major factor in being able to shoot it well when it does. If you're photographing a soccer game, you might want to position yourself near the goalie's net. Getting close to where points are scored will also help you catch the peak of the action at football and basketball games. A classic spot for shooting car or races is at a bend in the track.

When choosing a shooting location, keep in mind that the angle you're shooting from will greatly affect the types of shots you'll get. Action that moves directly toward or away from you is the easiest to stop, and you'll be able to use slower shutter speeds to capture it. Subjects moving at right angles to your camera are more difficult to stop and will require the fastest shutter speeds you have. It's also easier to stop the action at a distance than when it's close up.

# Winning Shooting Techniques

Many action pictures are taken with the fastest shutter speed possible. This freezes the subject's movement and results in stop-action photos with sharp images. Very fast shutter speeds can even capture images that contain more than the eye can see, such as the spray surrounding a

diver as he hits the water, or the dirt kicked into the air by a broad-jumper's feet as she lands.

But using fast shutter speeds is just one way to capture fast action. There are several other techniques you can also use that will allow you both to shoot in a wide variety of lighting situations and to capture pictures that better convey excitement and ongoing action.

## Freezing Action with Flash

Using a flash unit is one of the best ways to get good stop-action pictures in poor light conditions, both indoors and out. The burst of light made by an electronic flash only lasts about 1/1,000th to 1/10,000th of a second, more than enough to eliminate motion blur in any fast-action situation.

When taking stop-action photos, keep in mind that they're most effective when the viewer can see something that indicates what the subject is doing. Avoid shooting people as they fly through the air unless you can also include the object they're moving away from or towards. If you're taking a picture of a gymnast doing a dismount from the uneven bars, frame your shot so at least part of the apparatus is in the picture. A picture of a diver should include the springboard, the platform, or the pool. For track and field events, capture the javelin as it's being thrown or the hurdles as they're being jumped.

**ALERT!**

Ask before using flash when shooting indoor sporting events. Since the bursts of light can be distracting to the athletes, many organizations prohibit it unless you're a professional photographer covering the event.

## Panning the Action

Another great way to stop action in its tracks is to move your camera along with it. This technique, called panning, will result in a blurred background and a sharply focused subject.

Panning can be a little difficult to master, but it's worth taking the time to learn how to do it well if you're serious about taking action pictures. Not only do panned pictures convey a greater sense of speed, they can also be taken with longer shutter speeds—even speeds as slow as 1/8th of a second. The slower the shutter speed, the more blurred the background will be. Flash can also be used while panning to pop the subject out of the background.

Here's how to use this technique:

1. Stand with your feet planted firmly on the ground, facing directly ahead of you. You can shoot from other positions, but standing is usually easiest. Use a long lens, and stand far enough away from the subject to allow you to properly frame it.
2. Prefocus on the place where you want to take the picture. An autofocus camera with continuous-focus or focus-tracking mode will make panning easier as the lens will keep the subject in focus while you follow it in the viewfinder.
3. After you've prefocused on the point where you want to capture the action, aim your camera toward the direction where the action will appear. Try to only turn your upper body when you're doing this— keep your feet facing your focus point and concentrate on moving your body by twisting your torso from the waist up.
4. As the action approaches, keep it centered in your viewfinder. Keep your feet pointed forward while you move your upper body in an arc. Keep the camera level as you move to avoid tilted images.
5. When the moment is right, press the shutter.
6. Keep following the subject in your viewfinder after you take the shot. This follow-through action is necessary to capture the entire effect of the pan. Don't get distracted by the image blackout caused by the slow shutter speed—just keep moving through the shot.

You can also pan with your camera mounted on a tripod. Some people find it easier to do so for the following reasons.

- **Smoother panning:** The tripod will keep the camera steady throughout the panning action.
- **Better images:** Using the swivel head on a tripod eliminates jerkiness, which can cause vertical blurring in addition to the horizontal effect you're after.
- **Less shooting fatigue:** Standing in place with your camera, especially when you're using a long lens, can tire you out in a hurry.

Since the tripod replaces your body movement, you can follow the same procedure as given above when using one for panning.

Although panning is just about the best way to capture objects while they're moving and make them look like they're moving, it does have its drawbacks. It's not an easy technique to master, nor is it easy to keep things focused as you're moving the camera. Also, it takes some practice to match your panning speed to the speed of the subject, although panning faster or slower doesn't necessarily result in bad pictures, just ones in which the subjects are more blurred.

## Blurring the Action

Sometimes blurred images are the best way to portray action. You can create them by using extremely slow shutter speeds, even as slow as 1/4 to 1/2 of a second. If you're shooting with a tripod, only the objects that are moving will be blurred. If you handhold the camera, you'll end up with a shot that's blurry all over as the lens will also capture your movements as you take the picture. These pictures might be tossers, or they might turn out to be beautiful abstract portrayals of time and motion. Film is cheap—don't be afraid to experiment with it.

Shooting flowing water at slow shutter speeds will cause the water to blur and give the feeling of motion.

**Chapter 16**

# Photographing People

Taking pictures of people can simply be about recording their appearance or their attendance at a special event. Good people pictures, however, go beyond just asking people to say "Cheese." They say something special about their subjects. Whether you're taking pictures of kids or adults, the best images depend more on conveying feelings and relationships and less on striking picture-perfect poses.

## Getting Great People Pictures

If you're like most photographers, you take more pictures of people than anything else. Maybe you bring out the camera because you want to remember your daughter or best friend just as she is now. Or you might be celebrating a special occasion, and you want to mark the moment by recording the people around you. The way you feel about someone might inspire you to make him or her the subject of a photograph.

In each situation, you could simply take a couple of quick snapshots and be done. But you'll end up with a much better picture if you spend a little time thinking about what you'd like it to say about the subject.

There's nothing wrong with snapshots. Frankly, they're sometimes the only way to get a picture on the fly or to photograph a subject who's less than cooperative. But people pictures are always better when the photographer—you, in this case—builds some rapport with subjects and puts them at ease. This holds true regardless of the setting, whether it's indoors or out, formal or informal, although your considerations will differ a little depending on the setting.

Although most pets aren't very good at sitting still and probably won't follow your directions, many of the people-handling techniques discussed in this chapter will work equally well when taking pictures of Fido and Fluffy.

## The Smile Factor

Portraiture is about feelings and relationships, not about posing, although getting your subject to meet the camera in a flattering way is important too. Sometimes this means having your subject smile for the camera. But not always.

Most people look best when they're smiling as it indicates a cheery disposition and a pleasant mood. As the photographer, however, your job is to get the best picture of your subject. A smile might not be part of the equation, either because it doesn't fit the emotional tone of the picture or the subject's personality isn't that sunny to begin with.

## Putting a Smile on Their Faces

If you're taking a quick informal shot of a child or an adult, and the general tone of the situation is light, getting a smile for the camera is definitely the way to go. Ask your subject to do it, and you might end up with a pleasant expression. Then again, you might not.

Instead of asking for a smile, try to get one by using one of these tricks:

- **With an adult:** Joke a little as you fiddle with the shot, or ask some questions to help her relax. Choose general and pleasant topics. Even if you don't catch her laughing in the final picture, traces of earlier jollity will be evident in her face.
- **If you're taking a picture of a little kid:** Try wiggling your fingers or making a silly face.
- **Smile first:** Just about anyone will return a smile.

# Striking a Pose

Getting people to hold their bodies comfortably and naturally is another aspect of shooting people that's largely in the hands of the photographer. Most people stiffen up and do funny things with their bodies when asked to pose for the camera. If you're staging a people shot rather than grabbing one on the fly, you'll have to tell your subjects what they can do to make their body alignment more pleasing.

## Body Language

People almost always look best when they're not photographed straight on. This pose makes their shoulders and torsos look too wide for their heads. Sideways shots are also problematic as they make the shoulders look too small to support the head.

If you're posing people for a shot, have them turn their upper bodies slightly away from the camera. Anywhere from 15–50° will work.

Poor posture may or may not show up in a picture depending on how it's taken. If you're doing a posed shot, it almost always helps to ask your subject to sit a little taller just before you take the picture. In candid

shots it's up to you to find the camera angle and lighting that works the best with the person's posture.

Other common posture problems include these, with some suggested fixes:

- **Shoulder slump:** A very common problem for both men and women. You can correct it by asking them to push their shoulders toward the nearest wall while sticking their stomachs out toward the camera. This straightens the back and opens the chest, which also balances the proportion between the waist and the upper body.
- **Upper-body slouch:** This differs from shoulder slump as it results in the entire upper body leaning too far forward. Correct it by having your subject imagine that there's a string or a rope attached to her head that's pulling her up to the ceiling.
- **Chin tuck:** Men often tuck their chins right into their necks, which causes double chins and makes their necks look short. Ask your subject to point the tip of his nose toward the camera—it will bring his chin forward at the same time without making it jut out unnaturally.
- **Chin jut:** This one's fairly easy to fix. Just tell your subject to drop his chin or point his forehead toward the camera.

Posture problems and other figure flaws can also be solved with creative lighting and by finding more flattering camera angles.

**QUESTION?**

**Is it ever permissible to not show a subject's eyes in a picture?** Like most rules of photography, this one can definitely be broken. If your intention is a character study rather than a classic portrait, it's perfectly okay to obscure one or even both eyes, depending on how the subject is posed.

## It's All about the Eyes

Most portraits clearly show both of the subject's eyes, whether the subject is looking at the camera or away from it. This is one of the classical rules of portraiture. This composition is pleasing to the viewer because we expect to see the eyes.

The general rule is to keep the whites of the eyes fairly even when the subject is looking away from the camera. Seeing a lot of white disturbs the viewer. It's also disconcerting if the subject is turned away from the camera but is turning his or her eyes toward the lens.

## Those Pesky Appendages

Hands can make or break an otherwise well-posed photo. Bringing the hands to the face can be classic or cliché. Give it a try, but don't make it the main point of the picture unless the subject's hands are an important part of her profession or hobby.

Hands generally look best when photographed from the side rather than from the front or back. For the most natural look, have your subject pretend to hold a thick credit card between thumb and middle finger. Then turn the hand so the palm or the back doesn't show.

Feet and leg position can make or break pictures, too. For a formal, full-frame portrait have the subject assume the classic ballet "T"—front foot facing the camera with the heel of the foot positioned near the arch of the back foot. For more informal poses, anything goes as long as your subject is standing comfortably and attractively. The "T" position is considered feminine, men can stand with their feet apart.

# Taking Pictures of Individuals

Single-subject shots generally fall into two categories: classic portraits, in which the person is the only subject and is isolated from time and place, and environmental portraits, which include the person's surroundings.

**FACT**

Classic portraits are also called cosmetic portraits as they focus on the subject's features—hair, eyes, lips, nose, and mouth.

Most people think of formal studio shots when they hear the term "classic portrait," but the term really describes any picture of a person that focuses more on them than on their surroundings. While formal

portrait shots taken in specially equipped studios are also classic portraits, they're beyond the interest of most amateur photographers and won't be dealt with in depth here. If you're interested in learning more about them, turn to Appendix B for more information. Shooting classic portraits in more informal settings is vastly more fun as you don't have to worry as much about such factors as posing and lighting. For the most part, your subject is going to do what he or she does naturally. Your job is to figure out the best way to capture it on film.

# Setting up the Classic Portrait

Since backgrounds are secondary when taking classic portraits, you can shoot them just about anywhere. Since you'll be shooting with a wide aperture to blur the background, find a spot where the background's color and light will enhance the subject.

## Camera Placement

Classic portraits usually look best if you position your camera a few inches higher than the subject's eyes. This puts the subject's body and head at a flattering angle and puts the eyes at a pleasant spot in the frame. But this is by no means the only camera angle to use. Shooting upwards can emphasize the individual's stature or balance unflattering up-light if you're shooting outside. It can also put a different colored backdrop behind the subject, such as the sky, an arbor, or the leaves of a tree. Using a high camera angle and shooting down at a subject can make a heavy person look slimmer.

Not filling the frame with the subject and leaving too much space above the head are common errors in snapshot portraits. Avoid them by putting the eyes at the upper one-third line. Leave just enough room above the head so that it isn't crammed against the top of the frame. Back up or zoom out as needed.

Faces look best when viewed at a distance of 6 to 8 feet. Get closer than that, and the nose appears larger and the ears smaller. Move farther away, and there is a loss of connection between the subject and the photographer. Greater distance can also mean the face is slightly distorted by compression (which results from the absence of some visual cues about depth and perspective). Whether your image will include just your subject's eyes, or complete head and shoulders, keeping in the 6- to 8-foot range will give you the best results. Full length shots can be done at greater distances with no problems.

**FIGURE 16-1**

*Photograph courtesy of Eliot Khuner*

◀ This window-lit portrait was taken using a low camera angle to help show the subject's dignity. Note how the whites of her eyes are fairly equal even though she's looking away from the camera.

## Selecting the Lens

The best lens choice for shooting classic portraits is one with a focal length that's about twice the length of a camera's normal lens. For 35mm cameras, a lens with a focal length between 85mm and 135mm (short telephoto) fits the bill. If you have a zoom that covers this length, you're in business.

This short telephoto length works well for several reasons. It shows people's faces with the least amount of distortion. It also allows you to fill the frame with your subject without having to be too close for comfort. A zoom with an even longer focal length, say up to 135mm or 150mm, will let you get even tighter detail shots without having to move in.

**ALERT!**

Don't use a wide-angle or normal lens for classic portraits. They cause too much distortion of facial features, creating warped images.

Shooting with your lens's largest aperture will give you the shallow depth of field you need to isolate your subject from the background.

## Posing the Classic Portrait

In the classic portrait, the subject can look at the lens or elsewhere, he can make eye contact with the viewer or be absorbed in a book. A seated subject is usually the easiest way to do a head and shoulder portrait. Your subject should sit in a seat without the visual distractions of arms or back.

## Lighting the Classic Portrait

How you light your subject will have a great deal to do with the mood and tenor of the final picture. If you're after a pensive, introspective look, try lighting your subject from the side. If you're shooting indoors, try to use natural lighting whenever possible. If necessary, use a tripod and make a long exposure. Window light can make some of the most pleasing pictures.

For more on various lighting techniques, turn to Chapter 9.

**FIGURE 16-2**

Photograph courtesy of Eliot Khuner

◀ Directional lighting coming in through a doorway was used to create this simple and quick portrait. Note that the photographer broke the rule of balancing the whites of the eyes. Was this a good choice?

# Environmental Portraits

Unlike head-and-shoulder shots in which the background is secondary to the subject, environmental portraits include the person's surroundings—beaches or mountains, a teenager's bedroom, an artist's studio, or edgy, gritty urban settings—to show the relationship between subject and territory.

While not necessarily essential, when composing an environmental portrait, it is usually better to have your subject interacting with his or her settings, rather than just standing in front of a workspace.

# Locations for Environmental Portraits

Just about any place you want to take a picture is fair game for an environmental shot. Consider both indoor and outdoor settings. Ask the subjects where they feel comfortable.

As you're scouting locations, look for the setting that allows your subject to pose comfortably and safely. Think about the size of your subject in the frame. Keeping the subject large and close to the camera is usually a good starting place, given that the most common error in taking pictures of people is not filling enough of the frame with the subject. Experiment with a range of subject sizes: totally filling half, a third, or a quarter of the frame, or even doing a full-length shot in which the subject's height is about one-fifth the height of the frame.

Parking lots near wooded areas make ideal portrait locations. Not only are they convenient for you and your subject, they offer an open sky and scenery to light your subject, as well as a tree canopy to block out direct overhead light. You'll find the best light a few steps into the woods.

## Working with Outdoor Settings

Gardens, porches, the woods near your house—they're all possible places for taking environmental portraits. In fact, just about anywhere will work as long as the light is right.

Open shade, such as that found under the branches of a tall tree, in the shadow of a building, or under an awning on a sunny day, is the photographer's favorite as subjects are lit by the sky and the scenery around them. When looking for these settings, try to find those near something that will reflect sunlight into the shady area as light in the shade often lacks direction. Soft light, not direct light, that comes primarily from one direction is ideal.

**FIGURE 16-3**

*Photograph courtesy of Eliot Khuner*

◀ Breaking the rules can yield great shots. The bride is too distant for her features to be clear. However, her luminous gown, framed by the foreground porch, creates a sensitive and evocative portrait of a young woman's last minutes before her wedding. A soft-focus filter cuts down on the contrast and softens background foliage.

If you have to shoot a portrait with the camera pointing toward the sun, put your subject's back to the sun and use something bright, such as a piece of white cardboard or portable reflector, to light your subject's face.

Avoid shooting in overhead light as it casts shadows in the eye sockets and under the lower eyelids (a particular problem with children). You can erase them to a certain extent by raising the subject's chin. Young faces prone to undereye shadows might be able to tolerate up-lighting, which eliminates these shadows. Have the subject look down towards your feet or off-camera, not directly into the light.

## Improving Outdoor Light

It's often necessary to balance the light in environmental shots. Keep a piece of 2-foot by 3-foot (or larger) poster board in your car or bag when you go out on a portrait expedition. Use the reflector to bring light into dark shadows so that they don't print totally black, or as a hair light from behind the subject. You can also use it as a fill light to add a hair of light from behind or bring a touch of light into the shadows so they don't go black in the final image.

Flash also works well when shooting portraits outdoors. One neat trick is to take the flash off the camera. Have an assistant hold the flash close enough to your subjects to light them. Or, if your shutter speed is long enough (more than ten or fifteen seconds) you can release the shutter then run to the best spot to pop the flash. Feeling really adventurous? Have the subjects hold the flash and light themselves!

## Working with Backgrounds

While scenery plays an important role in environmental portraits, it isn't meant to be the main subject of these pictures. Use the surroundings to enhance your subject, not detract from him or her.

If you're working with color film, look for backlit foliage—its greens and yellows are great for bringing out flesh tones. Choose colors to flatter the subject. If your subject has dark hair, you will want your background to be lighter than the hair so that they don't merge. Backlighting can light up dark hair nicely so that it stands out from a dark background, making a dynamic portrait. Keep the background as simple as possible—if it's too busy, it will go to war with your subject.

Sometimes you just have to take a picture of someone right where he is standing, in front of your house, at a ball game, at the airport. Select a camera position that gives you a distant or low-contrast background. If the surroundings are very distracting, you can try a very low or high camera position to isolate your subject against the sky or pavement.

Avoid sharp lines poking into or growing out of your subject. The classic goof is to have a tree or telephone pole growing out of the head. You want to put the cleanest, least distracting part of your background

behind your subject's head. If there is a horizon or any strong horizontal in the background, either lower the camera angle to put it above your subject's head or find a higher vantage point so you can drop the line below your subject's shoulders.

While you probably won't be able to always consider all these factors when taking shots, keeping them in mind as much as possible can do nothing but improve the photographs you take, even the quick snapshots. Eventually, most of these techniques will become second nature.

## Posing the Environmental Portrait

The basic consideration is a simple one: seated or standing? Both poses have their advantages and drawbacks. Seated subjects are often more comfortable, and you can use a higher, more flattering camera angle to shoot them. Seat your subject on a bench, stool, or other perch without a back, which can be a distracting element in a portrait.

Full-length standing portraits will make subjects appear more slender. However, they can also create a lot of vertical lines (legs, arms, torso), which aren't good. Use props, such as a bouquet, a book, a pair of glasses, to occupy the hands. Men can put one hand lightly in a pants pocket, allowing the elbow to bend gently, the other can rest on the top of a chair, counter, or other prop so that it creates a diagonal line leading up to the head. Here's another rule of thumb for poses: if it bends, bend it! Cross legs or ankles. Bend the elbows, and let the head tilt just a touch, very subtly. Avoid idle hands that just dangle at the side.

Try to avoid cliché shots when taking portraits. The photograph of the maiden with her hand caressing a tree is so timeworn that the image is likely to look stale. Using that tree to stage a portrait of a couple of little kids shot from the ground, however, can result in a cute portrait that shows kids doing what they do best—having fun.

## Lens Choice

You can use just about any lens you own to take an environmental portrait. A wide-angle lens will let you include foreground, medium ground, and background to give your photo depth. A normal or telephoto lens will cut more of the environment out. While including the environment is essential for this type of photography, you still only want to include the environment essential to your image's composition.

## Camera Position

Environmental portraits can be shot from just about any camera angle. Try various positions to see how shooting from various angles affects the mood and tone of the picture. Taking full-length shots with the camera at about the height of the subject's midriff avoids distortion.

# Shooting More Than One

Pictures of couples, families, kids with pets, and so on also fall into the classic and environmental categories. Most of the techniques used to photograph single subjects also apply to these shots. However, taking them requires some extra finesse when it comes to posing, composition, and lighting. That's because all the factors you have to consider when taking pictures of individuals are now multiplied.

## Lighting Considerations

It's often difficult to light multiple subjects equally. If you pose two people looking toward each other, they'll both catch the light differently. Shooting with nondirectional light is often the best answer. Or you can stay with a strongly directional light and use a fill (poster board or flash) so that no details are lost in the shadow. Another option is to make the picture about just one person, whom you will light well, and let the other person be somewhat obscured in the shadows. For example, if you photograph a mother looking at her newborn, you might light the infant, but let the mother's face be in shadow.

Lighting a large group is always a challenge. If you're shooting outside, your subjects will squint if they face the sun. If you take the picture under noontime sun, the shadows on their faces will ruin the shot. Strong directional light from the side may put some of the people in other people's shadows. Try to time these shots for the hours around sunrise and sunset, which are great times for catching warm yet directional natural lighting. If you're limited as far as the times when you can shoot, create a backlit situation by placing your subjects facing away from the sun. Use the backlighting setting on your camera, or manually increase your exposure by one or two stops. Using fill flash to brighten the group and balance lighting between its members is also an option.

When shooting groups indoors, avoid using direct flash. Instead, use the bounce flash techniques described in Chapter 10 to create more pleasant artificial lighting. At a distance of more than ten to fifteen feet, your bounce flash will not be strong enough, so use a direct flash but aim it slightly higher than the group to even out the lighting.

## Posing Considerations

You have two options when taking pictures of groups: spreading them out so they fill the scenery, or keeping them close and in contact to emphasize interpersonal relationships. If the picture is more about the setting than the people, then you can increase the spacing. Zoom out or back up to include the scenery and the spread-out group. For group pictures at a picnic, family reunion, or celebration, you'll want to come in very close. The closer people are to each other, the larger they will appear in the final image. This is very important if you want to be able to recognize faces in a large group.

A good rule of thumb for relative subject size is to get close enough to the group that if you added two people at each end, you would have to back up the camera or zoom out.

# Choosing Film for Portraits

Some of the most familiar portraits in the world have been shot with black-and-white film, and it continues to be a popular choice for classic portraits. However, there's no universal reason to select black-and-white film over color, or vice versa. For the most part, film choice really depends more on what your subjects prefer, what will make them look their best, and what the feelings or emotions are that you want the picture to convey.

## Color Portraits

Slide film with give you beautifully saturated colors, but people with ruddy complexions will look even redder if you use it. The same slide film, however, will do a wonderful job of bringing out the subtleties in the delicate coloring of children's faces.

Color print film, which will also enable quick and inexpensive printing, is probably a better choice for outdoor color portraits. People with poor complexions may prefer a film that will disguise imperfections. Fast film—ISO 400 and faster—has larger grains that can help hide skin problems. Pictures taken with fast film will be more about mood and drama, regardless of the setting or the subject.

## Black-and-White Portraits

The long tradition of fine art black-and-white portraiture is carried on through the use of the finest grained film that lighting conditions will allow—usually ISO 50 to ISO 100. If you're using a good lens, fine-grained film, and a tripod, and if you focus carefully, every detail and imperfection will be obvious in the final print. Prepare your subject for a very truthful portrait. If you need to hide some skin imperfections, use faster film for its grainy effect.

Black-and-white film allows you to work with light sources (like fluorescent and tungsten) that with color film would produce bad skin tones. If your plan is to try some indoor portraits using incandescent lighting, definitely use a fast (ISO 400) black-and-white film. Outdoors, you can use a slow film (ISO 100) if you have a tripod, but use a high-speed film (ISO 400) for handheld portraits.

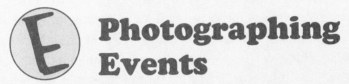

### Chapter 17

# Photographing Events

Graduations, weddings, birthday parties, retirement parties—life is full of special events worth capturing on film. Just as balloons and confetti are signs of celebration, so is taking out the camera often a sign that there is something important happening. In fact, taking pictures makes special events even more special.

## Know Your Place

Are you a guest with a camera at a formal occasion like a wedding? Or are you the photographer, with everyone counting on you? If you aren't the hired photographer, don't get in the way of the professional. In fact, professional photographers often have a contract giving them the exclusive right to capture posed shots. But you should be allowed to photograph all action that happens without the professional's prompting or arranging.

A professional photographer is absolutely the best choice for once-in-a-lifetime events. However, this doesn't mean that you can't take some good pictures, either for yourself or for other participants at the event, and still enjoy the occasion.

If you're taking pictures in a church or synagogue, respect the customs of the faith. Keep your movement and noise to a minimum so you don't interfere with the service or detract from the experience of other attendees. Don't be a bad representative of the photographic community. Flash photography? Check with the clergy and the event coordinator first.

The same cautions hold true for taking pictures at other occasions—school plays, museum exhibit openings, retirement parties, and so on. If you're not the official photographer, stay in the background. Be respectful of the others around you when you're shooting. Always check to make sure it's okay to use flash. And be respectful if the answer is no.

**ALERT!**

Museums often prohibit flash pictures. Some even prohibit the use of tripods. "Borrowed" exhibits are often restricted from being photographed. Ask what the restrictions are, if any, before you start shooting. You'd also be surprised at the number of places that don't allow photography at all. Always check ahead!

## Why Are We Here?

Before you take pictures at a special event, think about why these people have gathered. They are celebrating a tradition that connects all the people in the room, a tradition that connects them to their ancestors, and

even to their great-great-grandchildren, who will do the same rituals some day. These events acknowledge connection and joy, and so does good photography performed by a respectful photographer.

Don't interfere with the moment. Anticipate the flow of movement and emotion. What is the purpose of the photograph you are about to take? Is it just a snapshot? Or does it capture a special interaction? Are you taking the photos for your own pleasure, or for the honored family or couple? Who will your audience be? Think about what your viewers will want to see, and what their point of view is.

## Two Approaches to Event Photography

Today's photographers have two operating modes during the special day. One approach could be thought of as the "fly on the wall," or photo-journalism mode. You're there to capture what happens, but not to change or affect the people or the scenery. The subjects are unaware of your presence. You don't arrange the subjects in your photo. Instead, you anticipate and are in the right place at the right time to capture the moment.

The other mode is "subject aware." You help schedule the day, making sure time is set aside for you to take pictures. You move furniture, and you are in charge. You direct people where to stand, where to look. You help people look their best by adjusting the lighting, attending to details, and interacting with them so they enjoy their time with you and look real in the photographs. The "subject aware" approach is also called traditional photography.

Event photography is a mix of the two approaches. Develop the judgment to know which mode is called for at each moment. Keep your audience in mind. If there is a professional photographer taking formal pictures and you intend to give your images as a gift to the family, get the moments that the professional is missing, those little glimpses that the family doesn't see because they're busy posing. These would be done in the photojournalistic mode. On the other hand, if Aunt Minnie showed up late and missed the formal portraits, you can take a picture of her and the confirmation girl or the groom's father. This might be a traditional or posed picture.

## More on the Photojournalism Approach

Let's suppose your goal is to get a picture of the groom and his stepfather. You see the two men talking together in a corridor away from the main action at the event. You find an angle that shows both their faces, or maybe shows one man gesturing and the other responding with an interesting expression. Or maybe you sense the impending hug or pat on the back.

You anticipate the moment, snap enough frames so you can select a group from them that together tells a story about the moment, and then you move on to other subjects.

## More on the Traditional Approach

If you're taking the traditional approach, you'll wait until the two men finish talking. Then you'll direct them to face the camera and step to where the light and scenery will make a more pleasing image. You might ask them to put an arm around each other. You'll adjust their ties, jackets, and hair. You'll say a few words to them to get them involved in the moment, then snap the shutter when you sense that they are feeling connected and looking their best.

**FACT**

Which approach is best? If you're not comfortable directing people, or if your subjects don't like to pose, your best bet is to be a fly on the wall. If you've been asked to take more formal pictures of various event participants, then the traditional approach is the way to go.

## Essential Images

Whether you're taking pictures for fun or you've been asked to do so, there are some images that are expected, reasonable, or essential. If you think of the different types of images that comprise event photography, you'll avoid getting in a rut or missing something important.

A complete collection of event photos should include the following.

- **Scene setters:** Images that tell the viewer what the special event is.
- **Illustrative:** Images about the event that evoke a feeling or mood.
- **Traditional:** Portraits, from close up to full length, plus group shots and maybe a few staged moments between certain people.
- **Expected moments:** The traditional activities or parts of a special event.
- **Unexpected moments:** Unstaged, unplanned, intimate, or emotional exchanges that naturally take place.
- **Creative:** The unusual angle, the odd juxtaposition of subjects, the single shaft of light, a powerful piece of architecture. Use these to create photographs that are about the day but offer a new way of seeing it.

# Tips on Shooting Essential Images

Although there is no absolutely "right" way to photograph an event, knowing how various images are set up and composed will help you know what to do to create them.

## Setting the Scene

These are photographs of objects that tell the viewer, "This is a bar mitzvah" or "This is the bride getting ready." Look for items that evoke the day—the bride's shoes, the baby's christening gown, a yarmulke with the bar mitzvah boy's name embroidered on it. Find reflections of the personalities in objects, like the groom's cufflinks lying on his golfing magazine.

Once you put yourself in this frame of mind, these pictures are fun and easy to take. Since these pictures are usually of stationary objects, use available light and a tripod if necessary. Fill the frame with the subject.

**FIGURE 17-1**

*Photograph courtesy of Eliot Khuner*

▲ This scene-setting picture is of items used during a bar or bat mitzvah ceremony.

## Illustrative

These photographs tell a story with the mood of the lighting, the postures and gestures of the subjects, and the setting. Find natural settings that frame the subjects. Look for S-shaped paths for the bride and groom to walk along. Avoid having the poses look like the couple is following your direction. For example, if you want a picture of the couple kissing, start by having them face and hold onto each other, then have them kiss. Don't just tell them to kiss. The picture will look like they were told to.

**FIGURE 17-2**

*Photograph courtesy of Eliot Khuner*

◀ A good example of an illustrative special-event picture. The action of the flower girls scrambling up the stairs is more important than their faces.

## Traditional

If a professional photographer is taking these shots, you needn't duplicate them. In fact, your clicking the shutter while the official photographer is working may distract both the subjects and the photographer, ruining the pictures the family is paying for.

If you're the hired pro (more on this later), plan on taking pictures of every family member at formal events like weddings, confirmations, bar and bat mitzvahs, and so on. The following list of images for a wedding will give you an idea of the various combinations you should expect to shoot:

- Bride alone—close up, three-quarters, and full length.
- Bride with mom.
- Bride with dad.
- Bride with both parents.
- Just the parents.

- Bride with grandparents.
- Bride with siblings.
- Bride and family (if you include siblings with their spouses, then include the groom).
- Bride with each bridesmaid.
- Bride with flower girls.
- Bride with bridesmaids and flower girls.
- Groom—same family and groomsmen shots as above.
- Bride and groom with each set of parents.
- Bride and groom with each immediate family and each set of grandparents.
- Bride and groom with various aunts and uncles as needed to please the family.
- Bride and groom with minister or rabbi (if the couple wants).

As you work with each pose or grouping, remember that special events like these are about love, tradition, and tenderness. When photographing two people, let them be with each other, not simply posed standing together. Hugging and talking strengthens the sense of connection. Direct your subjects to touch, lean toward each other, or tilt their heads towards each other slightly. Exclude distracting items like purses, watches, and sunglasses.

Make group shots interesting. Have people pose naturally. Turn them toward each other, but usually at no more than a 45° angle.

**QUESTION?**

**Why should I pose people at an angle (instead of facing straight at the camera) for group shots?**
First, it slims the body. Second, it allows you to squeeze more people in. Third, it gets the heads closer together. Fourth, since pictures are about relationship, it is natural have your subjects' bodies turned towards someone they like.

Subjects can be standing, sitting, kneeling, holding each other—anything but standing shoulder to shoulder. Avoid having the subjects'

arms dangling straight down, which makes for a really boring shot. Direct women whose legs are showing to put their feet in third position (feet in a "T") so that the camera only sees the front leg. Don't seat heavy people as it emphasizes their width instead of their height. Slim them down by hiding part of their body behind someone else. People who are sitting should sit forward on their seats. Don't let them slump.

A bride and groom almost always look best if they're at the center of the picture, front row, standing. Don't let anyone cover the bride's dress by standing or sitting in front of her.

**FIGURE 17-3**

*Photograph courtesy of Eliot Khuner*

◀ A traditional portrait of a bride was made more interesting by shooting her from the back and rotating the camera (Dutch tilt) to frame her image diagonally. Posing her near a window highlighted the details on her dress.

## Expected Moments

From the priest's blessing at a baptism to the newlyweds driving off in a limousine, there are traditional activities in all special events. Know how the day will flow to catch these moments. There may be an event coordinator, disk jockey, or bandleader in charge of the scheduling. Keep in touch with them instead of bothering the family to find out what's next.

Depending on the event, there might be some traditions that require special setups and equipment. Anything taking place in a small room will require a wide-angle lens. If you're using flash, you'll want to bounce it off the ceiling or a wall. Bouquet and garter toss also require a wide angle. Position yourself so that you can find the angle that shows the entire crowd behind the bride as she throws the bouquet.

The first dance (and father-daughter dance, along with any other special dances) should first be photographed in a scene-setting way. Get a full-length shot of the couple. Capture reaction shots as people watch. Get a few close-ups of the faces, plus detail shots like his hand around her waist. Avoid busy backgrounds like the music speakers. If the moment is magical, don't interrupt to pose the couple.

Look for action and reaction shots. Photograph the parents watching the couple as they're dancing. Capture guests laughing as the cake is cut. Get a picture of the best man's toast, and the groom covering his face in embarrassment. If a speaker gets choked up while making a speech, watch for parents and siblings to be wiping their eyes too.

## Unexpected Moments

Yes, you can plan for these. Just before or after a scheduled activity, such as walking down the aisle or cutting the cake, watch for moments of deep connection between the main people at the event. Capturing these images may necessitate changing how you're thinking and feeling. Rather than anticipating large-scale action, keep your antennae up for the unexpected. Children are great subjects in this area. Watch for the bride to kneel down to talk to the flower girl. Children on the dance floor? Get out the camera and be prepared.

## Creative

You may have to lie on the floor or hang off a balcony to get an unusual angle. Tilt the camera; take creative risks. Tell yourself the picture might not turn out, but you'll give it a try anyway. Take these images on your own time, after you've shot all the pictures that are important to the event.

**FIGURE 17-4**

*Photograph courtesy of Eliot Khuner*

◀ This well-composed (and unposed) image of a bride's hand was lit by bounce flash, and taken while she was waiting in her room before the wedding. Its angle captures and emphasizes various curves—the bride's hand, the arm of the chair, and the woven patterns in the chair's side and back.

**ALERT!**

Unless you're extremely secure about your abilities as a photographer, and you completely trust your equipment, think twice about accepting an invitation to photograph a wedding. If your skills aren't up to the task, or your equipment fails, it will ruin both the event and the memories for the lucky couple and for you as well. If you do accept, make sure the bridal couple understands your capabilities and limitations. If they want a formal portrait that requires auxiliary lighting, for example, and you don't have it, they'll end up being disappointed in your efforts.

## Gearing up to Photograph Events

As previously mentioned, it's best to leave serious event photography to the pros. But let's say you've been taking pictures for a while and you've

had the opportunity to do some event photography. Enough of it, in fact, to determine that you like it and want to do more. You may even want to join the ranks of professional event photographers.

If so, you'll need the proper gear for capturing the different types of images that comprise such photography: portraits, candids, tableaus, action, and so on. Your specific choices depend in part on the location of the event and your preference for traditional or journalistic style.

## Basic Gear for the Event Photographer

Fast and easy-to-carry gear makes event photography easier. A fast autofocus, motorized 35mm SLR camera makes the job easy, but there are great photographers who work only with manual-focus cameras.

For indoor events you'll need a fast lens, like an 85mm $f/1.2$ and, if you like zooms, an $f/2.8$mm zoom. The 85mm is long enough to capture good head-and-shoulder couple shots. While a longer telephoto lens can capture special moments, if you're shooting indoors you'll probably be close enough to your subjects to do a great job with nothing longer than 85mm or 105mm.

Indoors or out, if you'll be working in crowds, a 24mm lens allows you to get close to the action and still capture all the participants. However, faces near the edge of the 24mm image show distortion, so you might want to go easy on the pocketbook and try the 35mm or 28mm lens to see if they work for you.

A 50mm $f/1.8$ lens is good start for the small budget. It's not too expensive, it's sharp, and can be used in low light. Don't use it for close-up portraits as it distorts the face, but it's fine for full-length or three-quarter shots.

If you're shootings outdoors with plenty of light, you may want a 200mm or a long telephoto zoom so you can simplify your composition by including just one or two people. For the long lenses, especially if they're slow ($f/4$, $f/5.6$), you'll need a tripod and maybe even a cable or remote release so you don't shake the camera when you trip the shutter.

Here's a modest equipment combination that you can carry to an indoor wedding:

- **35mm autofocus or manual body:** A second camera body for different film or to minimize lens changes is optional for guest or secondary photographers; essential if you're the only photographer at the event.
- **Lenses:** 28mm *f*/2.8; 50mm *f*/1.4; 85mm *f*/2.5 or 105mm *f*/2.5.
- **Tripod:** To eliminate camera shake in low-light situations or when shooting with wide apertures and slow shutter speeds.

Another modest system for working faster could look like this:

- **35mm autofocus or manual body:** Second camera body optional; essential if you're working alone.
- **Lenses:** 38mm *f*/2.8; 50mm *f*/1.4 or *f*/1.8 or other fast prime lens for low light. (The zoom lenses might be too slow for indoor available light settings.)
- **Tripod:** For the same reason as above.

Keep in mind that your selection of lenses should both match your artistic vision and give you the opportunity to stretch your way of seeing. Don't be awestruck by someone else's fancy gear, and don't buy an exotic lens just because you saw a great picture someone else took with it. If you don't have a practical use for a lens, be creative with what you have.

## Filters

Some photographers have a half-dozen filters, others work totally without altering the image. You may need to experiment to find out where your heart is. The following is a basic list of filters for illustrative and traditional event photography:

- **Soft focus:** Although most brides wear enough makeup to cover their blemishes, their parents don't. They usually appreciate any wrinkle-hiding help they can get from the photographer. Soft-focus filters also

reduce contrast; think about using them when shadows are darker than you'd like.

- **Soft edge:** This filter blurs the edges of images and brings the viewer's eye to the center of the picture where the subject is. It's especially useful when you need to remove an object from the edge of a scene but don't want to crop any tighter.

- **Star:** The star filter is a traditional wedding photographer's staple, but it's not as popular as it was twenty years ago. It can be fun for things like the candle-lighting parts of ceremonies. Be sure to rotate the filter so that the lines radiating from the lights don't cut into people's faces. This filter can also muddy the image, so do some shots with and some without so that you will have a choice later.

- **Close-up:** Unless you have a macro lens, you need a close-up filter. The +1, +2, and +3 diopter lenses are weak magnifying glasses that allow you focus much closer. Use one or two with a long lens (85mm to 105mm) to get the scene setting shots of small objects.

- **Warming:** You probably don't need a warming filter (pale yellow to pale pink) if you are shooting black-and-white or color negative film. If you're shooting slide film, either choose one with warm tones or use a warming filter.

- **Polarizer:** Useful for darkening the sky and removing glare.

- **Color Conversion:** If you want to make really good indoor pictures with no flash, and you are using color film under incandescent lights, you may need a color conversion filter to balance the film's color. (Check with a photography store to find the right one for your situation.) Without the filter, your indoor pictures will be orange or yellowish, and the bride's dress won't be white. No correction is needed if the indoor light is actually daylight coming through windows and doors. Avoid shooting under fluorescent light—it's too complex to filter without additional equipment.

- **Vignette filter:** Like the soft-edge filter, this filter brings the viewer's eyes to the center of the picture by darkening the edges of the image. It can darken all edges or just the bottom of the shot. There are also vignette filters that lighten edges, which are useful when the background is light, such as shooting against a white backdrop.

Before you start building your filter collection, consider how often you'll use them. If you think you might turn into a filter junkie, think about purchasing a filter holder. This handy device fits on the front of your lens. It also serves as a lens shade, but the best thing about it is that you don't have to screw the filters onto the front of the lens. Instead, you drop them into a slot on the holder. You can easily insert a filter, snap the shutter, then pull the filter out and take an identical picture without it. When shooting, you can easily switch filters to create various effects and versions of the same picture.

## Flash at Special Events

Unfortunately, flash plus white subjects, such as a wedding gown or wedding cake, can be a miserable combination. The basic problem is caused by the light source (the flash) being too close to the lens. Whether the flash unit is built into the camera or attached to the camera's hot shoe, it causes the "on-camera flash" look in your pictures. When used as the main light source, on-camera flash causes red-eye, overexposes the foreground or underexposes the background, and produces shadow-free lighting. Without shadows, details in white subjects, like wedding gowns and cakes, disappear.

Many cameras and flashes allow adjustments to lower the flash intensity, making it a secondary or supplemental light rather than the main light. The best option is to combine high-speed (ISO 400) film, weak flash, and proper exposure.

Be the hero who always has a safety pin or needle and thread in your bag. To keep you (and the couple) from fainting from hunger, bring a few protein bars. Tape, rubber bands, and ballpoint and/or permanent marking pens (for making signs and labeling film cassettes) are easy to carry. Don't forget a screwdriver that fits your gear, extra flash cords, and an extension cord with multiple outlets so that, if you need power, you can share electrical outlets with others.

Indoors, the weak flash with a slow shutter speed (1/15th to 1/60th of a second) allows the room lights to bring out the details and soften flesh tones. Better yet, pivot the flash so that rather than firing straight ahead, the light goes up, sideways, or backwards to bounce off a white wall or ceiling. For shots of objects, ceiling bounce is fine. For photographs with people, bouncing the light off the ceiling can create objectionable shadows under the eyebrows, so bounce off the wall instead.

## Film Choices for Special Events

Events provide so many opportunities for pictures that you will likely take dozens or hundreds of images. You will probably want prints that you can look through and sort, and unless you have a convenient and cost-effective black-and-white lab, color print film will be your first choice.

Use slow film (ISO 100) if you'll be working in sunny conditions or will be using a flash at close range, such as across the table or in a crowd. A faster film (ISO 400) doubles the effective distance of your flash (compared to ISO 100) and makes it easier to use available indoor light with just a minimum of flash to fill in the shadows.

ISO 1600 and ISO 3200 films are very grainy. They should not be used for the whole day, but they work for times and locations where there is no other way to get a picture—where flash would ruin the moment and there isn't much available light.

Your subjects will be primarily people, so skin tones are important. Professional portrait film, available at only select photography stores, has lower contrast and produces better skin tones than consumer film. Don't worry about refrigerating it as you'll probably use up what you buy. Have it processed within a few days of shooting, and use a lab that's familiar with your film choice.

## Taking Pictures People Want

When a family is relying on you to be their photographer, you need to meet their expectations, both stated and implicit. Meet with them beforehand so that they can see your work and know your style and skills. Find

out what style they want and what pictures are important to them.

Everyone has different expectations when it comes to the pictures they want to have of their special day. They may want to see traditional images, or they may prefer something new and different. Before you agree to be the primary photographer, they must be sure your style and quality match their expectations. Show them your typical work so that you and they will know that your work suits their tastes and standards. This will help you sleep better as you anticipate the big day.

## Picture Planning and Handling

In the old days, when film and processing was expensive, and most wedding albums looked the same, twenty good pictures were enough. But we've become a visually literate society, and we expect to see pictures and videos of everything. Brides today see between 120 and 4,000 images of their wedding day. If you start snapping before the bride is dressed and finish as the caterers are putting away the tables, you will go home with a sack full of film.

Anytime you set up a shot, regardless of its type, plan on taking at least two frames in case someone blinks or moves. Big groups require four, five, or six shots, sometimes with a change of flash, shutter, f-stop settings, or focus, just in case. If you don't want double (or triple) prints from your lab, you can use the extras as duplicates.

Although the Internet and CDs make it easy to distribute images to family members all over the world, most people want to handle prints. Usually the first step is proofs, which are the first set of prints made from the uncut film. You can order double or triple proof prints if you know you'll have many people wanting the same images. Each print must be labeled on the back with a roll and frame number that corresponds to the negatives from that event.

To keep your film in chronological order, time stamp the film cassettes when they come out of your camera, then sequentially number them when you get home.

When the prints come back from the lab, number them before you edit them or let anyone else get them out of sequence. Try using a three-digit system—101 for the first frame on the first roll, 201 for the first frame on the second roll, and so on. After they're numbered, and the negatives are marked to match, you can edit. Make it easy on the family by only showing them the best images. A box of prints is easier to sort and edit than an album of proofs, but the album is easier to browse through. So your choice of presentation will depend on your and your client's preferences.

If people ask for copies, keep a written record of each person's requests and label the back of the reprints with the correct numbers. If you give the negatives to the family they can make their own reprints, which saves them money and saves you time and trouble. But if you keep the negatives and make the prints yourself, you can redo any that are poorly made and also learn which images are the most popular.

**Chapter 18**

# Someday My Prints Will Come

Beautiful images are created with properly exposed negatives (or slides), but this is just part of the equation. To make the most of the time and effort you've put into taking those great pictures, you'll need to find someone who can process your film correctly and make prints the way you want them done. Or you can complete the creative process and do it yourself.

# Getting Great Images

If you're serious about how your pictures turn out, you have two choices: developing and printing your own images, or finding a custom processing lab that specializes in doing it. Yes, they cost more. Yes, they're not as convenient as using the minilab inside your local drug store or big-box retailer. Yes, it will take longer to get your film and prints back. And yes, it will be worth it.

There are plenty of fast-photo processors and photo minilabs that do a great job with lots and lots of film. Some will do custom work; however, unless they're really set up for it and are serious about maintaining the quality control necessary to deliver it, the chances are pretty good that you won't be thrilled over what you get. Because they're geared more for processing and printing snapshots taken with a variety of films and under a variety of conditions, they're rarely completely capable of handling the demands that serious photographers make of their processing labs. Some are, and they're definitely worth seeking out and using.

## Finding a Good Lab

Quality developing depends on how well lab personnel maintain their processing chemistry and machines. If a lab has good machinery and good personnel, then it's worth the time to develop a relationship so that together you and the lab can produce the images you want. First, however, you have to find that lab. Here are some ways to do it:

- Check the yellow pages listings in your local directory under "photo processing." Labs that specialize in working with professional photographers or offer custom services will say so in their ads.
- Ask other photographers in your area about what labs they use. This can be the best way to find a good lab as most photographers won't stay with a lab that's not up to snuff.
- Talk to someone in a framing shop or two to see if they can recommend a good local lab. Usually they can.

Once you've found a processing lab or two that look like possibilities, pay them a visit. Ask how often they check the chemicals in their

processing equipment. The answer should be "once a day." More often is even better. Also ask how often they run a test strip of film and measure the results. Without close attention to these details, a lab will produce color negatives that might be harder to print because the color isn't perfect.

Ask what kinds of film they can process. If you're shooting slide film, you want a lab that can handle it. Most slide film is processed using C-41 chemistry; however, chrome film (with the exception of Kodachrome) requires E-6 chemistry, which takes longer and requires more tests per day to make sure it hasn't drifted out of balance. Some shops can handle both; others send their E-6 processing out.

As mentioned in Chapter 7, there are two different types of black-and-white film, and they don't go through the same chemicals. If you're shooting true black-and-white, you need a lab that specializes in processing and printing it. Chromogenic black-and-white film goes through the same chemistry and machinery as color film does.

Look for obvious problems in film processing. Watch the lab personnel as they're working to see how they handle the film. Do they use gloves and hang up the film carefully, or do they carelessly drag it across the floor? You definitely don't want scratches and fingerprints on your negatives.

If lab personnel cut the film into strips, make sure they cut carefully between the frames instead of into the image area of the film. The negatives should be put into transparent or translucent sleeves, one strip (four to six images) per sleeve, so you can see each negative clearly.

Many custom processing labs offer both machine prints (automated) and custom prints, which are printed by hand so that a human operator actually looks at your negative and determines the best way to print them. If your negatives are good, a machine print will be just about as good as a custom print.

The machine operators should inspect every print and remake those that don't meet their standards. If the inspection or standards aren't good enough, you can't get consistently good color. Look at some sample prints—a good shop will have them on hand. Don't be fooled by sample

prints of colorful hot air balloons and beautiful bouquets. It's easy to produce dazzling colors. What you want to see is clean neutral tones, whites that are white with no loss of detail, blacks that are black, not milky or off color, flesh tones that are believable, and no overall color cast.

## Mail-Order Processing

The big advantage of working with a local lab is that you can talk face-to-face with the people who handle your film, adjust the machines, and make and inspect your prints. If you're not pleased with a print, you can show them the problem print as well as one that you like. You can discuss what went wrong with your print—was the problem at the time the picture was taken, or was there a lab error in processing or printing the film. If the problem is with your camera, lighting, or light meter, ask them what you can do to produce a better negative.

However, not everyone is fortunate enough to have a place like this near them. If you are one of them, you're not necessarily out of luck. There are plenty of processing labs in the United States and other countries that do custom work for people like you. Do an Internet search and you'll come up with a number of Web sites for companies that offer processing services. There are also Web sites that index the companies that offer these services.

## Doing It Yourself

Many photographers do their own processing and printing. Doing so gives them complete control over how their images turn out. And, they have no one to blame but themselves if something goes wrong in the process.

Black-and-white film is relatively simple to process, and the set-up for it isn't terribly complex or expensive. You don't even need a darkroom; just a sink with hot and cold running water will suit you fine.

Unlike more finicky color film, processing black-and-white film is a snap. It can handle using many different developers, a wider range of temperatures, and times between six and fifteen minutes for the first chemical bath. These variables, in fact, are what changes such aspects as contrast, graininess, flesh tones, tonal gradations, dynamic range, and density in the negatives, which means the film processing itself can

change the look of a picture before you even see a print.

Black-and-white printing (the step beyond processing) requires a room that can be made totally dark (except for a special darkroom red light), an enlarger, and room for several trays to hold the chemicals. Used enlargers are easy to find. A good, clean lens is essential. Having a sink and running water is also helpful.

**FACT**

Color processing is a little more involved and takes several more steps. Neither process, however, is usually anything that beginning photographers want to tackle, and detailed information on how to do them is beyond the scope of this book. If you're interested in learning more about processing your own film, it's a good idea to take a class and have a pro show you how to do it.

## Directing the Processing Process

When you take your film to a processor, it's up to you to tell the staff if there's anything they need to know about it before they crack open the cartridge and start to work on it. If you've pushed the film, that is, under-exposed it, either accidentally or intentionally, be sure to tell them so they can compensate for it. The same goes for film that you've pulled, or overexposed.

Slide film can be pushed when processing. Confer with your lab first about what slide film to use, and tell them how many f-stops you will un-derexpose the film. This is custom processing and will not be available at most labs. Color negative film is seldom pushed, but a custom lab can help you in that department too. At your typical one-hour processing lab, you should hope that the employees look at your film canister to make sure that they know what type it is. If you are handing them slide film tell them.

## Directing the Printing Process

The responsibility for producing a pleasing print rests with both the photographer and the lab. When you have reasonable expectations and

communicate using the same language, you and the lab can work together to make everyone happy.

Pro labs usually offer several grades of prints:

- **Machine prints:** This is the most automated process. The printing machine analyzes each frame and adjusts the color to make whites white, blacks black, and flesh tones believable. The sophistication of the machine determines if the colors are good or not. Cropping and color correction will not necessarily be done to your taste.
- **Custom machine printing:** This process, which necessitates more human involvement, offers better color correction and cropping options. If your negatives are good to begin with, custom machine printing should deliver good quality prints.
- **Custom hand printing:** Ideally, you light, compose, and expose so that your negative is perfect and can be printed very nicely without custom processing. If not, custom printing will take problem negatives and make good prints out of them, or take good negatives and get great prints.

**ALERT!**

Don't expect a low-cost lab to have the time and personnel to satisfy you. No matter what a lab charges, if you aren't happy with the prints and you can't work with them, it's too expensive and you'll have to find a new one.

## Choosing Your Paper

Paper for color prints is available in two contrasts. Consumer labs use a high-contrast paper because it makes up for the lower-quality lenses in inexpensive cameras. Professional labs use color printing paper with lower contrast, which delivers more pleasing skin tones and generally works better for images created under the controlled conditions that professionals shoot in.

Paper for both black-and-white and color prints is available with glossy or matte finishes. Glossy prints are better for scanning and reproduction because the fine detail is clearer. Matte paper hides fingerprints but has a tiny bit less detail and contrast.

Giving your lab a sample print with color (skin tone, usually) that you like is a way to start a good relationship. Tell them what you like about the print ("Make my skin tones look like this; I like this color"). Be as specific as possible. Everyone sees different things. Don't assume that they can tell what you like. Ideally, give the lab a couple of sample prints reflecting several lighting situations—direct flash, bounce flash, sunlight, window light, shade, or incandescent.

Once you find a lab that makes good prints, don't abandon them when they mess up occasionally. Unexpected color problems may be due to a change in personnel. Many photographers claim that only one employee can print their negatives correctly. When that employee goes on vacation, they hold onto their film until the employee returns.

## Dealing with Processing Problems

Although the majority of film is processed correctly, which means you'll get the type of prints you want from it, there are times when processing goes wrong. If your negatives are spotted, stained, scratched, or discolored in some way, there's a good chance that they've not been handled correctly during processing (although scratches can also be caused by dust or dirt in your camera). They could also have been processed using chemicals that were old, incorrectly mixed, or kept at the wrong temperature. There's really not anything you can do to save negatives with these problems.

If your color negatives turn out under or overexposed, and you believe you exposed them correctly when you shot them, they may have been over- or underdeveloped in the lab. These problems can be corrected to a certain extent during the printing process, but the prints won't be as good as those made with correctly exposed negatives.

Commercial, noncustom black-and-white labs are likely to overdevelop black-and-white film, which increases the contrast and makes light flesh tones pasty. This problem can be corrected during printing by changing

paper grades, which will alter the contrast of the image, or by using a variable contrast filter with variable contrast paper. If your images were taken on an overcast day, increasing the contrast will make the blacks blacker and the whites whiter. However, this can distort other shades of gray, such as flesh tones.

# Improving Your Prints

People are often disappointed when their prints come back from the lab too dark or too light. They blame themselves, the camera, the film, or the lighting. Sometime you just need to have the print made again. With its great latitude, print film is capable of producing good images even with improper exposure. A print whose murky shadows and highlights are too bright can be printed down (made darker with more exposure in the enlarger) to make the blacks truly black and produce details in the highlights.

If a print comes out especially bad, ask your lab to compare the negative with the print. You may need to explain what the lighting was if it's not obvious. If your film has been overheated (in the trunk of your car) or stored too long (months or years past the expiration date) it may be impossible to correct exposure and color problems. The lab may be correct when it states that there is no way to get a good print from a particular negative, but they should offer to try.

If your negatives are exposed incorrectly, it will be hard for the lab to make a good print. If the blacks in your prints look milky, and not truly black, your negatives may be too thin. In order to compensate for your mistake, the printer underexposed the paper, which means that not enough light hit the paper to turn it fully black. The print is underprinted or underexposed. Sometimes a printer doesn't know if an image is underexposed or if your subject is supposed to be dark. If the blacks in your silhouette are printed gray and milky, show the offending print and negative to your printer and explain what you want. They should reprint it at no charge.

If your negative is overexposed, the lab will correct the exposure when they are printing. There is a price to pay for extreme over- and

underexposure: The color and contrast cannot be totally corrected, no matter how good your printer. But if your negative was properly exposed in good light with the right level of contrast, you can expect and demand good color.

**FACT**

You cannot get 100-percent accurate color in prints or slides. They produce pleasing and believable color, but it is impossible for every color in real life to be captured and reproduced perfectly.

## Show-and-Tell Time

There's more to being a photographer than merely creating great images. If you don't somehow display your images, you haven't created the communication process. Nor have you shared your visions, your emotions, and your feelings. They're all part of photography too.

Far too many amateur photographers get their prints back from the photo lab and throw them into a drawer or a box with the intention of doing something with them "later." The problem is, later often doesn't come. Because of this, lots of really beautiful images never get seen by anyone else besides the people who take them and the people who process them—and they don't really look at what they're doing unless they're professionals and they're paid to do so.

Why bother to take pictures if you're not going to use them, especially in this digitally rich electronic age when there are so many opportunities to do so? Rather than being stuffed into a box or an album, they could be made into mouse pads or sweatshirts or screensavers. They can be put on a coffee mug, a calendar for the grandparents, a poster for a birthday party, or t-shirts for fundraisers. You can even do the old-fashioned thing and frame them.

A far better approach is to figure out what you want to do with your best pictures before you even take them. Having a system for handling your images once they're developed will give them a fighting chance of being seen by someone else. And that could be a very nice thing for everyone involved.

## Cull the Crop

First things first. Rather than keeping all of your prints and negatives (or slides), do yourself and your surroundings a favor by going through them and tossing the bad ones as soon as you get them home. Maybe hang onto a couple for later study if you think you can learn something from them, but remember: There is no reason to hang onto bad pictures besides this. If you're not proud enough of your shots to show them to others, dump them.

After you've pitched the losers, go through the rest and think about what you want to do with them. If there are some you want to do something with right away, such as mounting and framing, pull the image and the negative (if it's a print), and put them in a separate envelope or folder. Be sure to somehow indicate what they are and when they were taken—many photographers lightly write this information on the back of their prints. If you're working with slides, the slide holders are a great place for this. Mark the ones you're not using as well, and put them away in some sort of an organized manner.

If you're working with prints, you can buy specially sized boxes or file cabinets to hold them. Slides can go into slide sheets or remain in the boxes they came in.

## Labeling and Storage

Every print, whether from a negative or a digital file, should be marked on the back in ball point pen (carefully) or fine permanent marker with a catalog number that will allow you to match it up with the original file or negative at some later date.

When you get prints back from the lab, mark the negative sleeves and the negatives with matching roll and frame numbers so that you and your family can order more prints. This is especially important when you have taken several pictures of the same subject, but only one of them has the right smile or expression in the eyes. Once you have shuffled the prints, it

will be very hard to match up a negative to the print. Number them first thing, before you do any editing. Double check, then edit and sort your prints.

Store your negatives in normal humidity and temperature ranges. Hot attics and damp basements will ruin film and prints. Do not touch the negatives except by the edges. Do not get the negatives wet, as they will stick together or pick up dust. If they need to be cleaned, let the lab do it. Do not cut out a single negative from a strip of four or six. It is easier for the lab to handle the larger strip.

## Making Them Big

If you've decided you're going to mount and frame some of your images for display on the walls in your home, you'll probably want to get them enlarged to make them easier to see. This is when having a personal relationship with a photofinishing shop can really pay off. You want a lab that will give you the best enlargements you can get. This means taking your pictures to someone who is willing to take the time to get them right, who understands what it means to lighten or darken and image and adjust color balance on prints, and who might even suggest doing these things before you have the chance to say a word. Most quick photo places aren't up to the task unless they also do custom work. Find a shop that does.

The colors in enlargements can be different than in smaller prints if different filtration systems are used to produce them. If you like the color and contrast in the smaller print, bring it along when you order the enlargement and ask the lab to match it.

The three factors in print size are viewing distance, the size of room, and the sharpness of the image. In a large room, you will probably have a greater viewing distance, which allows for greater enlargement, even from a slightly unsharp image.

Although it's always best to crop your images when you're taking them, you can also improve them by cropping them when you enlarge

them. Most photofinishing places have cropping masks that you can place on the print (or on a projected image of your slide, if they can do it) and fiddle around with until you get the image you like. Or you can mark the crops yourself on the picture or the slide mount.

**ALERT!**

Never make crop marks directly on a slide. Remember, slides are first-generation images. When they're printed, everything that's on them—from scratches to ink marks—will show up in the final print.

If you are having your pictures custom framed, you might want to wait to do your cropping until you consult with your framer. He or she can either trim the print so that the mat fits around it, or cut the mat so it crops the print as you wish.

**FIGURE 18-1**

*Photograph courtesy of Eliot Khuner*

▲ An uncropped photo with lots of dull foreground.

**FIGURE 18-2**

*Photograph courtesy of Eliot Khuner*

▲ An after example of effective cropping. By cutting out some of the foreground and empty space on the photo, the final cropped photo looks tighter and more interesting.

## Mounting and Framing

This is something you can do yourself, but it does take some special equipment and a little time to learn how to do it well. For these reasons, it's often a good idea to find a frame shop to do it for you.

Whether you're doing the job yourself or having someone else do it, make sure your prints are first mounted on mount or backing board. This stabilizes them and keeps them from wrinkling and curling.

If you have a series of three or four images that work together, such as a child making faces or showing a variety of emotions, try mounting them together in a mat with individual windows cut out for the images.

Many people find it difficult to decide on the mats and frames they should use on their pictures. A good rule is to go a simply as possible, and choose colors that flatter your images. With black-and-white prints, white mats with white, silver, or black frames are classic choices. Color prints often look best in wood or gold frames, although a colored frame that picks up and emphasizes a color in the print can be effective as well.

Also think about how the images are going to be displayed. If they're going to hang as a series, you'll want the mats and frames on all of them to match. If the picture is going to be the main focal point on a wall, something a bit grander than your basic mat and frame might be in order.

Regardless of what mounting and framing materials you choose, make sure they're archival quality. This means they're free of any chemicals that could alter the image's appearance over time.

**ALERT!**

Prints can fade when they're displayed in sunlight and even artificial light. Color prints, in particular, are susceptible to fading. Their color layers react differently to light rays, causing color shift over time. Display your color prints away from bright windows, or protect them with UV-coated glass.

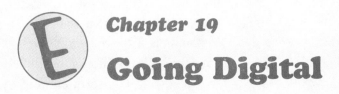

**Chapter 19**

# Going Digital

Digital photography is giving film-based photography a run for its money. More and more film-based photographers are embracing the technology and making room in their camera bags for digital cameras. Does putting one in yours make sense as well? This chapter will help you decide.

# The Digital Revolution

Being able to capture images digitally represents a major advance in the evolution of photography, and, in some respects, its logical next step. As digital technology reshapes all aspects of the world around us, it only makes sense that it should reshape photography as well.

There's no denying that digital imaging is the fastest growing area of photography, with improvements in products and techniques driving its popularity and acceptance. Digital imaging is also replacing much of film-based photography, although the day when film photography will cease to exist is a long way off. Some people believe it will never entirely disappear. As good as today's digital technology is, film-based photography still has the edge when it comes to versatility, through-the-lens creativity, and image quality (although digital aficionados will debate this point). However, the gap between the two technologies will likely narrow even further in the next few years. Interchangeable lenses are already available on top-end digital cameras. Continuing advances in digital technology have improved image quality and added features to digital cameras that rival those found on comparable SLR cameras.

**FACT**

Worldwide shipment of digital cameras in 1999 was about 6.5 million units and 24.5 in 2002. The industry expects to ship more than 42 million units in 2005.

# Advantages of Digital Photography

The most obvious advantage to digital photography is the technology itself. By converting analog information to bits of data, processors can store image on digital media instead of film. Those same images can be viewed immediately after they're taken, and you can delete them from memory if you don't like the way they look. For photographers needing instant gratification, digital photography is the easiest and fastest way to get it.

Taking pictures digitally also speeds up and streamlines the entire digital imaging process and makes it far easier to add images to digital communications. To merge film-based images with digital media, prints or

slides must be developed and then converted to digital format by scanning them into computer memory. Digital images can be transferred directly from the camera to the computer, and sometimes even directly to a printer. Some cameras can transfer images through wireless infrared. You can make perfect copies of digital files—no matter how many times you copy the same image, each will be identical. With film, every generation will be worse than the previous ones.

Images from digital cameras can be edited without taking them into the darkroom. All you need is the hardware and software necessary to do it. You can crop them, straighten them, adjust their color, contrast, and brightness, and even add words or special effects if you want.

Shooting digitally eliminates having to develop film, fuss with film cartridges, or worry about the quality of the film itself. A memory card can sit inside a digital camera forever. Leave your film inside your camera too long, and it's likely that the images on it will be compromised.

Digital cameras are compact, quiet, and convenient, which makes them extremely popular for point-and-shoot photography. Most are small enough to slip into a pocket. As the cost behind the technology has come down, so too have the prices. Technology that cost upwards of $1,000 or more a year or two ago now costs less than half that.

## Disadvantages of Digital Photography

Some of the advantages of digital photography are disadvantages on their flip side. The technology itself is a fairly large disadvantage when it comes to image storage. Film might be of questionable quality at times, but it's widely available and relatively cheap. (Many photographers also feel that film continues to deliver images far superior to those created digitally.) The memory cards used for storing images in digital cameras are relatively expensive and not widely available. Their storage capacity also varies depending on the image's size, format, and quality.

Other drawbacks to digital photography include the following:

- **Less through-the-lens creativity:** While digital images can be endlessly manipulated with imaging software, there's not much you

can do about them when you're taking them. Unless you can afford professional digital setups with interchangeable lenses, or your camera can be fitted with auxiliary lenses, you're limited to the capabilities of the lens on your camera.

- **Poor image quality on enlargements:** Digital cameras produce images that are almost as good as what can be achieved with film. In fact, you probably won't see much of a difference between digital and film images unless you enlarge them. Then the differences can be huge. Getting large, crisp digital images takes an enormous amount of camera memory, which puts the equipment capable of delivering them out of the reach of the average consumer.

- **Shutter lag:** Digital cameras have to analyze the scene before they'll record an image. This causes a delay between the time the shutter button is pressed and when the picture is taken, which often results in missing the height of action in action shots.

- **Cost:** The technology necessary to get good pictures is still more expensive than using film-based cameras. A good film-based camera is available for under $500. To get the same quality with a digital camera, you'd have to spend at least three times as much.

- **Print quality:** It takes a fairly good printer and special paper to make quality digital prints. However, even the best digital prints will not be of the same quality as photographic prints. Prints made on color printers usually don't last as long as traditional inkjet photographic prints.

- **Other print problems:** When you shoot with film, technical mistakes such as bad color balance and poor exposure can be corrected in the lab. Digital imaging puts that responsibility squarely on the shoulders of the photographer. The result is that you spend your time (sometimes a lot of time) fixing pictures so they print properly, or you go out and take them again. That is, if you can.

## Is Digital Right for You?

Although the differences between taking pictures with digital and film-based cameras aren't that significant, it still takes a certain paradigm shift to embrace digital technology. It isn't film-based photography, nor will it ever

be. You have to deal with some of the quirkiness inherent in digital technology. Shutters won't immediately snap, although newer cameras have greatly reduced lag times. Colors can go goofy under certain lighting conditions. If you want prints, you'll have to learn how to make them or find an alternative printing method, which can be inconvenient and expensive.

There are definitely tradeoffs to digital photography. It can be lots of fun to edit digital images yourself, but a real drag if it's the only way you have of making prints. Plus, not everyone enjoys this process or is willing to spend the time to get good at it. You might find yourself longing for the old days when all you had to do is drop off your film and pick up your prints. It also costs less to have pictures printed on photo paper, which is an important consideration if you plan on making lots of prints.

You'll spend less money per click with a digital camera, but you'll pay more for the technology itself on the front end. If you don't shoot that many pictures a year, the savings you realize when you say goodbye to film may not be all that significant.

If you're a traditionalist, chances are pretty good that you won't ever be completely satisfied with digital imaging. It's just too different from traditional photography, and the slight differences in image quality won't be slight in your eyes. In time, digital technology will evolve to the point where the difference will hardly be discernible, but for now, film yields better prints.

On the other hand, if you're open to embracing new technology, and you like the challenge of learning how to use it, you'll probably enjoy adding a digital camera to your other camera equipment.

## Using a Digital Camera

Taking pictures with a digital camera isn't significantly different from using your other equipment. The basics of good photography still come into play: lighting, composition, framing, point of view, and so on. However, there are several factors you need to keep in mind when using these cameras.

- **Parallax error:** Most digital cameras don't use SLR technology (especially those priced under $1,000), which means that the image you see through the viewfinder is different from the image the lens will capture.
- **Shutter lag:** Although newer cameras have significantly reduced this factor, there's still a discernible amount of time between when you snap the shutter and when the camera actually takes the picture. If you're taking action shots and you want to be sure to capture the height of action, choose a camera with continuous shooting mode, which will take pictures for as long as you hold the shutter-release button down.
- **Power problems:** Digital imaging uses a lot of power. While it's never a good idea to leave any camera on for extended periods between shots, doing so with a digital might cause your camera to die in the middle of a shot. Digital cameras vary as to power usage, but they all use far more juice than traditional cameras do.

The best way to get to know your digital camera is to read the instruction manual thoroughly before using it. These cameras do operate differently, and it's easy to make handling errors that can damage them.

All the other considerations related to handling and storing a camera also apply to digital equipment. Because these cameras are so small, they often get carried around more than they should be. When not using your camera, store it in a cool, dry, well-ventilated area. Don't let it end up in the bottom of your briefcase or purse where it can get damaged. If it doesn't come with a case, buy one.

**FACT**

Most digital cameras now come with LCD screens that allow the user to see the image perfectly composed before shooting. This eliminates parallax error, but it also drains the batteries faster. LCDs also enable the photographer to instantly preview and delete unwanted shots, saving on card memory.

# Choosing a Digital Camera

The process of choosing a digital camera is much the same as selecting an SLR: set a budget, look for the camera with features that best suits your needs, and figure out where to buy it.

The good news about digital cameras is that their prices have come down significantly over the past several years, which means that the technology required to take good digital pictures is by no means out of reach. As is the case with film-based cameras, the more you spend, the more camera you'll get. But it's now possible to spend around $300 and get a well-equipped digital camera that can do everything you want it to. Pay much less than this, however, and you'll probably have to make some tradeoffs regarding resolution and features.

Because prices for digital technology have dropped so quickly in recent years, you'll see a fair amount of variation prices on many cameras. It definitely pays to comparison shop for them. As is the case with traditional cameras, you'll usually find better prices online or through mail-order houses than you will at your local camera shop. Online auction sites are also good places to shop for digital equipment.

**ALERT!**

A seemingly simple mistake, like not turning off the camera before taking out a memory card, can damage the card and the digital data stored on it. Leaving the camera on while taking out its battery or unplugging it from an AC adapter can damage its internal circuitry or memory.

## The Pixel Factor

Digital cameras record images on charge-coupled devices (CCD) or complementary metal-oxide semiconductors (CMOS), which are computer chips comprised of rows of tiny light-sensitive cells. Also called photosites, these cells register color and light and convert them into electrical signals.

How much detail a digital image can contain depends on the number of cells that are on the chip and on the size of the chip itself. CCD chips generally have better quality pixels and more of them. CMOS chips, however,

are less expensive to make, and they use less power than CCDs.

Digital cameras with megapixel capacity have one million light-sensing cells on their image sensors. As pixel counts go up, images get better. If you're only going to use digital images onscreen, however, you don't need to spend your money on a high megapixel camera. That's because most computer monitors can't display the high-resolution images these cameras deliver. If you're planning to print your images, a high megapixel model or one with two or three megapixels, minimum, is a must.

## Understanding Image Size

In the digital world, image size refers both to the physical size of a picture and to its resolution. It also indicates how large prints can be before they become noticeably pixelated (the digital equivalent of being grainy).

A pixel can be considered a unit of length. However, in this case, that unit can change. For example, an image that measures 1600 by 1200 pixels is 1600 pixels wide and 1200 pixels high. The next step is the resolution of the image. Resolution is measured in dots per inch (DPI) and refers to the number of pixels set side by side that will fit in an inch.

A typical 2 megapixel digital camera will offer three different image sizes:

- **Full (1600 x 1200 pixels):** Best resolution, but images contain a lot of data and take up a large amount of storage space. They're also slow to upload and download and hard to edit. On the plus size, images in this format will yield fairly large prints—roughly 8" x 6".
- **XGA (1024 x 768 pixels):** Yields good image resolution but smaller prints. XGA images also display well on large monitors.
- **VGA (640 x 480 pixels):** Considered low-resolution. They're great for displaying on small computer monitors but not for printing.

## Memory Considerations

Most digital cameras on the market today use removable memory cards for storing images. The more memory the card is capable of storing, the more it costs. Memory cards have also dropped in price

significantly. However, as digital cameras improve, the resolutions improve, and then the resulting images end up larger. As a result of this, larger memory cards are needed.

## Understanding Digital Zoom

Although most digital cameras don't have interchangeable lenses, many do have zoom capability. Optical zoom is the same as the zoom lenses you use on traditional cameras. Since it actually changes the size of the image, it provides the best image quality. Digital zoom only enlarges part of the image—its center—to give the appearance of a larger subject. Because images are magnified, their quality is poorer.

## Viewing Screens

One of the advantages that digital photography has over traditional photography is the ability to see your images onscreen as you shoot them. Low-end digital cameras might not have LCD screens. Some LCD-equipped cameras don't have separate viewfinders. It's desirable to have both as it's far easier to frame pictures using the viewfinder—LCD screens must be held several inches away in order to see them, which makes accurate framing difficult. However, you'll need the LCD screen for shooting close-ups since in this case, depending on the viewfinder can result in parallax error.

LCD screens are also notoriously difficult to see in bright light, and they add extra weight as well as expense to digital cameras. However, they are one of the coolest features of these cameras, and you'll regret not having one if you opt for a camera without it.

**QUESTION?**

**How can I improve the visibility of my LCD screen in sunlight?**
LCD screen hoods are widely available and don't cost very much. Some cameras will let you adjust the brightness on these screens. Newer LCDs are also easier to see in bright daylight.

## Bells and Whistles

Digital cameras are available with the same creative controls that traditional cameras have, including the following:

- Autofocus
- Autoexposure
- Aperture priority

- Shutter priority
- Auto flash

Most also have shooting modes that are similar to those found on traditional cameras, including these:

- Auto
- Portrait
- Party/indoor
- Night portrait

- Beach/snow
- Landscape
- Sunset
- Backlight

While digital cameras don't use film, they record the colors just like film does. Most digital cameras automatically adjust colors according to different lighting conditions, including daylight, overcast, tungsten/incandescent, flash, and fluorescent. Some will allow you to set these adjustments manually, which is desirable when you want an image with colors other than those set by the automatic system. Colors can also be corrected and altered with image-editing software.

**FACT**

Like traditional cameras, the price you'll pay for your camera will determine how many of special features you'll get. Unlike SLRs, many digital cameras have panorama shooting modes. Some will even shoot short movies.

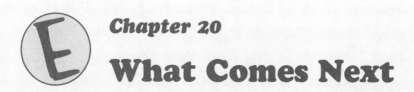

**Chapter 20**

# What Comes Next

hat kind of a photographer are you? What kind of a photographer do you want to be? Is it your dream to someday take pictures for a living? Maybe you're content knowing how to take excellent pictures for your own use and want to become even better at what you do.

# Learning More about Photography

One of the best ways to improve your photographic abilities, of course, is to keep taking pictures. But this is just one way to grow in photography. Developing your skills also means spending some time studying the process to learn more about techniques as well as the technical side of picture-taking. There is always something to be learned, and you have plenty of resources at your disposal. You'll find specific suggestions for most of them in Appendix B.

## How-to Guides

Ranging from in-depth discussions on specific aspects of photography, such as nature, action, or portraits, to detailed information on using your camera equipment better, how-to guides let you tackle the aspects of photography that interest you the most. Many of these guides are written by experts in their chosen field; some are more general guides published by film and camera manufacturers.

If you don't have an instruction manual for your camera, buy a how-to guide. Even if you do have a manual, how-to guides are often easier to understand than the manuals are, and they'll present information that goes beyond what the manual can offer.

## Fine-Art Books

Large-format books on photography are a great resource for studying the techniques of the masters as well as for getting good ideas for taking your own shots. There is a wealth of these books available, ranging from the documentary black-and-white images of early photography to the avant-garde techniques that comprise the photography of invention.

## Photography Magazines

There's perhaps no better way to keep up to date on what's going on in the world of photography than reading magazines that cover it. If you're looking for new equipment or new techniques, you'll find them

here, along with coverage on new technology and anything else pertaining to taking good pictures. Some magazines focus on a specific aspect of taking pictures, such as wildlife or studio photography; most are designed to meet the needs of a general audience.

## Web Sites

Photography is also a popular subject online, although most of the sites deal more with selling equipment than in providing tips and techniques. Take what you read online with a grain of salt unless the site looks and feels somewhat commercial in tone and content—some of the pages put up by amateur photographers as part of their personal home pages can be pretty opinionated, and the information isn't always accurate.

## Exhibits and Shows

Many museums regularly include photography offerings as part of their exhibit schedules. Some also have standing photography exhibits featuring images that are part of their permanent collections. Here are a few other public places where you'll find photography on display:

- Art galleries
- Restaurants and cafes
- County and state fairs
- Community centers, especially those that offer community education programs

## Taking Classes

Every photographer, regardless of status or experience level, can benefit from taking classes and master workshops. Some might offer a rehash of what you already know, while others will turn your world upside down. Sometimes it will seem that you have so far to go. But a week later you might find yourself solving a problem with a technique that you wouldn't have known about if you hadn't taken the class.

Investing time in learning can be fun and challenging. You'll be exposed to techniques, philosophies, aesthetics, and business practices.

You'll meet people who have the same camera, the same problems, and the same enthusiasm that you do. Whether you attend a hands-on workshop, a week of lectures and field trips, or an evening slide show, you will enrich your photographic world.

Photography classes are regularly offered as part of college or university extension courses, adult education, and community education programs. Other sponsors include local photography clubs, stores, and even equipment manufacturers. Aim for at least one class or workshop a year, and fit in more if you can afford the time and money.

If you're thinking about pursuing a career in photography, you may want to attend an accredited photography school or a college or university that grants degrees in photography. Some art institutes and museums also offer degree programs.

## Joining a Club

Just about every city or town has at least one photography club. Even if you're not much of a joiner, these clubs are great ways to learn more about camera techniques and equipment from other photographers. They can also be a good way to get your work shown as many of them sponsor exhibits and competitions on a regular basis.

## Selling Your Work

You don't have to be a professional photographer to sell your work. There are plenty of ways to do so and plenty of places looking for good images taken by you and other good amateur photographers. Here are just a few:

- Stock image companies
- Greeting-card companies
- Newspapers and magazines
- Your friends and neighbors

If you love taking pictures, you definitely can do something you love and make a little money at it as well.

## The Greeting-Card Market

There are more than 2,000 greeting-card companies in the United States. Large chain stores may only carry products by one or two of the largest companies. Visit other card outlets, such as gift shops, florists, stationery stores, small bookstores, and other retailers that carry cards by the small card companies. Look for a publisher that sells images that are similar to yours. When you find a company that matches, get their address or Web site and ask for their submission guidelines. These will tell you exactly what they're looking for and how they will accept submissions. Don't send any pictures until you get this information.

**QUESTION?**

**Should I call a greeting-card company to see what they think of my pictures?**
In a word, no. It can take a month or longer for someone to review your pictures, especially if it's a small company. Wait until they contact you.

Don't send the same photographs to another company until you have received a response from the first company. Having the same photograph on cards published by different companies is an unhappy experience for all parties involved.

If your photographs contain recognizable faces, you'll need a model release before you can sell them to a card company. The publisher may expect you to supply a signed release, or they may have their own release. If subjects are shown from the back or in profile, they may not be recognizable, but it's still a good idea to get a release just in case.

Every publisher has its own fee structure. Some offer royalties, which means you get paid every time your image is used. Others offer flat fees— a one-time payment that allows them to use your image as many times as they wish without paying you anything further. A royalty agreement is definitely better than a one-time fee if your image becomes a best seller, but the one-time fee will net you more money in the short run.

## Stock Image Companies

These companies buy images from photographers and make them available to buyers looking for specific pictures. Stock images are classics, like flowers, children, pretty landscapes, and so on. As is the case with greeting card publishers, you'll need to get submissions guidelines from the companies you think might be interested in your images. Again, don't submit anything until you get these guidelines, and follow them exactly when you do. These companies get queries from thousands of photographers, and your chances of getting your images seen will be much better if you submit your work according to their guidelines.

The pay scale for stock image companies is similar to that of greeting card companies. A royalty agreement might make you more money in the long run, but a flat fee will put money in your pocket faster.

## Newspapers and Magazines

Newspapers and magazines are always on the lookout for good images. Your best "in" with either of them is knowing someone on staff, but it's also possible to break into these markets if you don't. Again, get submissions guidelines from any publication you're interested in working with.

## Your Friends and Neighbors

Many amateur photographers are a little nervous about approaching people they know and offering their services for a fee; however, many a professional photographer's career has been launched by doing just that. People always need pictures, and they'll pay for them because of their emotional attachment to the subject, their love of the image, or because they need them for one reason or another. If your skills are up to snuff, they'll pay you for them.

## How to Price Your Work

Many beginning photographers are pleased just to get their costs covered by what they charge. But you really need to charge for your skills, time, and materials as well as for the value of the work itself.

Unfortunately, there is no one-price-fits-all in the world of photography. Learning how to price is your work is similar to learning how to create your work: You start out as a beginner and learn by making mistakes.

**ALERT!**

If you sell your work, be very clear about the rights you're giving up and how much you'll be paid for them. There are a number of different rights you can sell—stipulating what they are and how much you'll be paid for them will help prevent legal battles in the future. The rights to your creative work are precious commodities. Never take them lightly.

# Going Pro

If your dream is to become a part-time or full-time photographer, running a photography business out of your home or a studio is a goal you can achieve.

As a business, photography has a relatively low barrier to entry. You've already made the investment in the basic equipment, which is usually a big part of the start-up cost for any business. With a small additional investment of maybe a few hundred dollars a month for a few years—and a substantially larger investment in taking the time to further hone your skills and learn the business—you could provide services and products that people want in return for charging fees that can support a part-time or full-time business.

## Learning the Ropes

One time-proven way of getting into the photography business is by assisting an established photographer. Even graduates from the best photography schools are often advised to start their career working with an experienced photographer. Among other things, assisting will show you if the profession feels right to you.

Try to work with a photographer whose work you like and who makes a good living at it. Your chances of being successful are greater if you do.

For better or worse, being a great photographer does not guarantee financial success, and of course there are many, many mediocre photographers who have thriving businesses. If you take advice from a photographer whose images aren't the best and who does not have a successful business, you may be putting roadblocks in your own path.

Photography is a lifetime pursuit. It will grow with you, lead you places, and take you where you want to go. Regardless of where your future lies with photography, there's a lifetime of shooting pleasure ahead of you.

## Networking with Professionals

Every photographer benefits from networking with other photographers. From a professional's point of view, an amateur today might be a colleague tomorrow. Even a professional has something to learn from a beginner. Of course, the converse is also true. Spending time with a professional in your field is a great way to learn technique, business concepts, the latest in technology, and the history behind current trends and business practices. You can join a professional organization, such as an affiliate of the Professional Photographers of America or American Society of Media Photographers. Their monthly meetings feature professionals who share their experience as well as their unique approach to the business. Or you can take a less formal approach. Form a group of four to ten photographers in your area who have a similar specialty. From them you will learn accepted business practices, which vendors and customers to avoid, what equipment works best, and so much more. If you have an idea of the going rate for products and services, then you can see if your pricing structure is appropriate for your unique work, quality, and service.

Remember the context in which advice is given. Useful advice early in your career may have to be reformulated or discarded in order for you to learn more. As you progress, remember that education consists not only of gaining new knowledge but also of discarding those old rules that once helped you move ahead. Ⓔ

*Appendix A*

# Glossary

# A

**accessory flash unit:**
A flash unit not built into the camera.

**accessory lens:**
A lens that attaches to the front of a camera lens.

**adjustable focus lens:**
A lens that can be focused at different distances.

**ambient light:**
Light that doesn't come from your flash. Also called existing light and available light.

**angle of view:**
The area that a lens can capture. Also called field of view.

**aperture:**
The opening that allows light to pass through the lens.

**APS:**
The abbreviation for Advanced Photo System.

**artificial light:**
Light from sources other than the sun.

**ASA:**
The abbreviation for American Standards Association, one of two film rating systems replaced by the ISO film speed system.

# B

**background light:**
Light behind the subject used to separate the subject from the background.

**backlighting:**
Putting the main source of illumination behind the subject, shining toward the camera.

**bellows:**
A flexible accordion-like device used in close-up photography to increase the distance from the lens to the film.

**bounce lighting:**
A lighting technique in which the main source of illumination is reflected off a wall or ceiling instead of being aimed directly at the subject.

**bracketing:**
Shooting one or two more exposures on either side of the shot thought to be correctly exposed.

**built-in flash:**
A flash unit built into the camera.

# C

**cable release:**
A flexible cable that screws into the shutter release, used to prevent camera movement.

**camera movement:**
Any movement of the camera that causes images to blur. Also called camera shake.

**catchlight:**
A small light in the eyes of a portrait subject created by reflection from a light source.

**center-weighted metering:**
Exposure metering that puts more emphasis on objects in the center of the viewfinder.

**changing bag:**
A light-tight bag used for opening a camera in daylight.

**chromogenic film:**
Black-and-white film that can be processed using conventional color print chemistry.

**circular polarizer:**
A polarizing filter designed for use on automatic cameras.

**close-up:**
A picture taken with the camera close to the subject.

**color negative film:**
Color film that produces a negative image. Also called color print film.

**color slide film:**
Color film that produces direct-positive transparencies. Also called color reversal or color positive film.

**compact camera:**
A small, 35mm camera with automatic features. Also called point-and-shoot camera.

**composition:**
The arrangement of the elements in a picture.

**continuous advance:**
A shooting mode that allows pictures to be taken for as long as the shutter release button is depressed.

**contrast:**
The range of brightness in a subject.

**contrast filters:**
Lens filters used with black-and-white film to lighten or darken certain colors.

**conversion filter:**
Lens filters that allow film balanced for one type of light to be used with other light.

**cropping:**
Removing unwanted parts of a picture.

**cross lighting:**
Lighting a subject from opposite sides.

# D

**daylight film:**
Film that's color balanced for use in daylight and flash situations.

**definition:**
The clarity of detail in a negative or print.

**density:**
The relative darkness of a negative or print.

**depth of field:**
The area of a photo that is in sharp focus.

**diffused lighting:**
Nondirectional lighting that illuminates objects uniformly. Also called soft lighting.

**DIN:**
The abbreviation for Deutsche Industrie Norm, the European film rating system superseded by the ISO system.

**diopter:**
The term used to indicate the strength or magnification power of a close-up lens.

**directional lighting:**
Direct lighting from a concentrated source.

**Dutch tilt:**
A technique in which the camera is rotated about the lens axis.

# E

**emulsion:**
The light-sensitive coating on film.

**existing light:**
See ambient light.

**exposure:**
The amount of light captured on film, controlled by lens openings and shutter speeds.

**exposure latitude:**
A measure of a film's ability to produce acceptable images shot with various exposures.

**exposure lock:**
A device that holds the exposure setting until the shutter is released.

**exposure meter:**
A handheld or built-in device that reads the intensity of light falling on or reflected by a subject.

**extension rings:**
Rigid metal or plastic tubes or rings that are inserted between the lens and the camera body to increase focal length for close-up photography. Also called extension tubes.

# F

**fast film:**
See high-speed film.

**fast lens:**
A lens with a large maximum opening.

**field of view:**
See angle of view.

**fill light:**
Light used to enhance or augment the main illumination source to brighten dark areas in a picture.

**film cartridge:**
A light-tight container that holds film before and after it's exposed.

**film leader:**
The narrow strip of film extending from the film cassette used to attach the film to a camera's take-up spool or mechanism.

**film plane:**
The flat field on which the film captures the image.

**film speed:**
Measurement of a film's sensitivity to light.

**filter:**
A piece of colored or coated glass or plastic that alters the light reaching the film.

**filter factor:**
A number indicating how much exposure needs to be increased when using filters.

**fish-eye lens:**
An extreme wide-angle lens that produces circular images.

**fixed focal-length lens:**
A lens with only one focal length that can't be adjusted.

**fixed focus lens:**
A lens with nonadjustable focus.

**flash:**
A brief, intense source of artificial light.

**flash bracket:**
A fitting used to attach a flash unit to a camera.

**flash range:**
The maximum and minimum distances that a flash will cover.

**flash synchronization:**
Controls that synchronize shutter movement and flash illumination.

**focal length:**
The distance from the optical center of a lens to the point behind the lens where light rays focus to create an image.

**focus:**
Process of adjusting a lens so images are sharply defined.

**focusing frame:**
A set of brackets or circle on a viewfinder that determines the area covered by an autofocusing system.

**front/flat lighting:**
Lighting adjusted so the main source of illumination falls on front of the subject.

**f-stop:**
The aperture setting on a lens used to control the amount of light that enters it.

**full stop:**
A change in the lens opening from one f-stop to the next number.

## G

**graduated filter:**
A lens filter that gradually changes from clear to colored.

**grain:**
The sandy or pebble-like appearance found on some negatives, slides, or prints.

**gray card:**
Gray-colored cardboard used to make exposure readings.

## H

**half-stop:**
A lens opening between two f-stops.

**high-speed film:**
Film that is very sensitive to light.

**hot shoe:**
The slot with electrical contacts on top of a camera where a flash mounts.

## I

**incident light meter:**
An exposure meter that reads the light falling on a subject.

**infrared film:**
Film that records infrared radiation.

**ISO number:**
A film rating system set by the International Standards Organization that indicates how sensitive film is to light.

## K

**keystoning:**
Image distortion caused by tilting a camera or projector upward.

# L

**lens axis:**
The imaginary line that runs from the middle of the film through the middle of the lens.

**lens hood:**
A metal, rubber, or plastic shade that shields the lens from direct light.

**light balancing filter:**
A lens filter used to balance the color of a light source with the color the film registers.

**light leak:**
A gap or defect in light proofing (in camera, film cassette, or darkroom) that allows stray light to strike the film, or the resulting defect on the processed film.

**light meter:**
See exposure meter.

**long lens:**
A lens with a focal length greater than a normal lens.

**loupe:**
A magnifier used for looking closely at negatives and prints.

# M

**macro lens:**
A lens that allows close lens-to-subject focusing for close-up photography.

**manual exposure:**
An exposure set manually by the photographer.

**maximum lens aperture:**
The widest opening (f-stop) of a lens.

**medium-speed film:**
Film that is more sensitive to the light than slow film and less sensitive than fast film.

# N

**neutral density filter:**
A transparent piece of glass or plastic that cuts down the light entering the lens without changing its color.

**normal lens:**
A lens that produces an image similar in perspective to what the human eye sees.

# O

**off-camera flash:**
A flash unit not mounted on a camera.

**overexposure:**
Too much light reaching the film.

# P

**panchromatic film:**
Black-and-white film that is sensitive to all colors of light.

**panning:**
Following action in the camera's viewfinder.

**parallax error:**
A framing problem common in cameras

with viewfinders that see subjects at a different angle than the camera lens does.

**perspective:**
How objects appear relative to their distance and position.

**point of focus:**
The specific spot at which a camera lens is focused.

**polarizing filter:**
A lens filter used to eliminate glare and reflections.

**power points:**
Points created by the intersection of lines that divide an image area into thirds horizontally and vertically.

**prime lens:**
A lens with a single focal length.

**pull processing:**
Developing film for less time than usual.

**push processing:**
Developing film for a longer time than usual.

# R

**red-eye:**
The effect caused when flash illuminates the retina.

**red-eye reduction:**
A camera feature that reduces red-eye with a preflash or a steady beam of light before the actual flash.

**reflected light meter:**
An exposure meter that reads the light reflected by the subject.

**resolution:**
The amount of detail in a digital or film image.

**ring light:**
A flash unit used for close-up photography that encircles a camera lens.

**rule of thirds:**
A compositional concept that divides the image area into thirds.

# S

**saturated color:**
Color that is rich and uncontaminated.

**selective focus:**
Bringing the viewers attention to a subject by using shallow depth of field.

**shutter:**
The device that regulates the amount of time that light reaches the film.

**shutter speed:**
The length of time that light exposes the film.

**side lighting:**
Illumination aimed at the side of the subject and roughly perpendicular to the lens axis.

**single lens reflex camera:**
A camera with a viewfinder that shows subjects through the same lens used to record images. Commonly called an SLR camera, or just SLR.

**slave flash:**
A flash unit used to supplement light from a main flash.

**slow film:**
Film that is less sensitive to light than medium or fast film.

**spot metering:**
An exposure mode that reads only a small area designated by a circle in the middle of the viewfinder.

**stop:**
See f-stop.

## T

**telephoto lens:**
A lens with a longer focal length than a normal or wide-angle lens.

**through-the-lens metering:**
A metering system that reads the light coming through the camera lens. Commonly referred to by the abbreviation "TTL."

**top lighting:**
Lighting coming from above the subject.

**tungsten light:**
Light produced by an artificial light source such as a light bulb or a halogen lamp.

## U

**ultraviolet filter:**
A lens filter used to diminish the amount of ultraviolet light reaching the film. Also called haze filter or skylight filter.

**underexposure:**
The result of not enough light reaching the film.

## V

**viewfinder:**
The optical window used to view the subject being photographed.

**vignetting:**
A darkening of the corners of a picture, either accidentally or intentionally.

## W

**wide-angle lens:**
A lens with a shorter focal length than a normal or telephoto lens.

## Z

**zoom lens:**
A lens with multiple focal lengths.

*Appendix B*

# Additional Resources

# Magazines

Aperture—✑ *www.aperture.org*

Outdoor Photographer—✑ *www.outdoorphotographer.com*

Nature Photographer—✑ *www.naturephotographermag.com*

PHOTOgraphic—✑ *www.photographic.com*

PHOTO Techniques—✑ *www.phototechmag.com*

Popular Photography—✑ *www.popphoto.com*

Shutterbug—✑ *www.shutterbug.net*

# Web Sites

✑ *www.kodak.com*—Kodak's commercial site is full of information on Kodak products, of course, but it also has a great guide to photography.

✑ *www.PhotographyTips.com*—This information-rich site will tell you everything you want to know about virtually every facet of photography, from equipment choices to shooting techniques.

✑ *www.photo.net*—This online photographers' community offers discussion forums, information and articles for the rank beginner to the seasoned pro, classified ads, and opportunity for posting photos for review.

✑ *www.photographyreview.com*—This site features equipment reviews and price comparisons, although with limited educational content.

✐ *www.brightbytes.com*—Should you want to learn more about the *camera obscura,* this is the place to do it.

✐ *www.rleggat.com*—A site on the history of photography with some interesting biographical sketches on the men and women who shaped photography's early history.

# Books

*National Geographic Photography Field Guide: Secrets to Making Great Pictures,* Peter K. Burian (National Geographic Society: 1999). This guide covers the essentials of photography in the field, including composition, equipment, and techniques.

*John Shaw's Landscape Photography,* John Shaw (Amphoto: 1994). Shaw is a master of this genre. Any of his books are well worth reading; this one presents more "how-to-do-it" information than some of the others.

The New Ansel Adams Photography Series, Robert Baker (New York Graphic Society: 1981). Composed of three books—*The Camera, The Negative,* and *The Print.* Introduces you to Adams's techniques and is renowned as containing some of the best and most accessible writing on the technical aspects of photography.

*Posing and Lighting Techniques for Studio Portrait Photography,* J.J. Allen (Amherst Media: 2000). If you're interested in doing studio portrait work, this book will tell you how you can do it by using available and affordable equipment. Also covered are lighting setup and poses.

*The Art of Photographing Nature,* Art Wolfe (Crown Publishers: 1993). This is one of the classics on nature photography written by a legendary nature photographer.

*Photography of Natural Things*, Freeman Patterson (Key Porter Books: 1994).

*Travel Photography: How to Research, Produce and Sell Great Travel Pictures*, Roger Hicks (Focal Press: 1998).

*Capturing the Night with Your Camera: How to Take Great Photographs After Dark*, John Carucci (Amphoto: 1995).

*Flowers*, Heather Angel (Morgan & Morgan: 1976).

*How to Shoot and Sell Sports Photography*, David Neil Arndt (Amherst Media: 1999).

*How to Take Great Pet Pictures: Recipes for Outstanding Results With Any Camera*, Ron Nichols (Amherst Media: 2001).

*Understanding Exposure: How to Shoot Great Photographs*, Bryan Peterson (Amphoto: 1990).

## Other Photography-Related Books

*Photographer's Market*, (Writer's Digest Books: 2003). Published annually, this guide contains thousands of up-to-date market listings, including magazines, stock agencies, advertising agencies, newspapers and more.

*ASMP Stock Photography Handbook*, Michael Heron (American Society of Media Publishers: 1990).

*The Photographer's Market Guide to Photo Submission and Portfolio Formats*, Michael Willins (Writer's Digest Books: 1997).

*ASMP Professional Business Practices in Photography,* (American Society of Media Publishers: 2001).

*Photos That Sell: The Art of Successful Freelance Photography* (Watson-Guptill: 2001).

*How to Shoot Stock Photos That Sell,* Michael Heron (Allworth: 2001).

*The Business of Studio Photography: How to Start and Run a Successful Photography Studio,* Edward R. Lilley (Watson-Guptill: 2002).

*How to Start a Home-Based Photography Business,* Kenn Oberrecht (Globe Pequot: 2002).

*How to Look at Photographs: Reflections on the Art of Seeing,* David Finn (Harry N. Abrams: 1994).

# Index

# THE EVERYTHING SERIES!

## BUSINESS

Everything® **Business Planning Book**
Everything® **Coaching and Mentoring Book**
Everything® **Fundraising Book**
Everything® **Home-Based Business Book**
Everything® **Leadership Book**
Everything® **Managing People Book**
Everything® **Network Marketing Book**
Everything® **Online Business Book**
Everything® **Project Management Book**
Everything® **Selling Book**
Everything® **Start Your Own Business Book**
Everything® **Time Management Book**

## COMPUTERS

Everything® **Build Your Own Home Page Book**
Everything® **Computer Book**
Everything® **Internet Book**
Everything® **Microsoft® Word 2000 Book**

## COOKBOOKS

Everything® **Barbecue Cookbook**
Everything® **Bartender's Book, $9.95**
Everything® **Chinese Cookbook**
Everything® **Chocolate Cookbook**
Everything® **Cookbook**
Everything® **Dessert Cookbook**
Everything® **Diabetes Cookbook**
Everything® **Indian Cookbook**
Everything® **Low-Carb Cookbook**
Everything® **Low-Fat High-Flavor Cookbook**

Everything® **Low-Salt Cookbook**
Everything® **Mediterranean Cookbook**
Everything® **Mexican Cookbook**
Everything® **One-Pot Cookbook**
Everything® **Pasta Book**
Everything® **Quick Meals Cookbook**
Everything® **Slow Cooker Cookbook**
Everything® **Soup Cookbook**
Everything® **Thai Cookbook**
Everything® **Vegetarian Cookbook**
Everything® **Wine Book**

## HEALTH

Everything® **Alzheimer's Book**
Everything® **Anti-Aging Book**
Everything® **Diabetes Book**
Everything® **Dieting Book**
Everything® **Herbal Remedies Book**
Everything® **Hypnosis Book**
Everything® **Massage Book**
Everything® **Menopause Book**
Everything® **Nutrition Book**
Everything® **Reflexology Book**
Everything® **Reiki Book**
Everything® **Stress Management Book**
Everything® **Vitamins, Minerals, and Nutritional Supplements Book**

## HISTORY

Everything® **American Government Book**
Everything® **American History Book**
Everything® **Civil War Book**
Everything® **Irish History & Heritage Book**

Everything® **Mafia Book**
Everything® **Middle East Book**
Everything® **World War II Book**

## HOBBIES & GAMES

Everything® **Bridge Book**
Everything® **Candlemaking Book**
Everything® **Casino Gambling Book**
Everything® **Chess Basics Book**
Everything® **Collectibles Book**
Everything® **Crossword and Puzzle Book**
Everything® **Digital Photography Book**
Everything® **Easy Crosswords Book**
Everything® **Family Tree Book**
Everything® **Games Book**
Everything® **Knitting Book**
Everything® **Magic Book**
Everything® **Motorcycle Book**
Everything® **Online Genealogy Book**
Everything® **Photography Book**
Everything® **Pool & Billiards Book**
Everything® **Quilting Book**
Everything® **Scrapbooking Book**
Everything® **Sewing Book**
Everything® **Soapmaking Book**

## HOME IMPROVEMENT

Everything® **Feng Shui Book**
Everything® **Feng Shui Decluttering Book, $9.95 ($15.95 CAN)**
Everything® **Fix-It Book**
Everything® **Gardening Book**
Everything® **Homebuilding Book**

All Everything® books are priced at $12.95 or $14.95, unless otherwise stated. Prices subject to change without notice.
Canadian prices range from $11.95–$31.95, and are subject to change without notice.

Everything® **Home Decorating Book**
Everything® **Landscaping Book**
Everything® **Lawn Care Book**
Everything® **Organize Your Home Book**

## EVERYTHING® KIDS' BOOKS

All titles are $6.95

Everything® **Kids' Baseball Book, 3rd Ed.** ($10.95 CAN)
Everything® **Kids' Bible Trivia Book** ($10.95 CAN)
Everything® **Kids' Bugs Book** ($10.95 CAN)
Everything® **Kids' Christmas Puzzle & Activity Book** ($10.95 CAN)
Everything® **Kids' Cookbook** ($10.95 CAN)
Everything® **Kids' Halloween Puzzle & Activity Book** ($10.95 CAN)
Everything® **Kids' Joke Book** ($10.95 CAN)
Everything® **Kids' Math Puzzles Book** ($10.95 CAN)
Everything® **Kids' Mazes Book** ($10.95 CAN)
Everything® **Kids' Money Book** ($11.95 CAN)
Everything® **Kids' Monsters Book** ($10.95 CAN)
Everything® **Kids' Nature Book** ($11.95 CAN)
Everything® **Kids' Puzzle Book** ($10.95 CAN)
Everything® **Kids' Riddles & Brain Teasers Book** ($10.95 CAN)
Everything® **Kids' Science Experiments Book** ($10.95 CAN)
Everything® **Kids' Soccer Book** ($10.95 CAN)
Everything® **Kids' Travel Activity Book** ($10.95 CAN)

## KIDS' STORY BOOKS

Everything® **Bedtime Story Book**
Everything® **Bible Stories Book**
Everything® **Fairy Tales Book**
Everything® **Mother Goose Book**

## LANGUAGE

Everything® **Inglés Book**
Everything® **Learning French Book**
Everything® **Learning German Book**
Everything® **Learning Italian Book**
Everything® **Learning Latin Book**
Everything® **Learning Spanish Book**
Everything® **Sign Language Book**
Everything® **Spanish Phrase Book,** $9.95 ($15.95 CAN)

## MUSIC

Everything® **Drums Book (with CD),** $19.95 ($31.95 CAN)
Everything® **Guitar Book**
Everything® **Playing Piano and Keyboards Book**
Everything® **Rock & Blues Guitar Book (with CD),** $19.95 ($31.95 CAN)
Everything® **Songwriting Book**

## NEW AGE

Everything® **Astrology Book**
Everything® **Divining the Future Book**
Everything® **Dreams Book**
Everything® **Ghost Book**
Everything® **Love Signs Book,** $9.95 ($15.95 CAN)
Everything® **Meditation Book**
Everything® **Numerology Book**
Everything® **Palmistry Book**
Everything® **Psychic Book**
Everything® **Spells & Charms Book**
Everything® **Tarot Book**
Everything® **Wicca and Witchcraft Book**

## PARENTING

Everything® **Baby Names Book**
Everything® **Baby Shower Book**
Everything® **Baby's First Food Book**
Everything® **Baby's First Year Book**
Everything® **Breastfeeding Book**

Everything® **Father-to-Be Book**
Everything® **Get Ready for Baby Book**
Everything® **Getting Pregnant Book**
Everything® **Homeschooling Book**
Everything® **Parent's Guide to Children with Autism**
Everything® **Parent's Guide to Positive Discipline**
Everything® **Parent's Guide to Raising a Successful Child**
Everything® **Parenting a Teenager Book**
Everything® **Potty Training Book,** $9.95 ($15.95 CAN)
Everything® **Pregnancy Book, 2nd Ed.**
Everything® **Pregnancy Fitness Book**
Everything® **Pregnancy Organizer,** $15.00 ($22.95 CAN)
Everything® **Toddler Book**
Everything® **Tween Book**

## PERSONAL FINANCE

Everything® **Budgeting Book**
Everything® **Get Out of Debt Book**
Everything® **Get Rich Book**
Everything® **Homebuying Book, 2nd Ed.**
Everything® **Homeselling Book**
Everything® **Investing Book**
Everything® **Money Book**
Everything® **Mutual Funds Book**
Everything® **Online Investing Book**
Everything® **Personal Finance Book**
Everything® **Personal Finance in Your 20s & 30s Book**
Everything® **Wills & Estate Planning Book**

## PETS

Everything® **Cat Book**
Everything® **Dog Book**
Everything® **Dog Training and Tricks Book**
Everything® **Golden Retriever Book**
Everything® **Horse Book**
Everything® **Labrador Retriever Book**
Everything® **Puppy Book**
Everything® **Tropical Fish Book**

All Everything® books are priced at $12.95 or $14.95, unless otherwise stated. Prices subject to change without notice.
Canadian prices range from $11.95–$31.95, and are subject to change without notice.

## REFERENCE

Everything® **Astronomy Book**
Everything® **Car Care Book**
Everything® **Christmas Book, $15.00**
   **($21.95 CAN)**
Everything® **Classical Mythology Book**
Everything® **Einstein Book**
Everything® **Etiquette Book**
Everything® **Great Thinkers Book**
Everything® **Philosophy Book**
Everything® **Psychology Book**
Everything® **Shakespeare Book**
Everything® **Tall Tales, Legends, &**
   **Other Outrageous**
   **Lies Book**
Everything® **Toasts Book**
Everything® **Trivia Book**
Everything® **Weather Book**

## RELIGION

Everything® **Angels Book**
Everything® **Bible Book**
Everything® **Buddhism Book**
Everything® **Catholicism Book**
Everything® **Christianity Book**
Everything® **Jewish History &**
   **Heritage Book**
Everything® **Judaism Book**
Everything® **Prayer Book**
Everything® **Saints Book**
Everything® **Understanding Islam**
   **Book**
Everything® **World's Religions Book**
Everything® **Zen Book**

## SCHOOL & CAREERS

Everything® **After College Book**
Everything® **Alternative Careers Book**
Everything® **College Survival Book**
Everything® **Cover Letter Book**
Everything® **Get-a-Job Book**
Everything® **Hot Careers Book**

Everything® **Job Interview Book**
Everything® **New Teacher Book**
Everything® **Online Job Search Book**
Everything® **Resume Book, 2nd Ed.**
Everything® **Study Book**

## SELF-HELP/ RELATIONSHIPS

Everything® **Dating Book**
Everything® **Divorce Book**
Everything® **Great Marriage Book**
Everything® **Great Sex Book**
Everything® **Kama Sutra Book**
Everything® **Romance Book**
Everything® **Self-Esteem Book**
Everything® **Success Book**

## SPORTS & FITNESS

Everything® **Body Shaping Book**
Everything® **Fishing Book**
Everything® **Fly-Fishing Book**
Everything® **Golf Book**
Everything® **Golf Instruction Book**
Everything® **Knots Book**
Everything® **Pilates Book**
Everything® **Running Book**
Everything® **Sailing Book, 2nd Ed.**
Everything® **T'ai Chi and QiGong Book**
Everything® **Total Fitness Book**
Everything® **Weight Training Book**
Everything® **Yoga Book**

## TRAVEL

Everything® **Family Guide to Hawaii**
Everything® **Guide to Las Vegas**
Everything® **Guide to New England**
Everything® **Guide to New York City**
Everything® **Guide to Washington D.C.**
Everything® **Travel Guide to The**
   **Disneyland Resort®,**
   **California Adventure®,**

**Universal Studios®, and**
**the Anaheim Area**
Everything® **Travel Guide to the Walt**
   **Disney World Resort®,**
   **Universal Studios®, and**
   **Greater Orlando, 3rd Ed.**

## WEDDINGS

Everything® **Bachelorette Party Book,**
   **$9.95 ($15.95 CAN)**
Everything® **Bridesmaid Book, $9.95**
   **($15.95 CAN)**
Everything® **Creative Wedding Ideas**
   **Book**
Everything® **Elopement Book, $9.95**
   **($15.95 CAN)**
Everything® **Groom Book**
Everything® **Jewish Wedding Book**
Everything® **Wedding Book, 2nd Ed.**
Everything® **Wedding Checklist,**
   **$7.95 ($11.95 CAN)**
Everything® **Wedding Etiquette Book,**
   **$7.95 ($11.95 CAN)**
Everything® **Wedding Organizer,**
   **$15.00 ($22.95 CAN)**
Everything® **Wedding Shower Book,**
   **$7.95 ($12.95 CAN)**
Everything® **Wedding Vows Book,**
   **$7.95 ($11.95 CAN)**
Everything® **Weddings on a Budget**
   **Book, $9.95 ($15.95 CAN)**

## WRITING

Everything® **Creative Writing Book**
Everything® **Get Published Book**
Everything® **Grammar and Style Book**
Everything® **Grant Writing Book**
Everything® **Guide to Writing**
   **Children's Books**
Everything® **Screenwriting Book**
Everything® **Writing Well Book**

## Available wherever books are sold!
## To order, call 800-872-5627, or visit us at everything.com